CW00594806

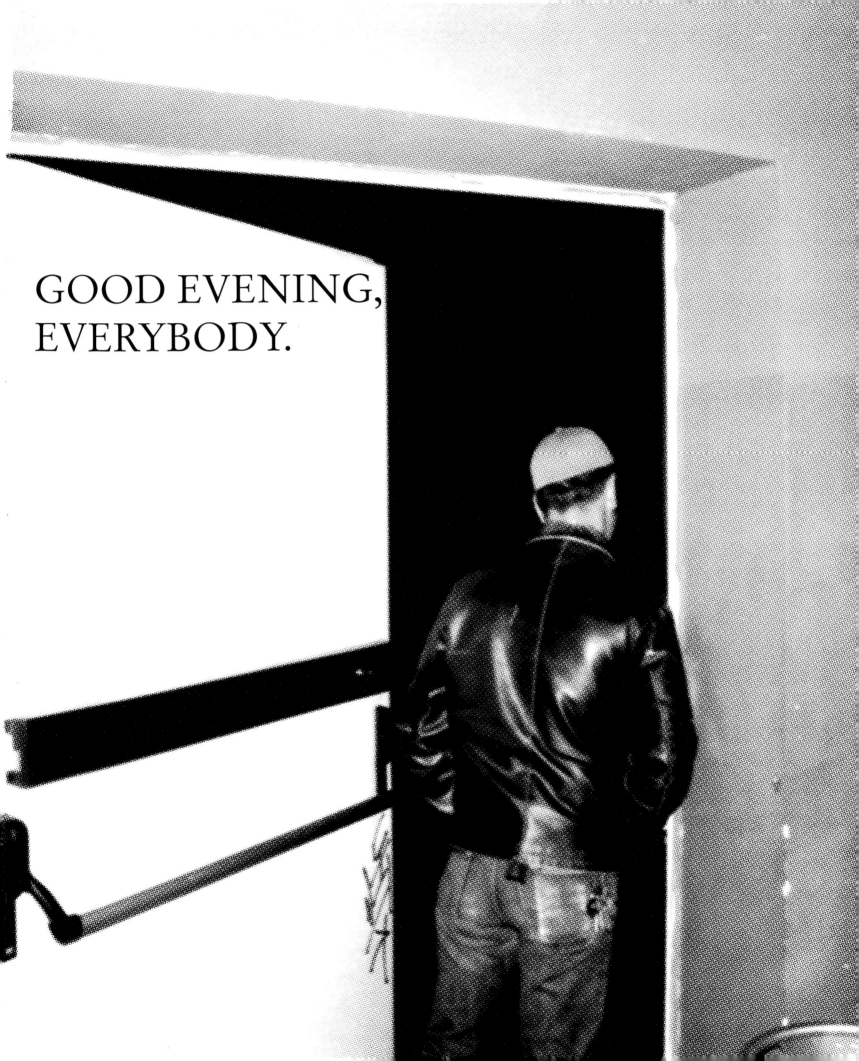

GOOD EVENING,
EVERYBODY.

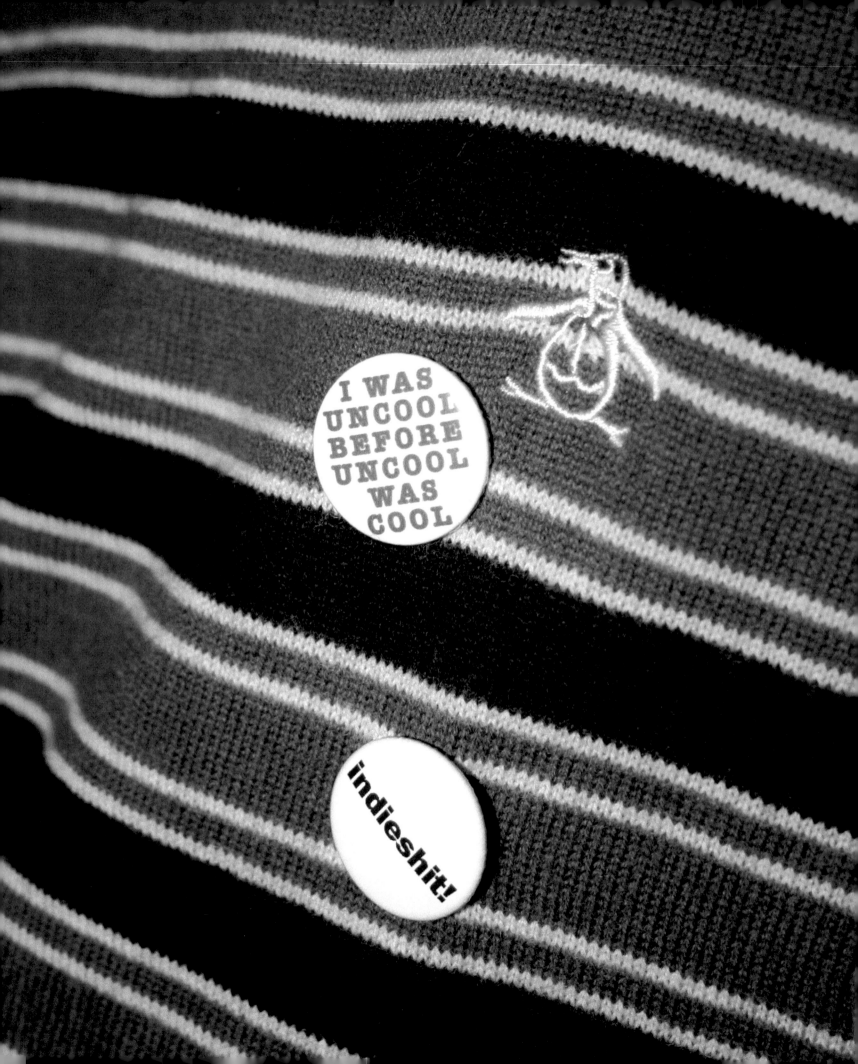

ROCK'N'ROLL MEMORIES

Alan McGee

Biff Bang Pow... I don't remember 1988 to 1994. We were actually alright.
We did too many drugs.

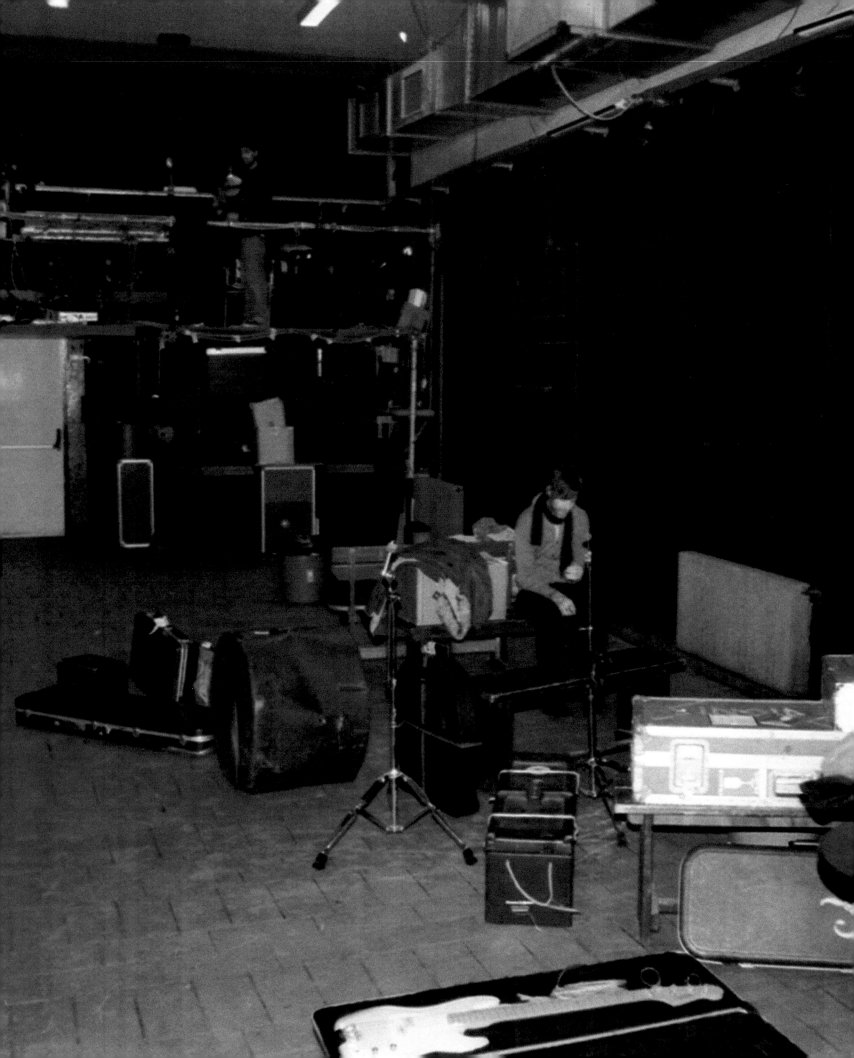

FROM THE COVO HEADQUARTERS

Massimiliano Bonini

When Angelo first told me about his plan to publish a book of photographs of bands at Covo I thought it was a brilliant idea. For years directors, journalists and writers had been approaching me to document the club's musical life and history. But up till now I hadn't done much of anything. Angelo's passion changed all that. Covo started in 1980 when a bunch of local band guys asked the city for a place to play music and put on parties. The authorities gave us a few rooms in the building known as "Casalone." And we've been there ever since. From the early 80's to today, Bologna was, and is, a city of talent, brimming over with musicians passionate to make art and sound. But there were few spots to allow the scene express itself. Covo changed that. We drew capacity crowds right from the beginning. After a few years, live music became the most important activity of the club. Bands from all over the world began to fly straight to Bologna just to spend a weekend in Italy and play at Covo. Being HERE was the cachet. Our legendary New Year's Eve parties are proof of the buzz. Through these pics I relieve live the experience of glorious gigs, feel the adrenaline rush, and witness the celebration of Amplified Youth of Rock 'n' Roll. In this book you'll find only a part of the Covo history. The club hosted a number of bands through the years who became worldwide superstars. But "digging the best music around" is our trademark. The people who started it all were moved solely by their passion. Some of them are still involved now, after twenty five years, spinning on a Saturday night or collecting money at the door, still ready to spend some hours in deep conversation about the latest record they bought. Some people left, some people came, but the passion for music is still there… Enjoy the pictures and see you in twenty five years, always in the same place.

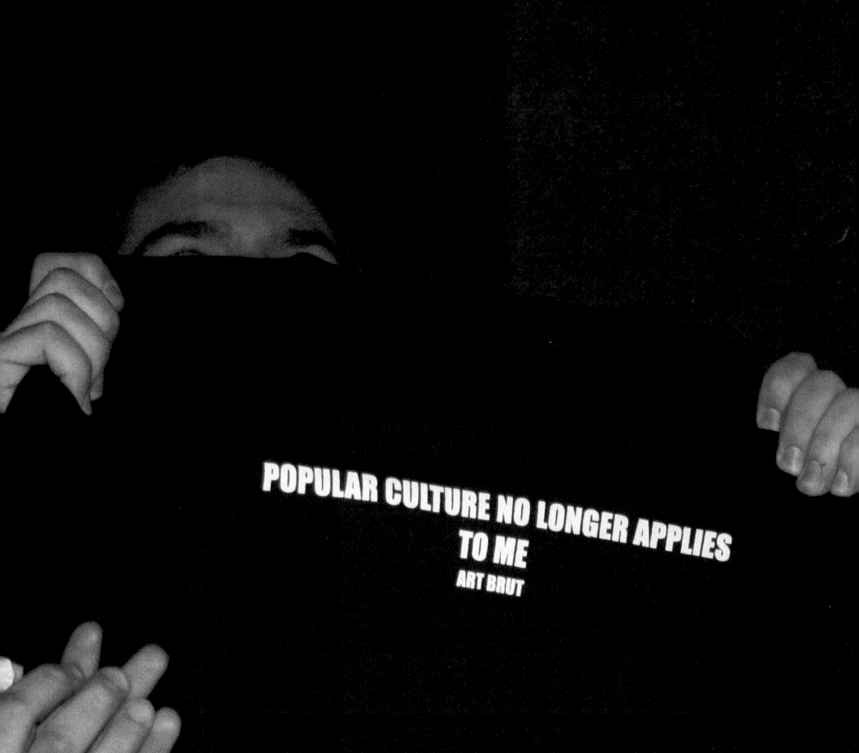

ANGELO SINDACO
A.K.A. JACK THE RIPPER

Christian Zingales

When I used to call Angelo on the phone, he always answered, "Sindaco in the house!". It was the 1990s and though the times have changed, he hasn't. He still has that big buzzing curiosity, that unquenchable passion for music and art, that creates a sort of cynical filter between himself and the world. It must come from his culture, a flip side of the theatricality that comes from being Pugliese, a region with cultural influences and deep roots in the Levantine. Someone like Angelo Sindaco is a fighter, a man who has to engage in combat, both for himself and within himself, to preserve the deep and noble sense of the individual. He chose to live in the rich textured and artistic city of Bologna because he wanted a bigger stage on which to work, to battle. He who before becoming a deejay designed comics, giving life to superheroes within himself. He who became deejay because house music was the incessant beat of his own blood rhythm. He who traffics in graphics, design and fashion, because in those contemporary fields he maintains close contact with the world. He who as a photographer uses his camera to zoom in on the dirtiness of the world, because his passion to get the shot right is the flip side of his rough and wild individualism. In the images collected in this volume, there is the perfect representation of retro-modernism and the realization of a dream: to lose himself in true musicality, cut off from reality. Captured in the frame of a comic, lost in a deep groove, in the slick cut of a garment, in a fashionable style. An image (and a piece of reality) captured. But only after Sindaco coaxes it out of its lair and then finishes the job. With a killer stare, in the recesses of a club. Where the exquisite corpse of rock'n'rock is still standing. Each picture, a stab in the dark. Sindaco, like Jack the Ripper.

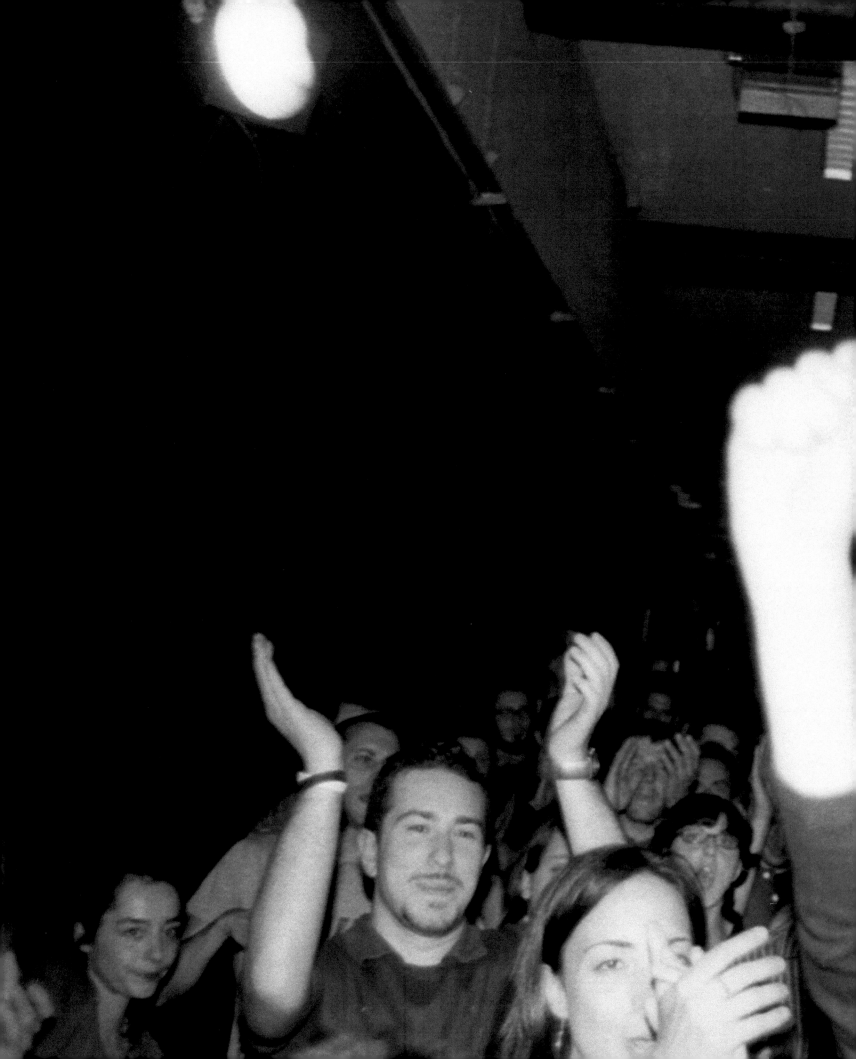

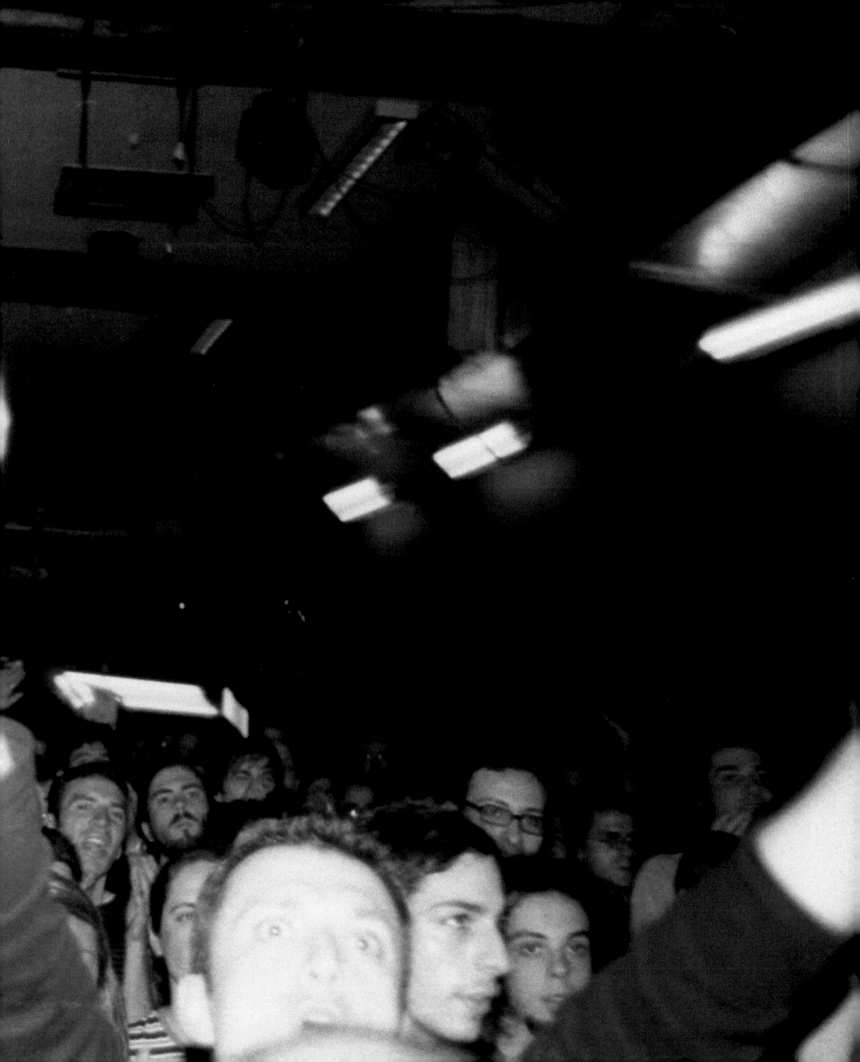

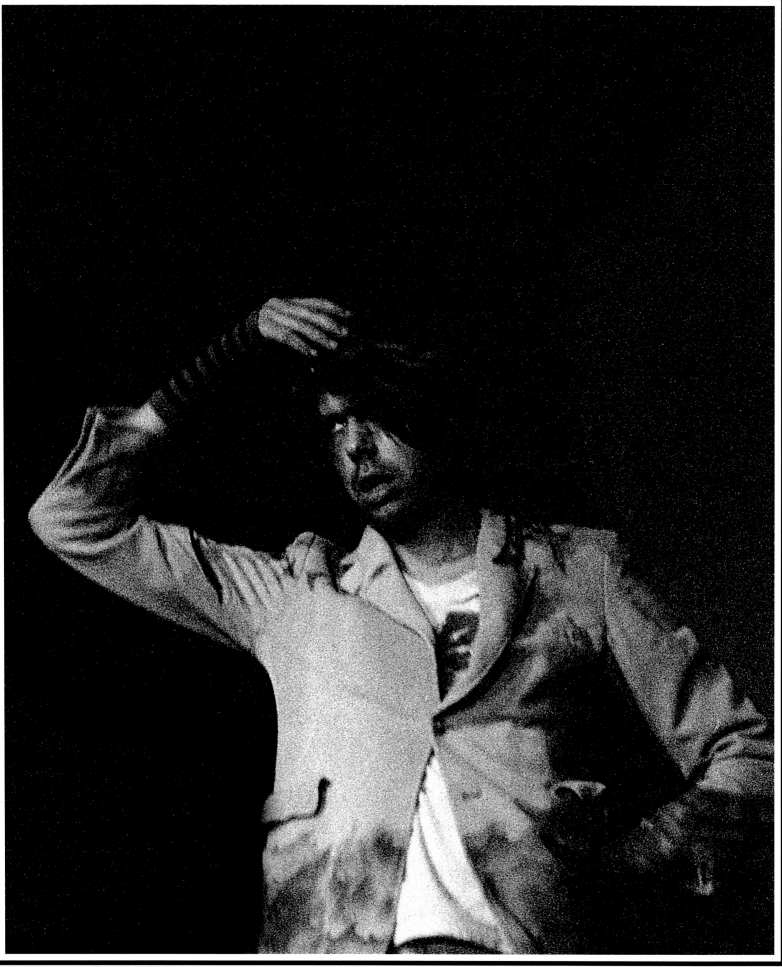

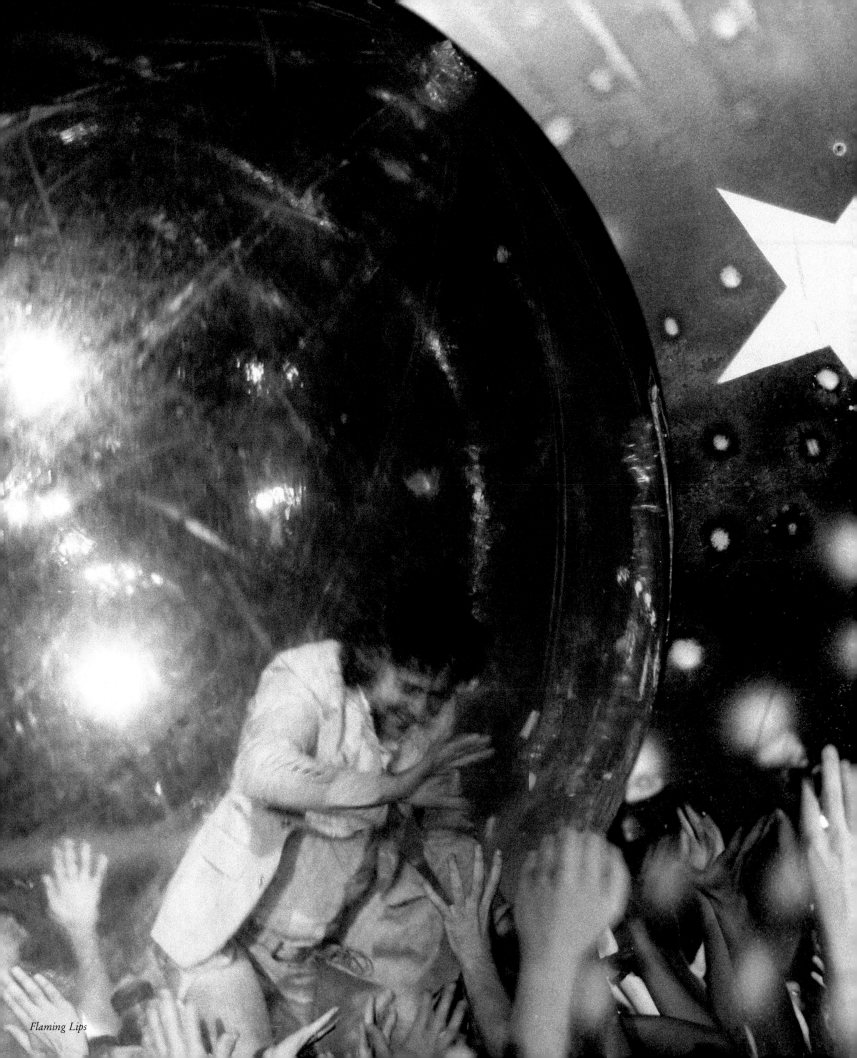

Flaming Lips

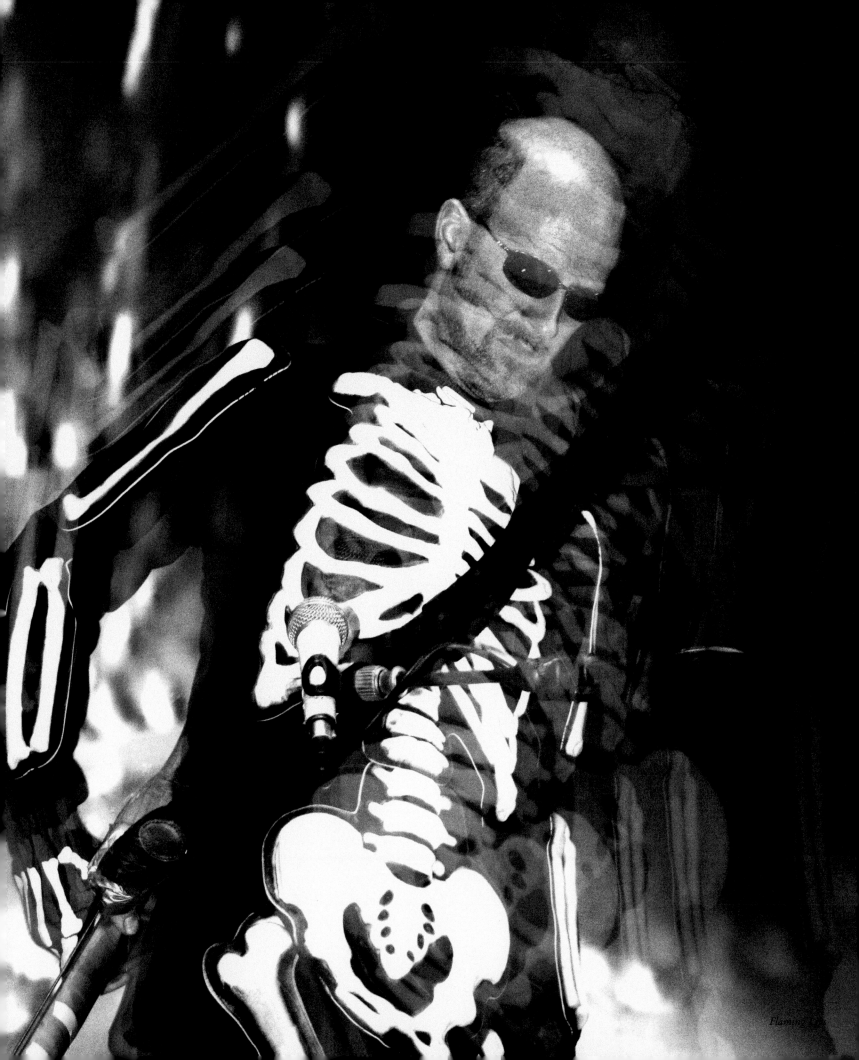

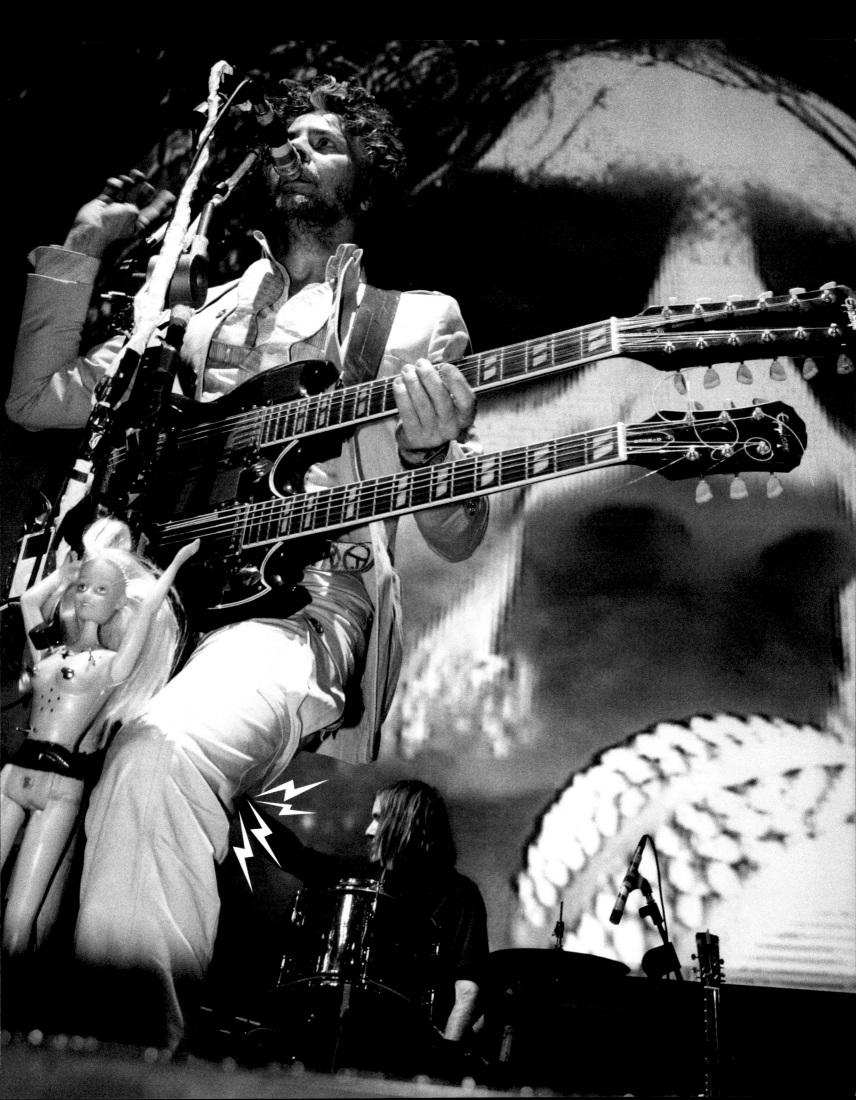

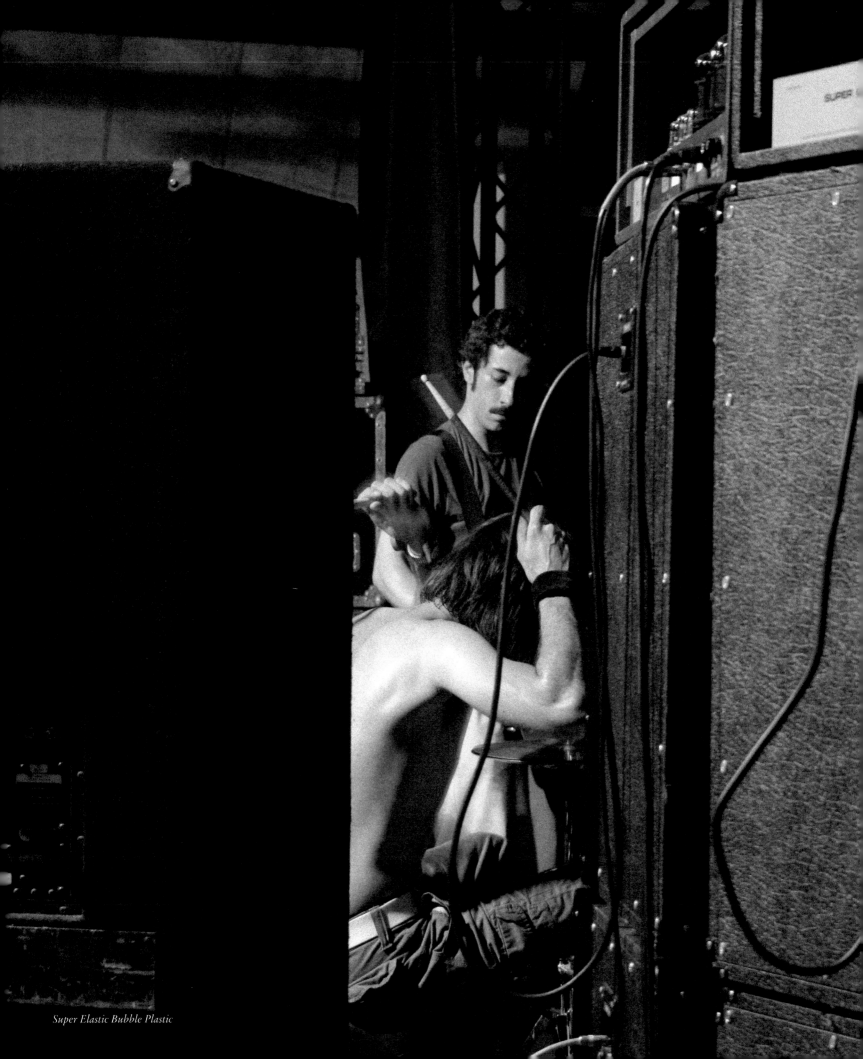

Super Elastic Bubble Plastic

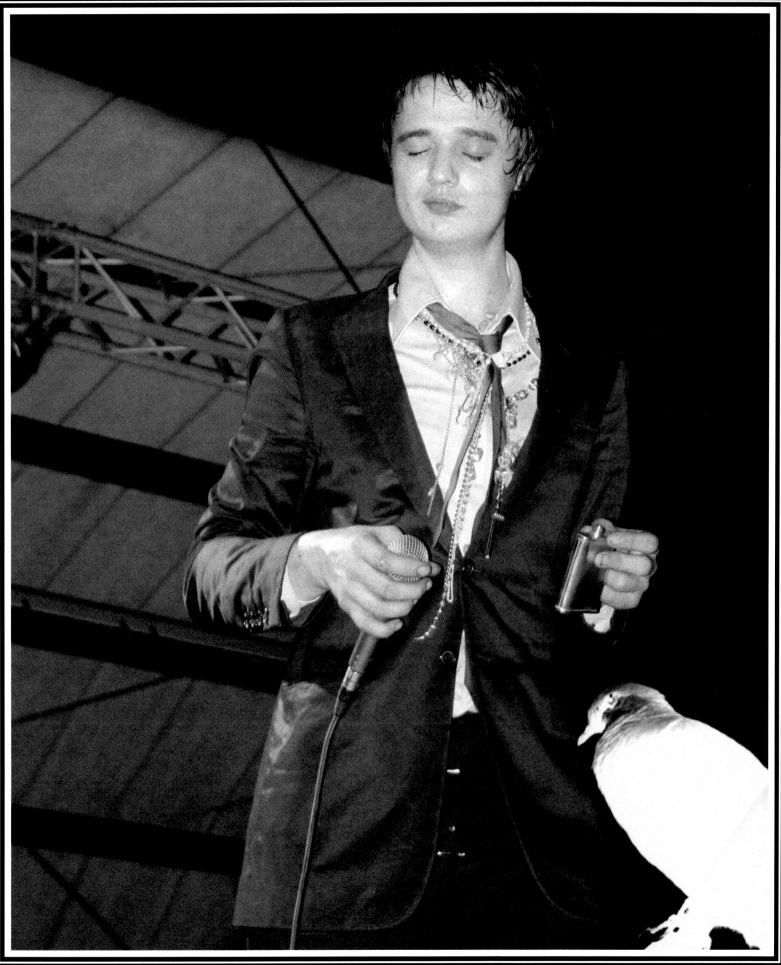

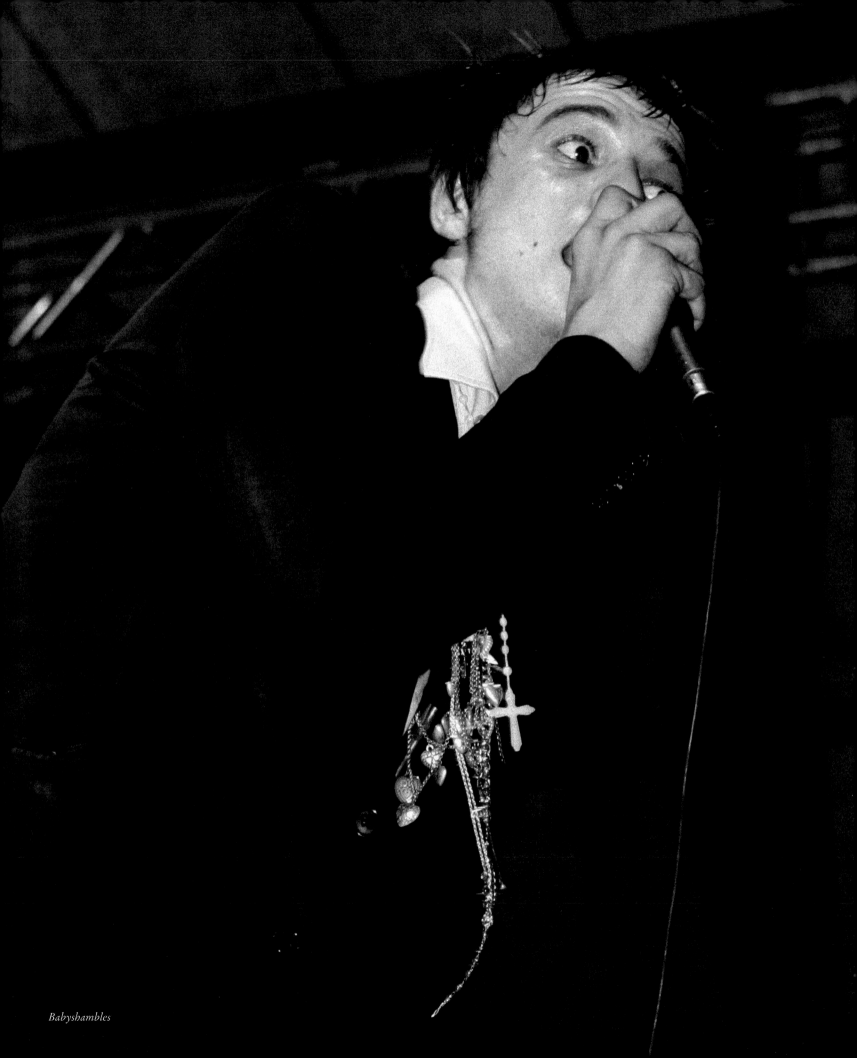

Babyshambles

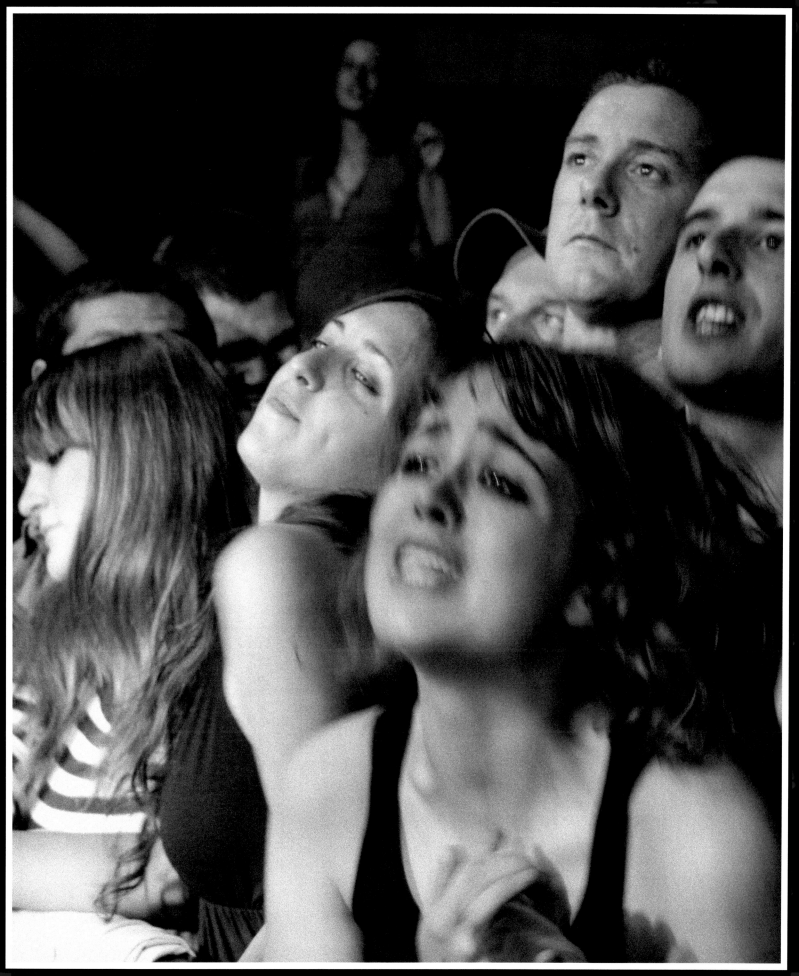

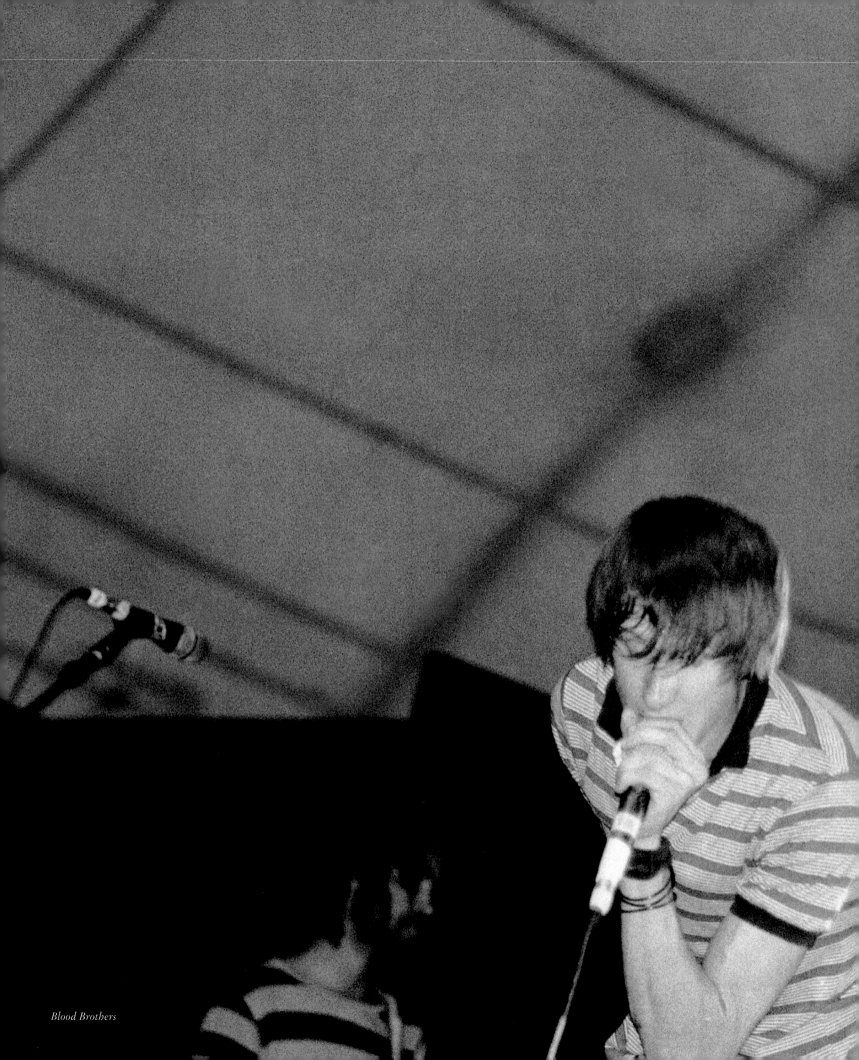

Blood Brothers

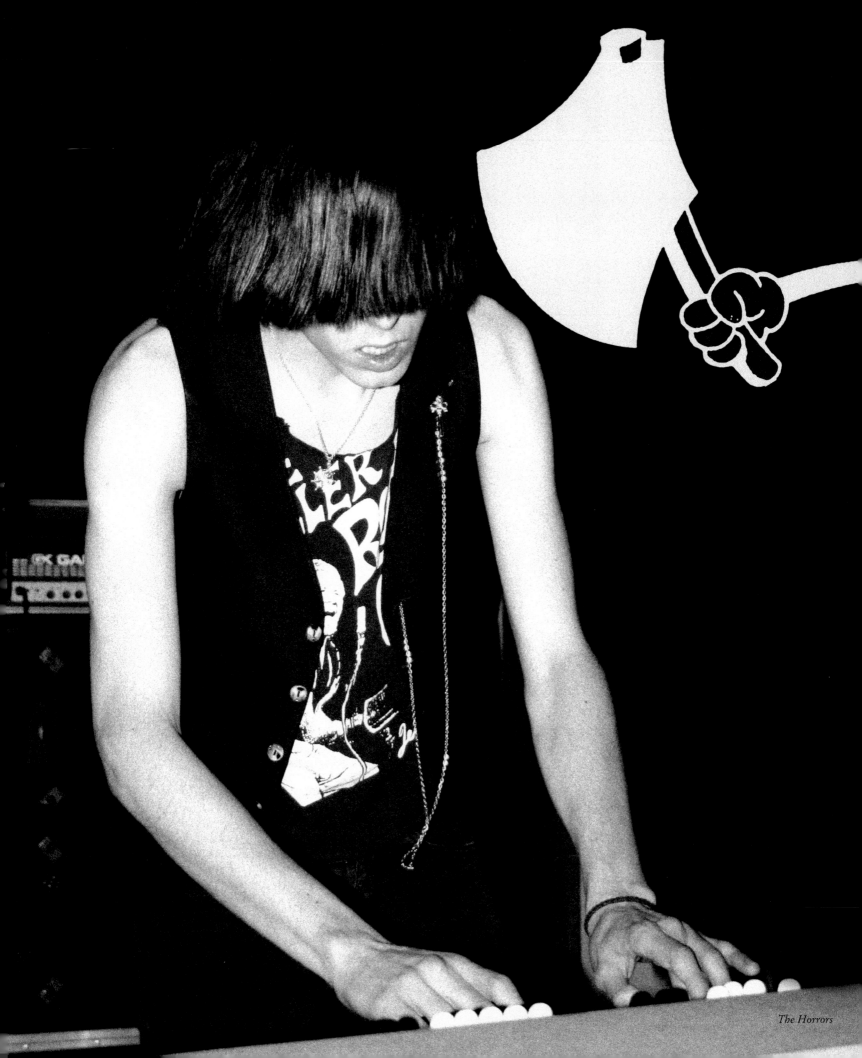

The Horrors

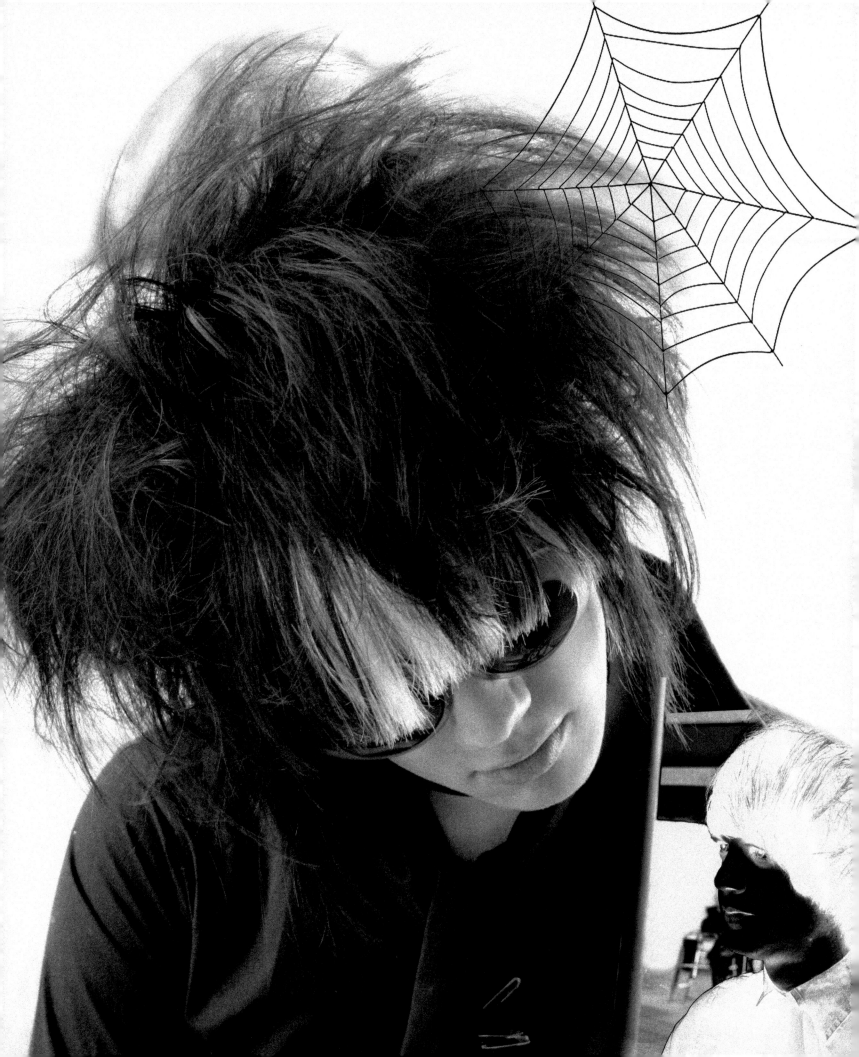

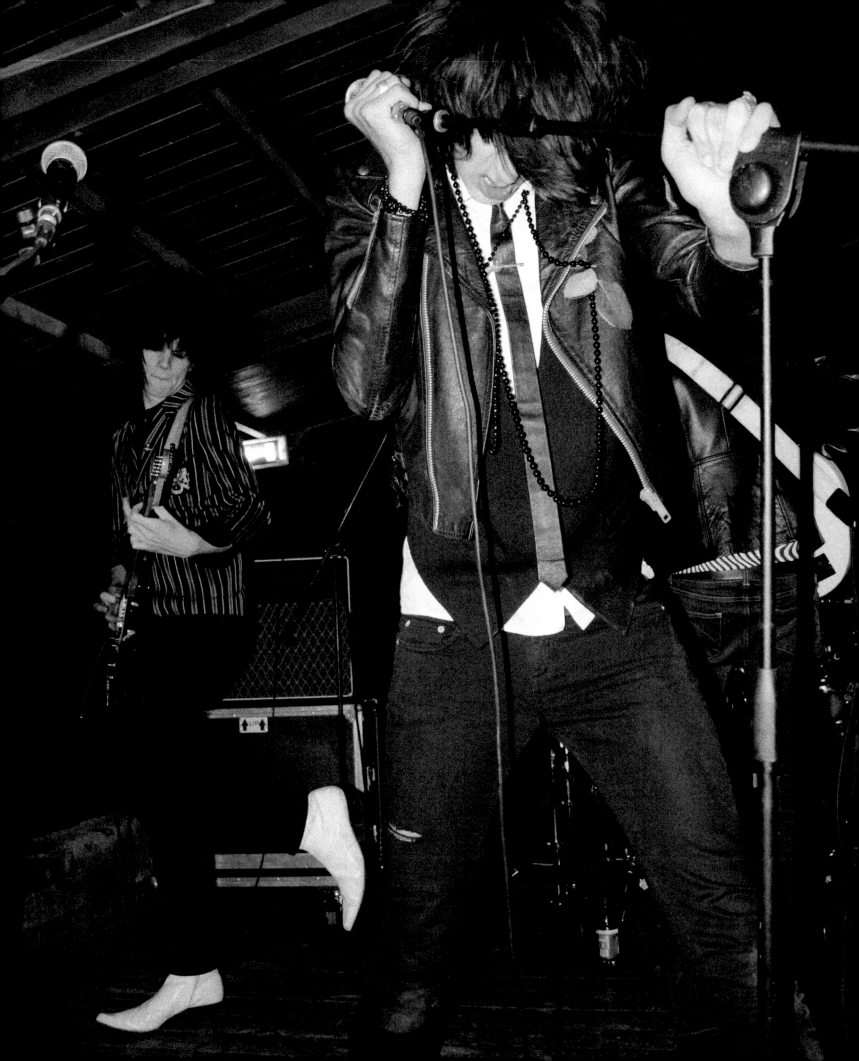

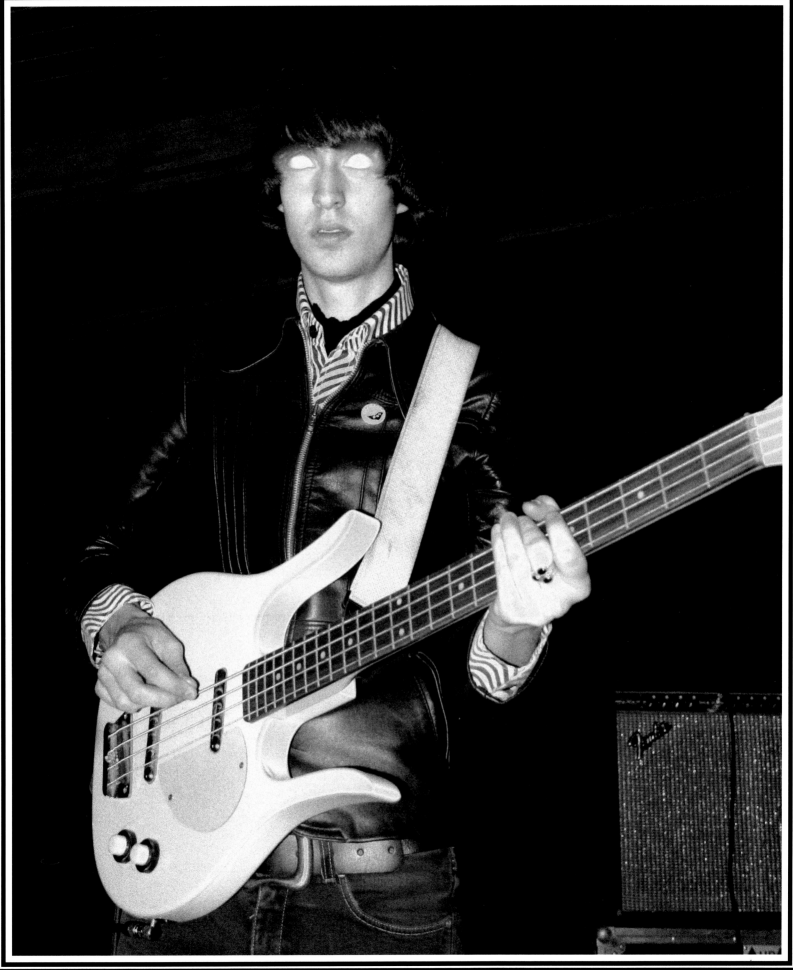

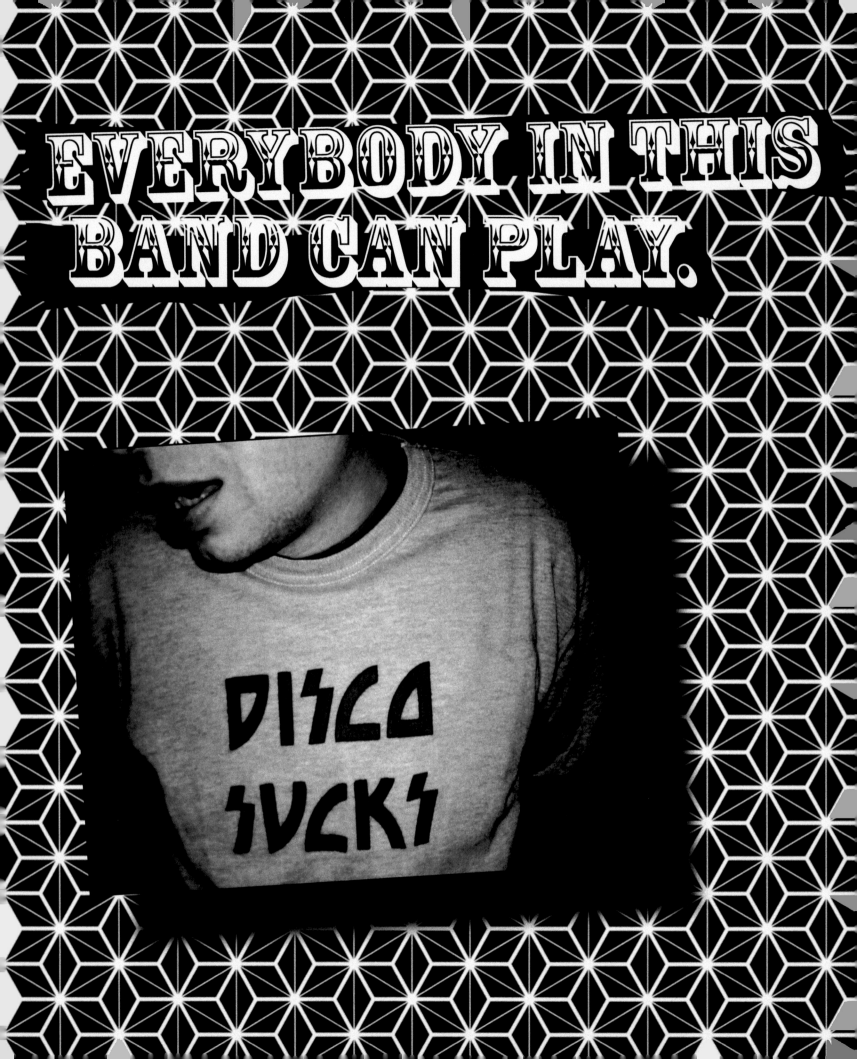

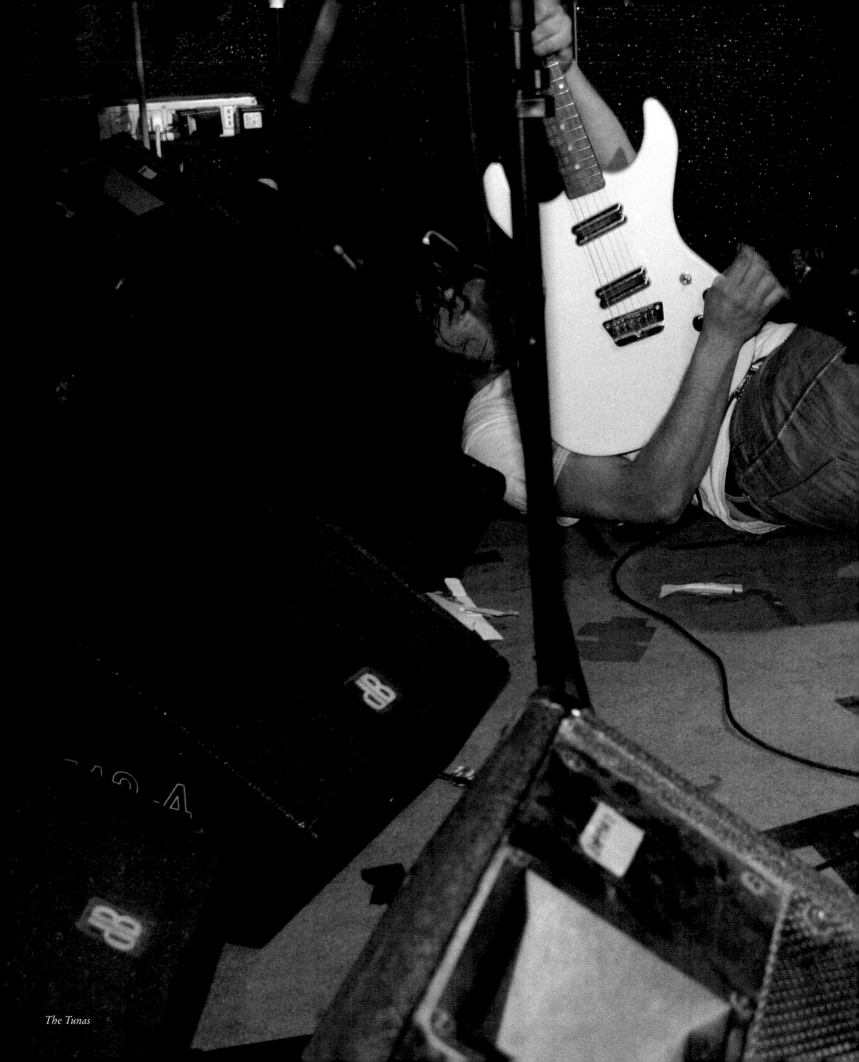

The Tunas

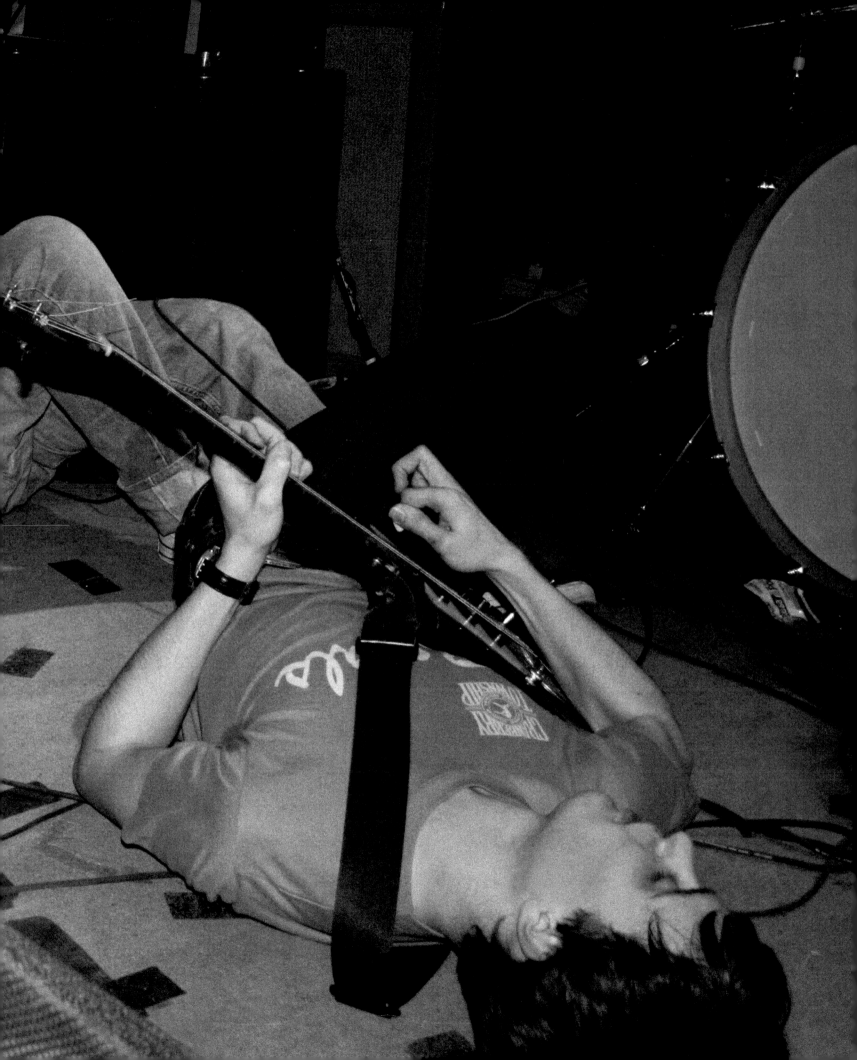

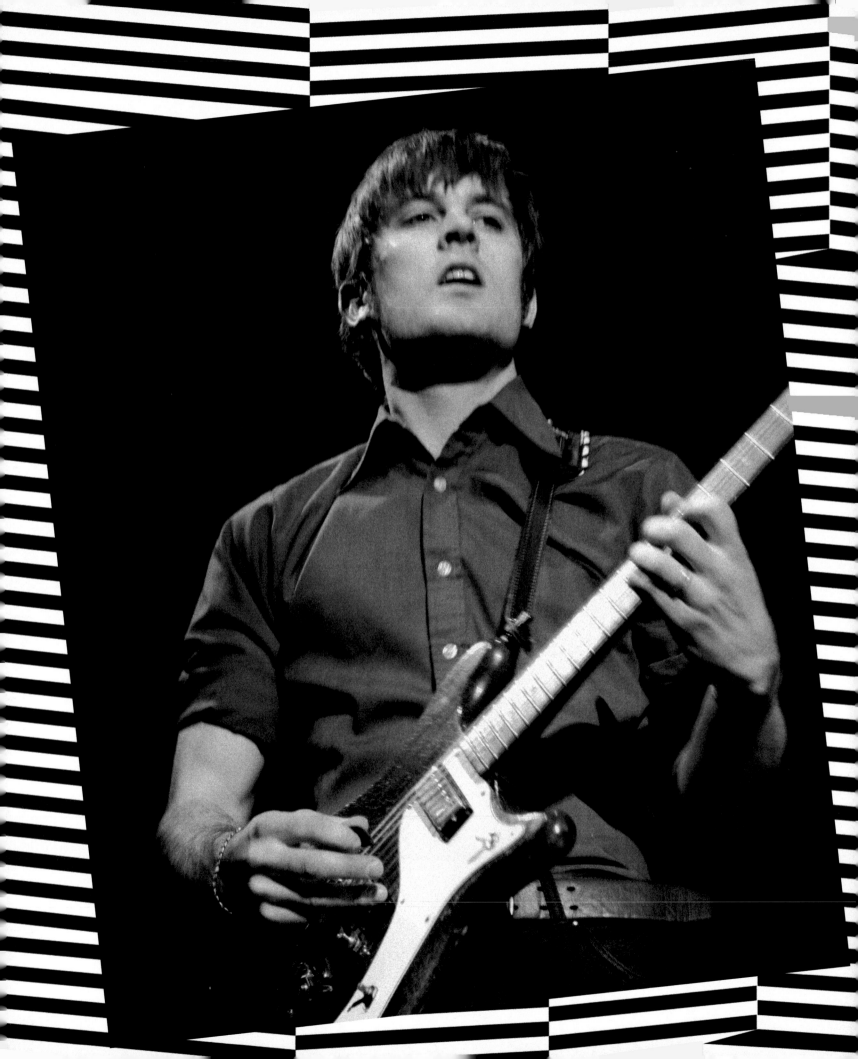

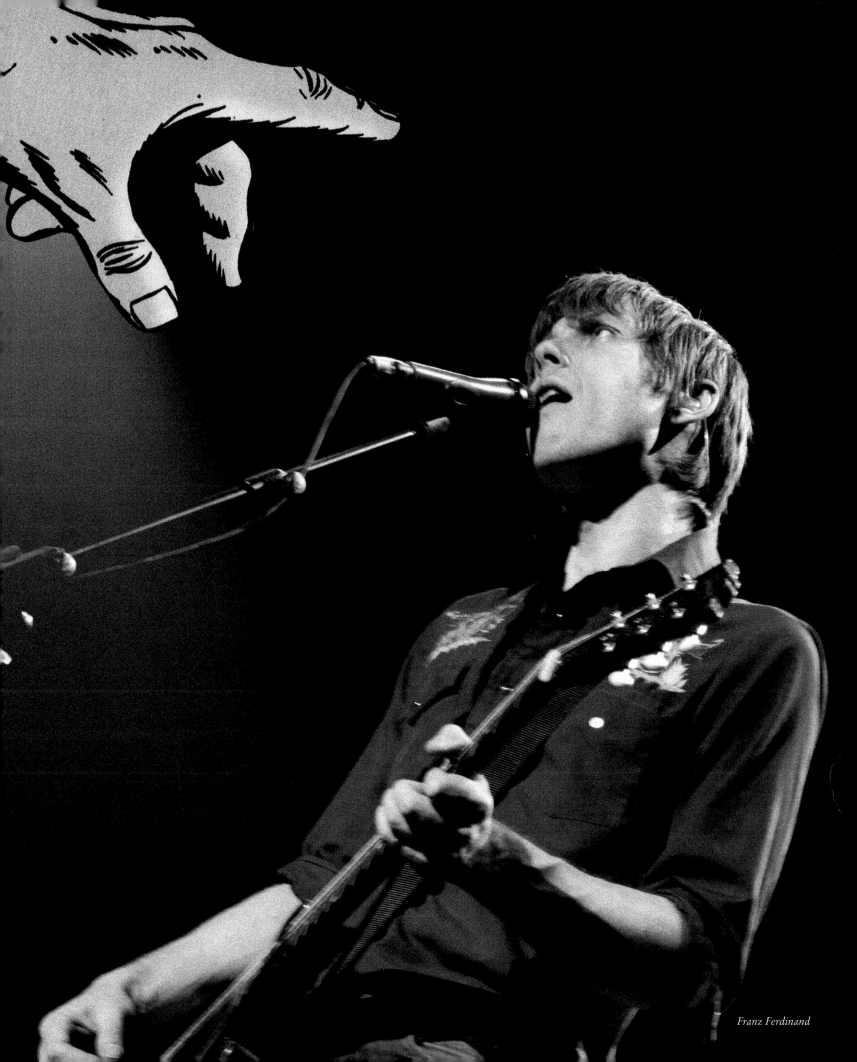

Franz Ferdinand

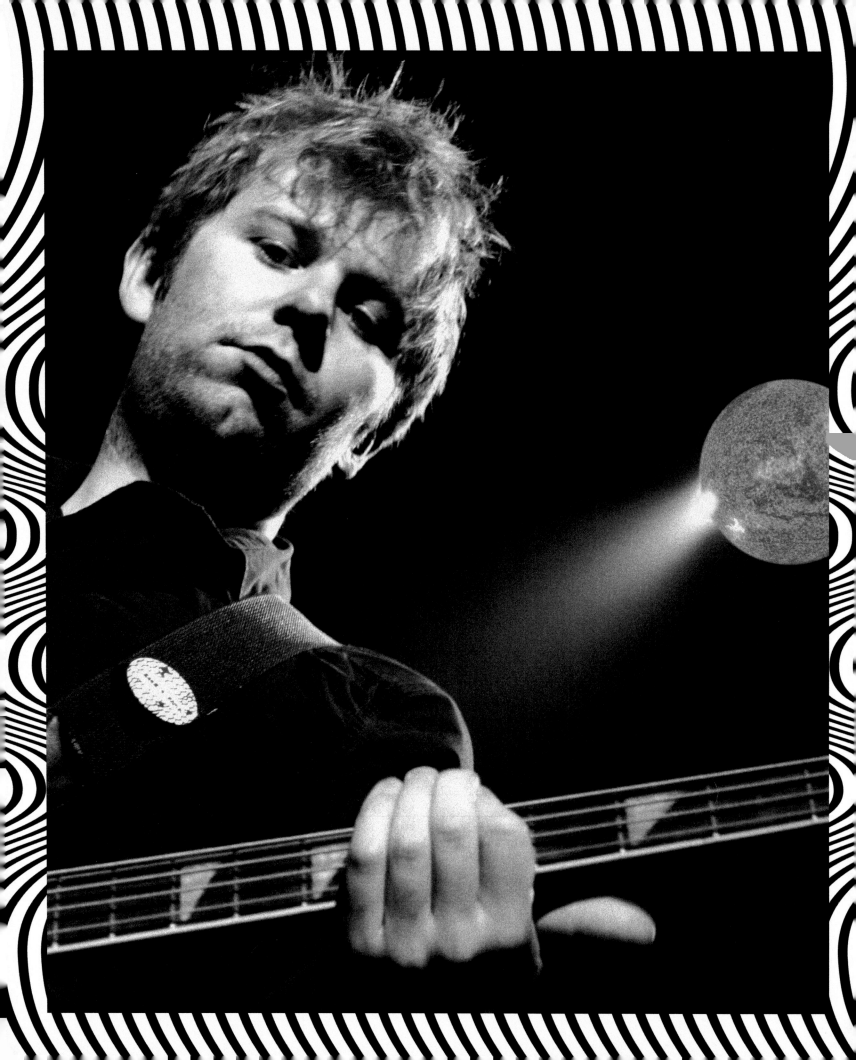

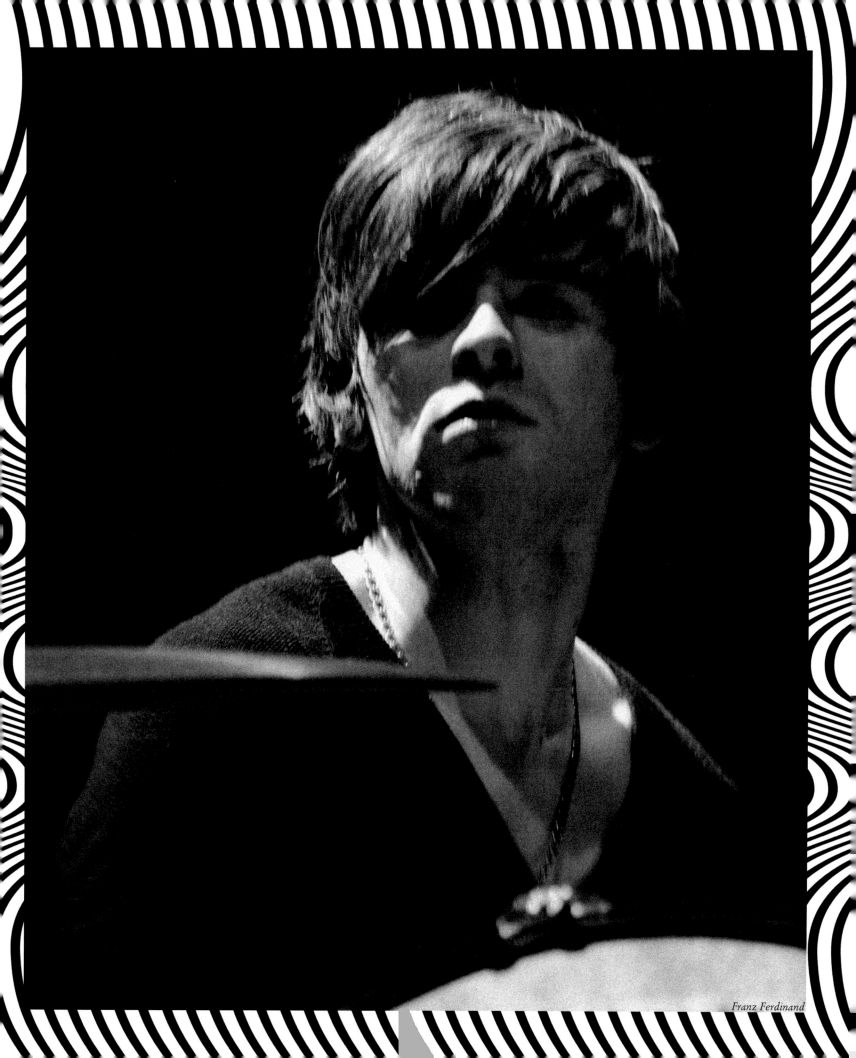

Franz Ferdinand

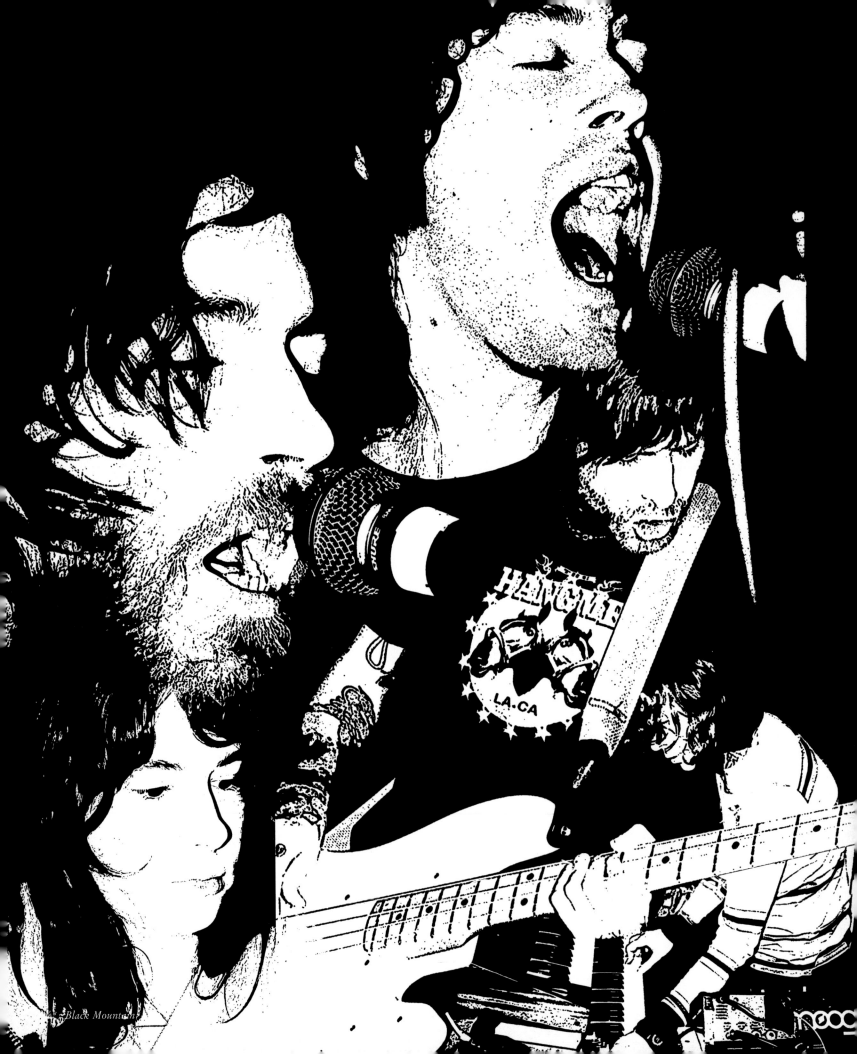

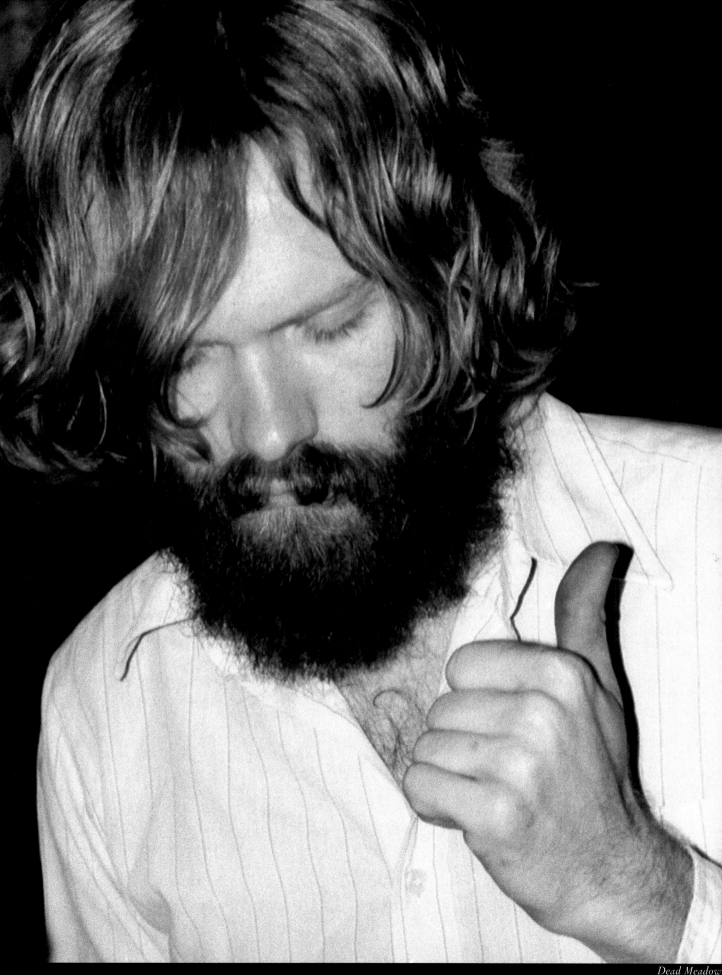

Dead Meadow

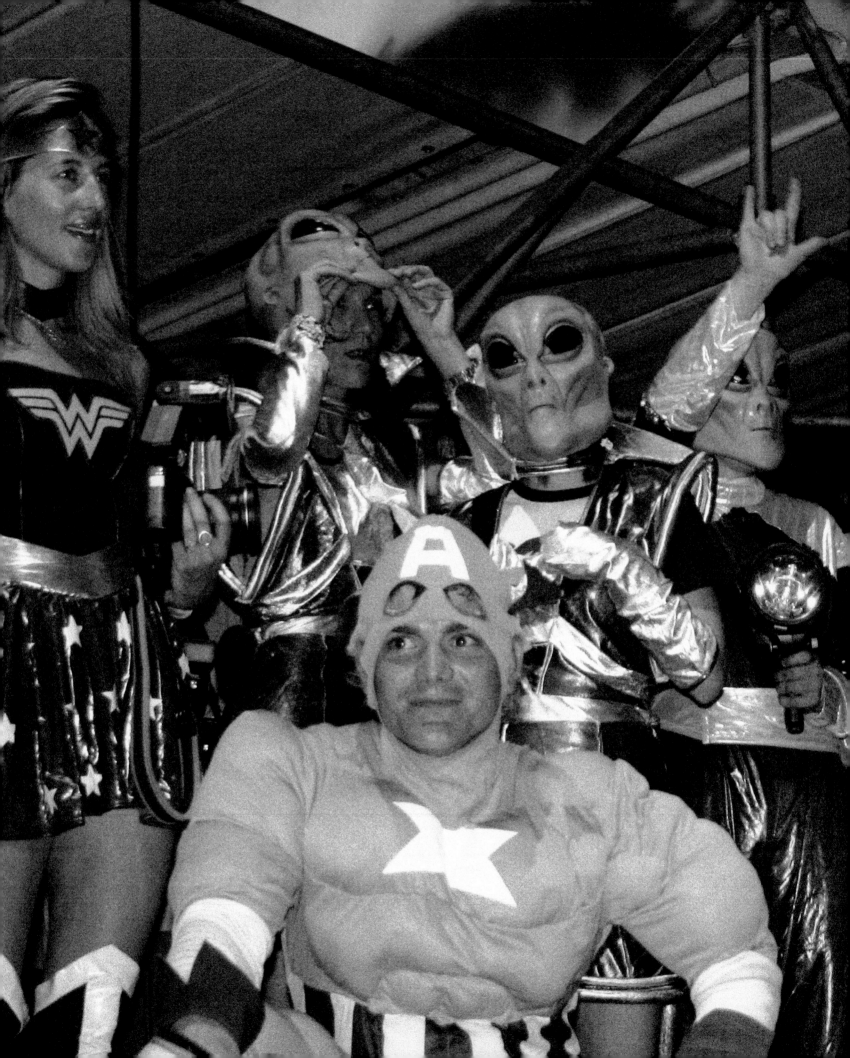

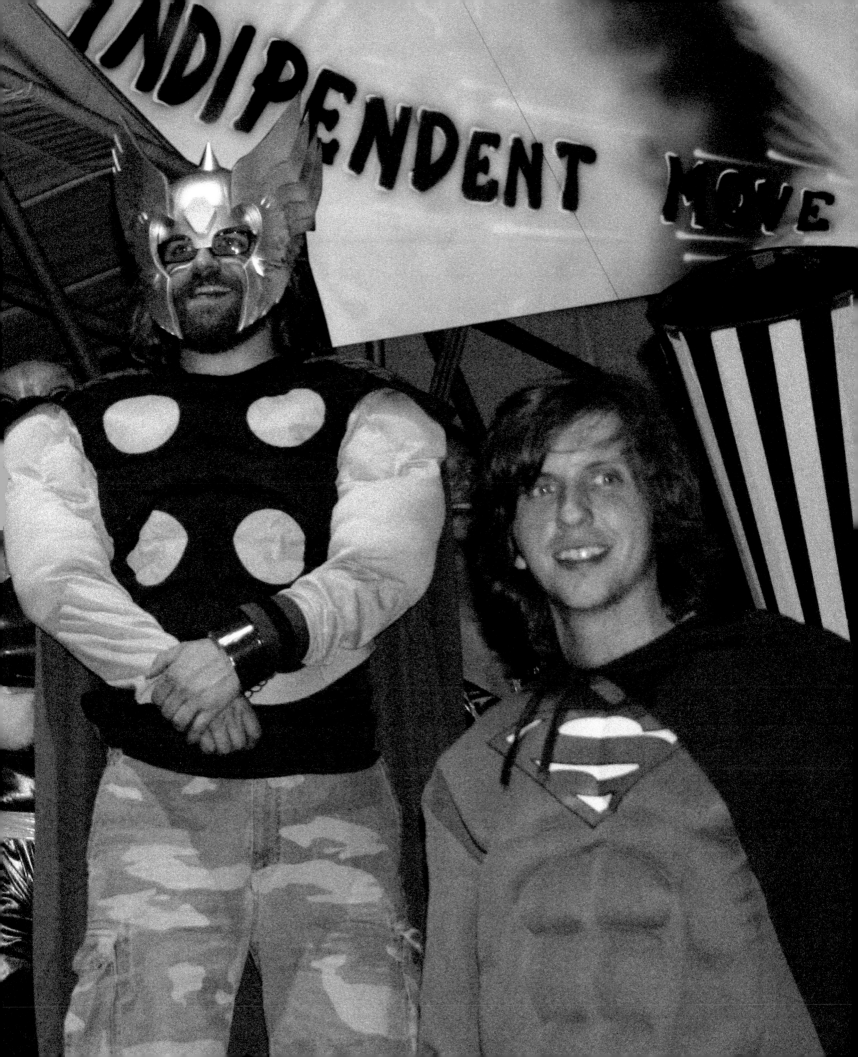

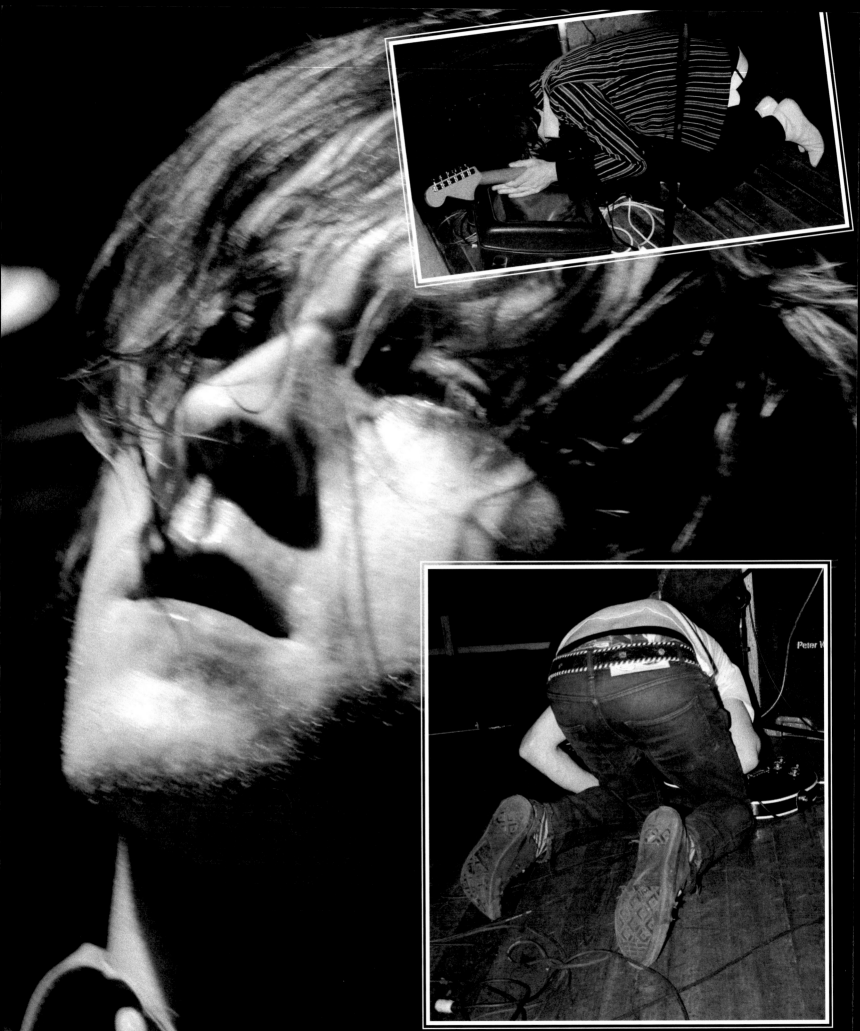

It's the same old story:

kids don't want to listen

to their older brother's music.

They think it's crap

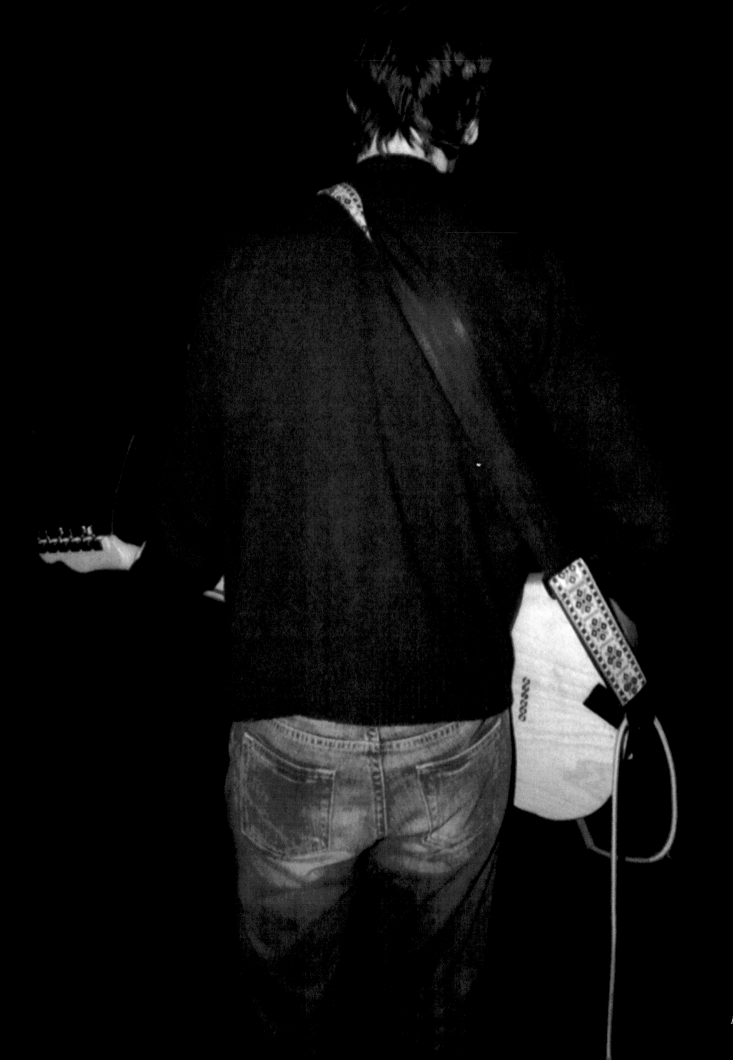

Dead Meadow

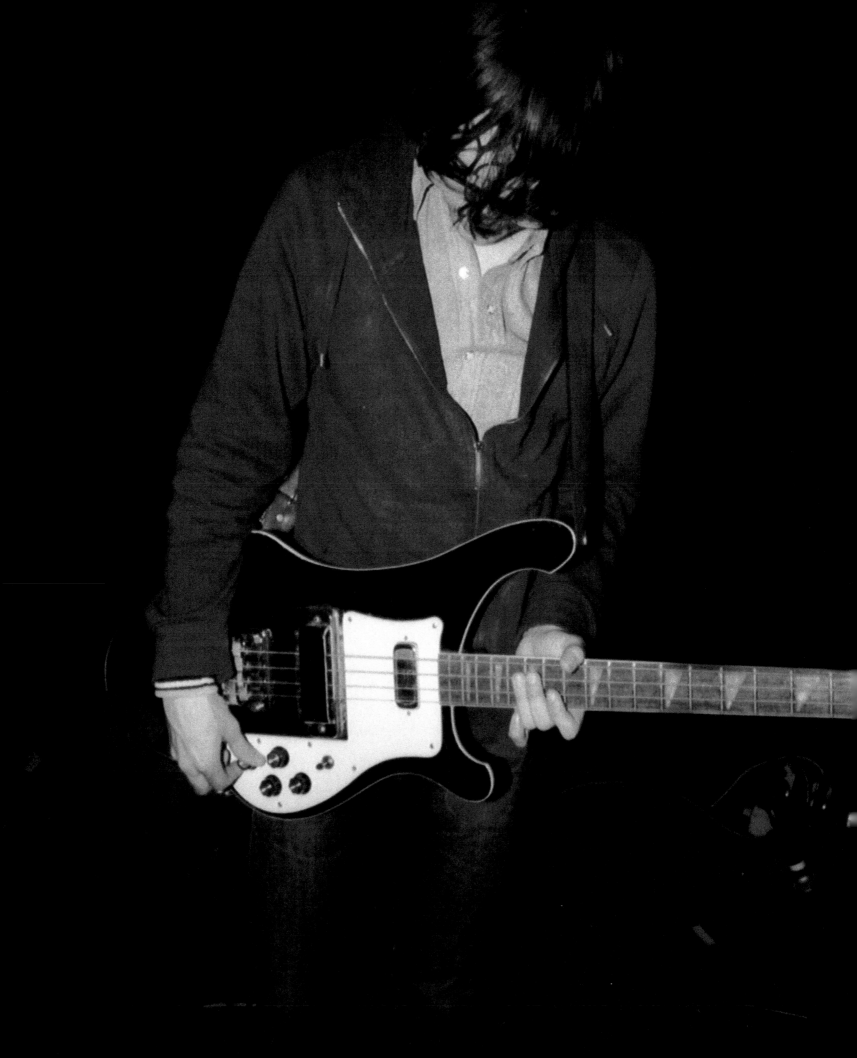

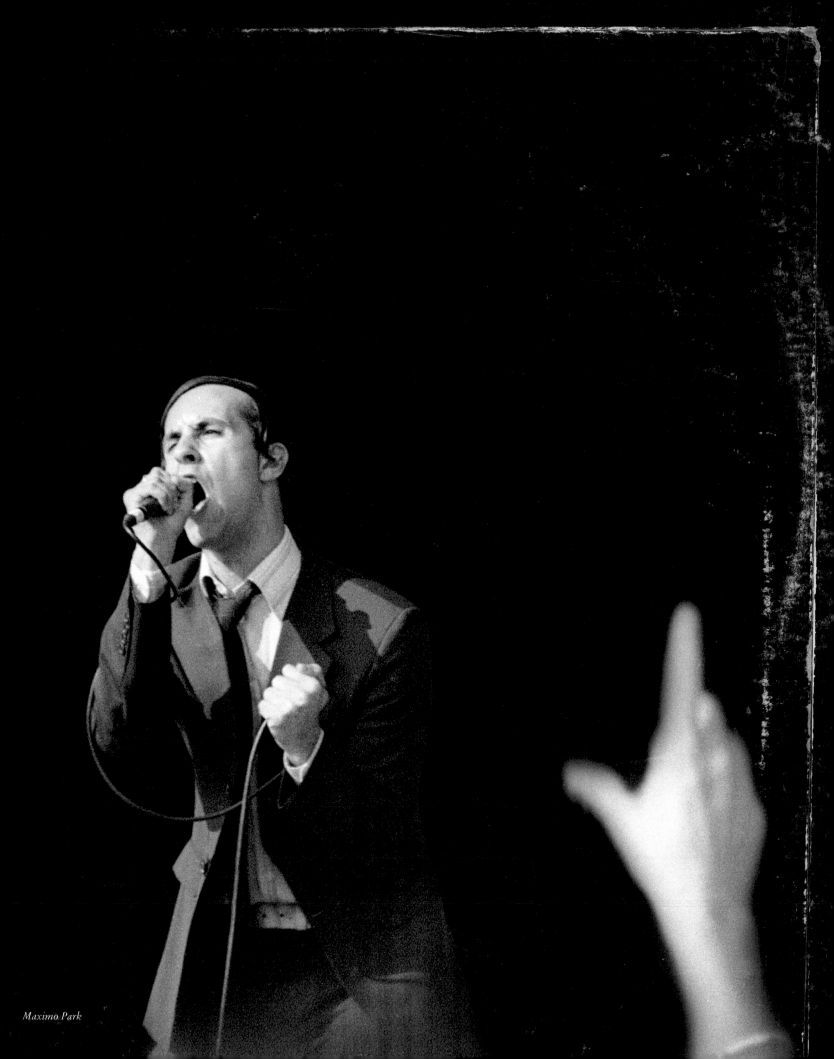

Maximo Park

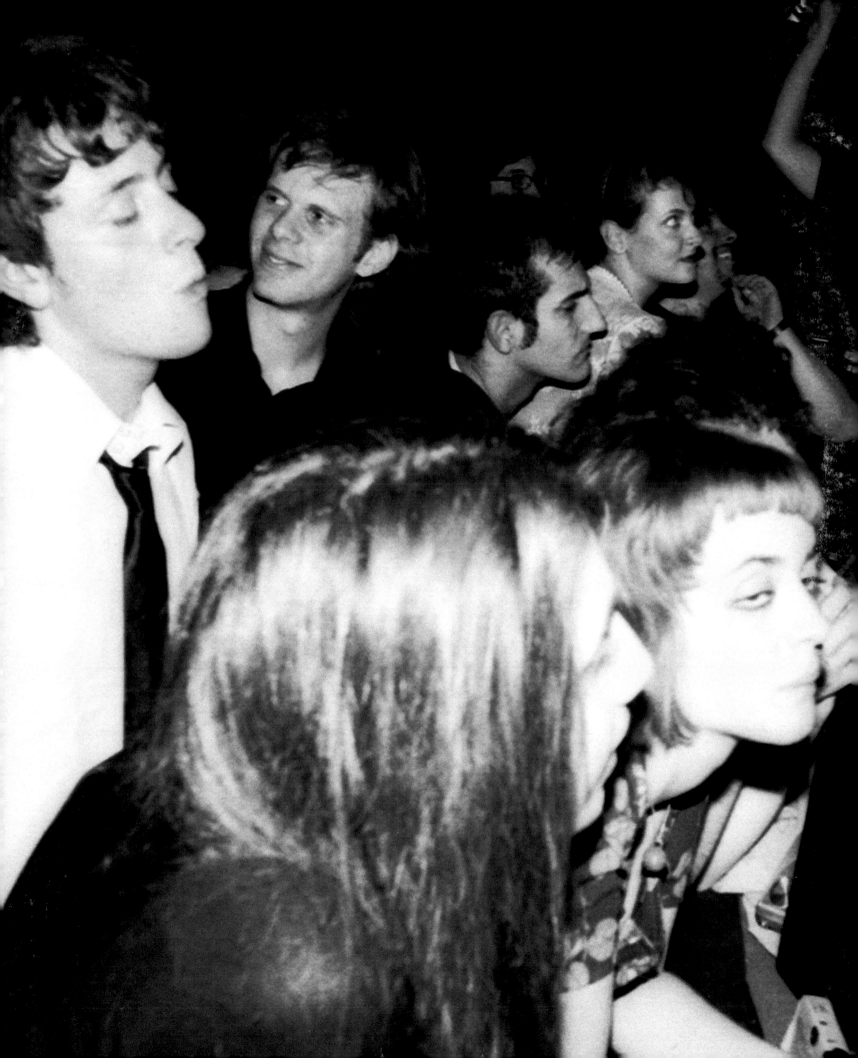

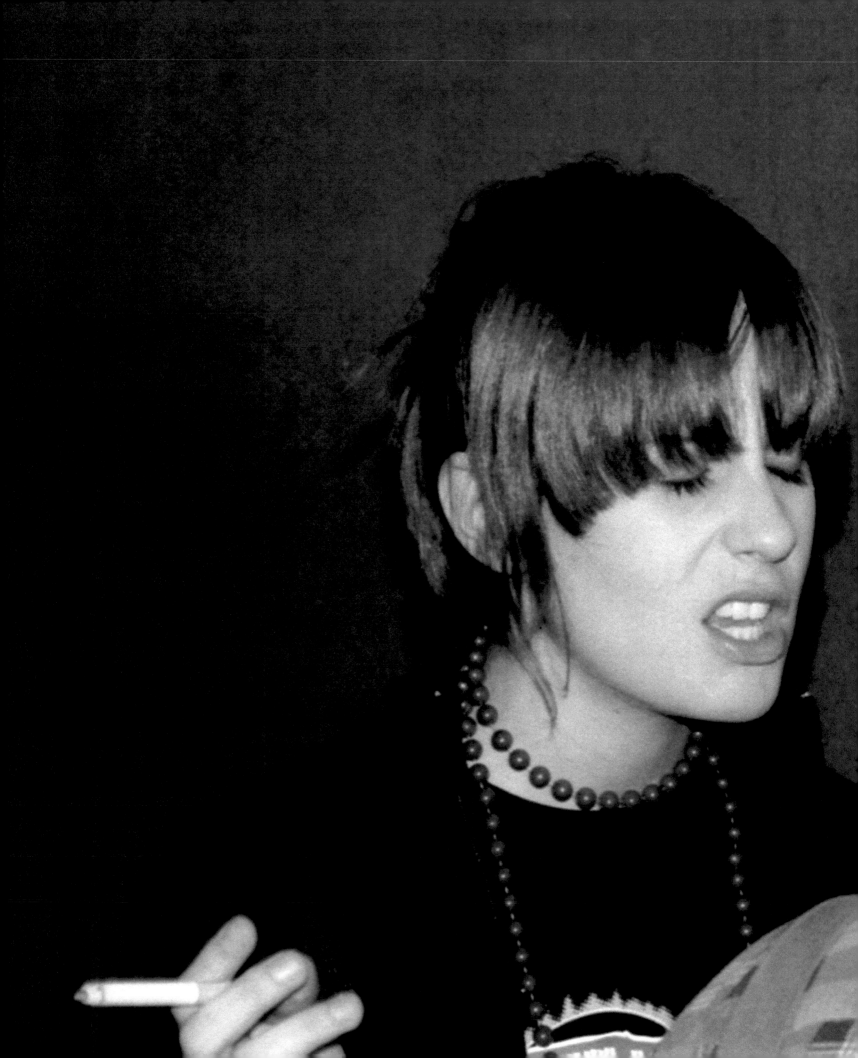

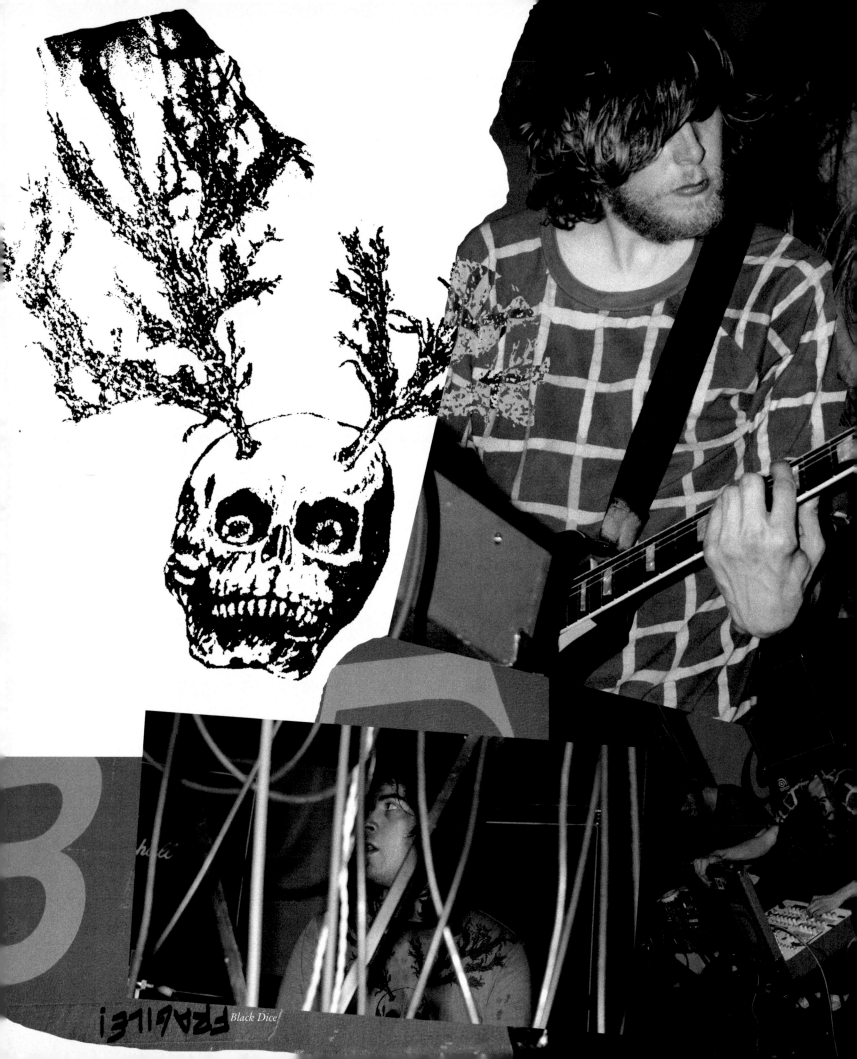

Black Dice

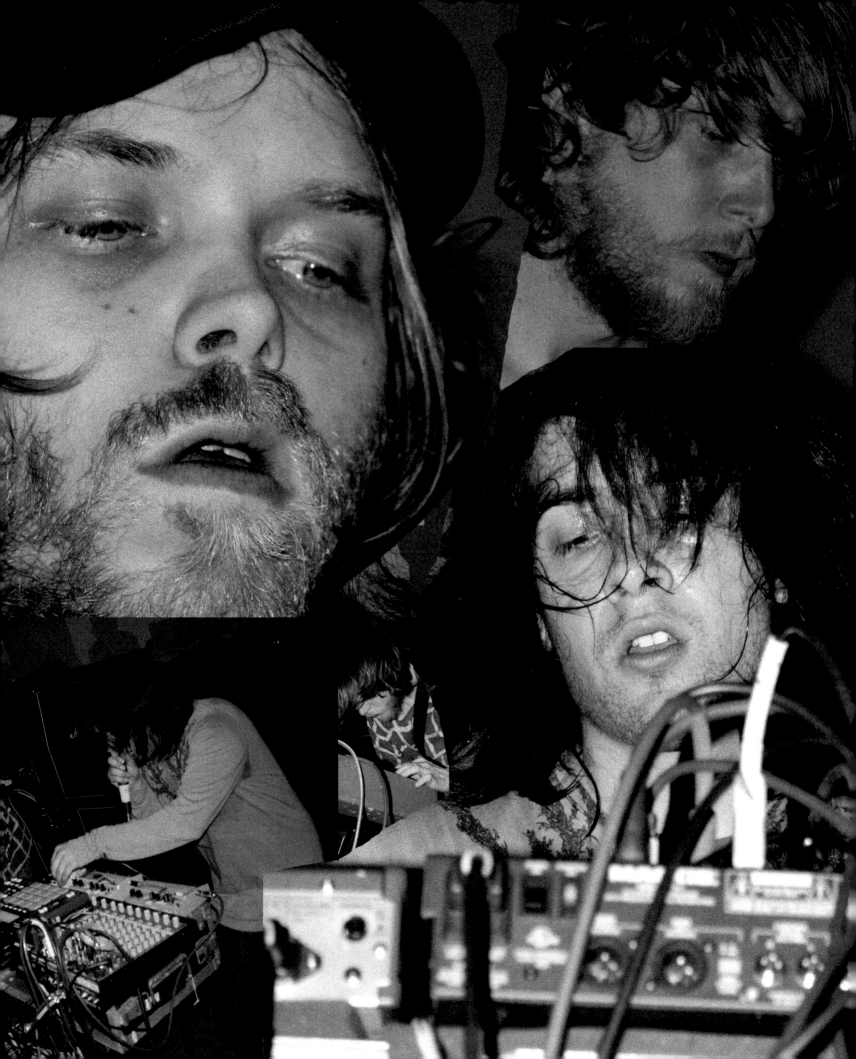

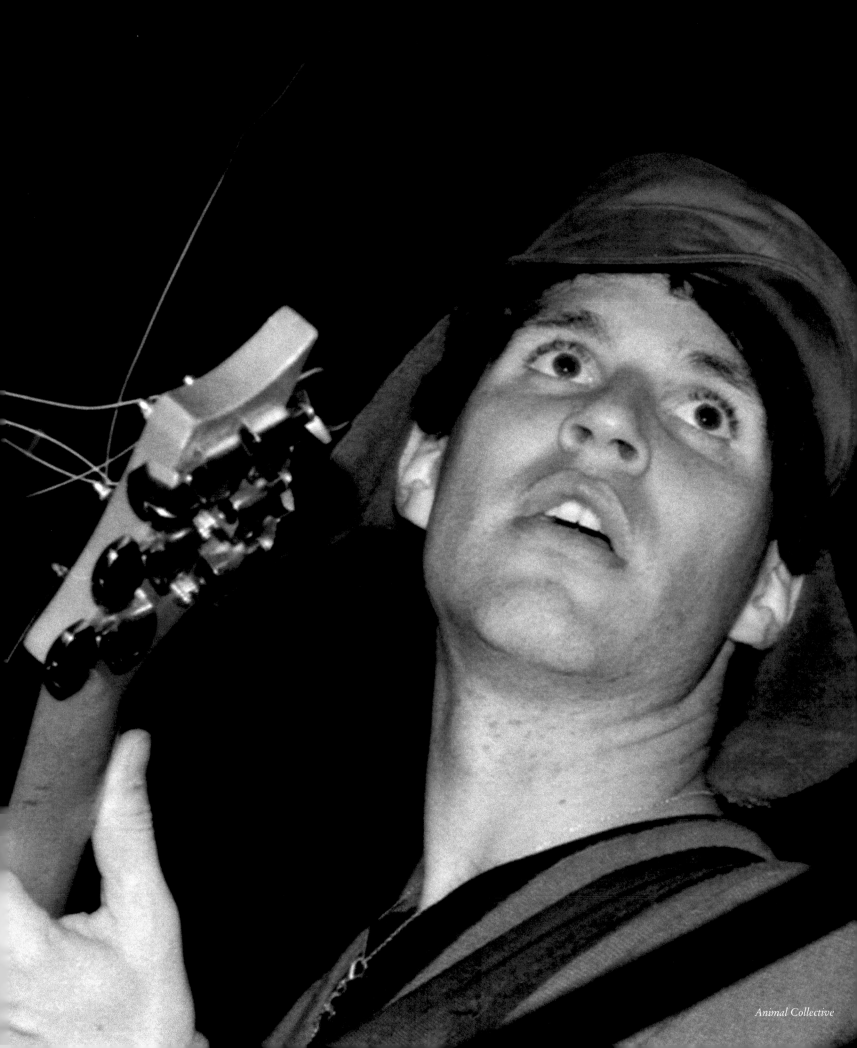

Animal Collective

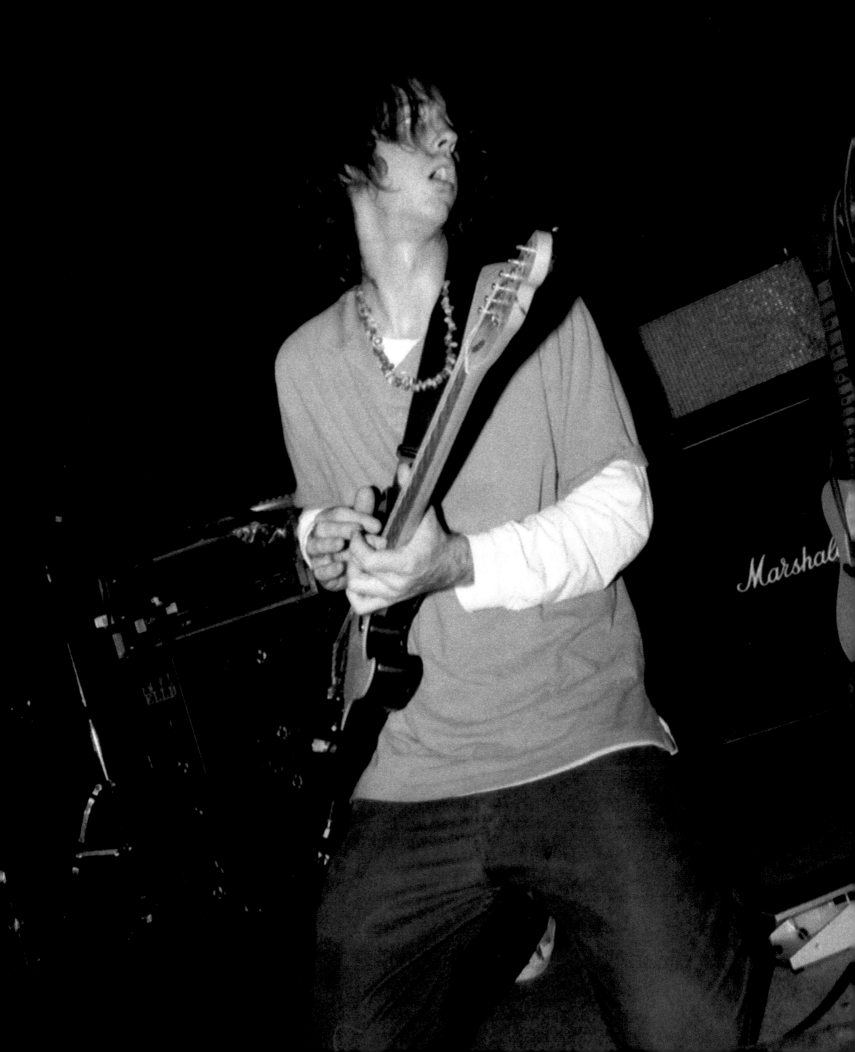

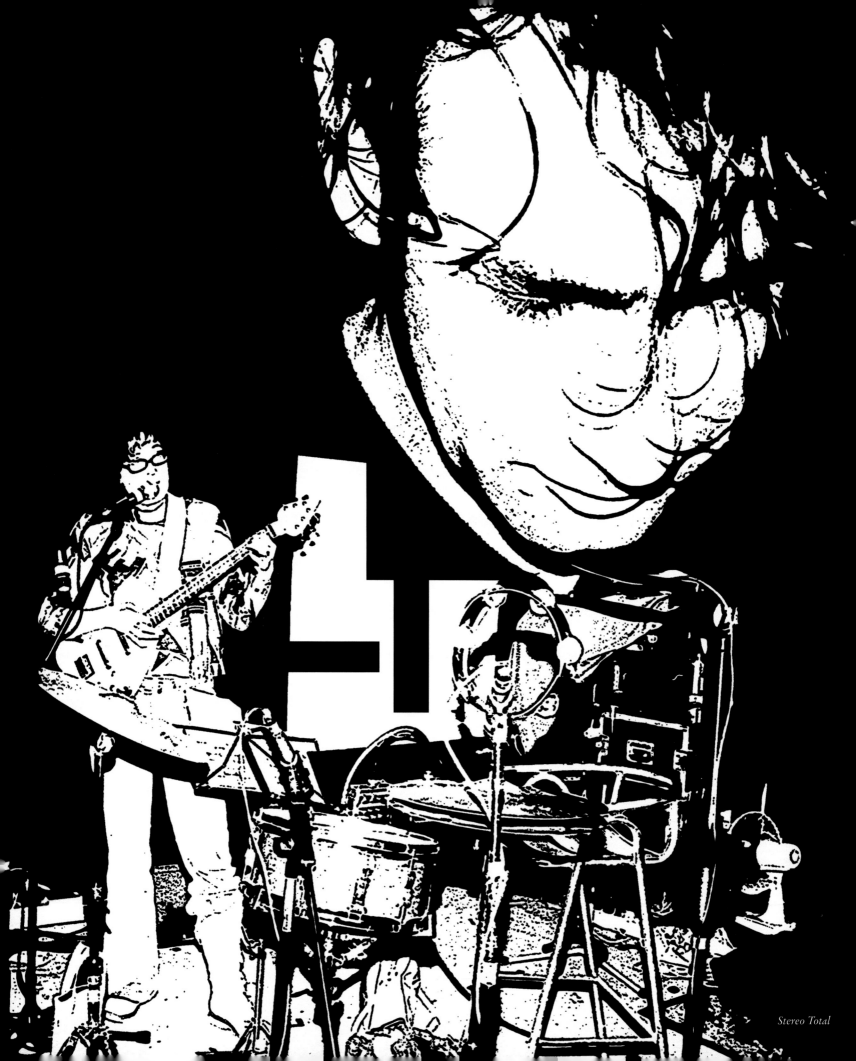

Stereo Total

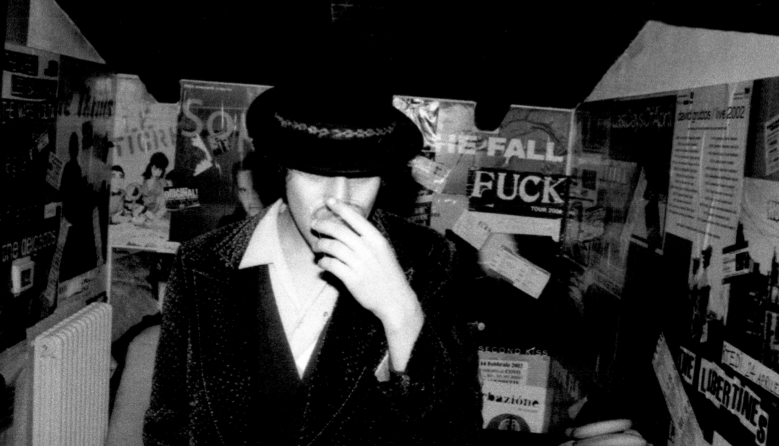

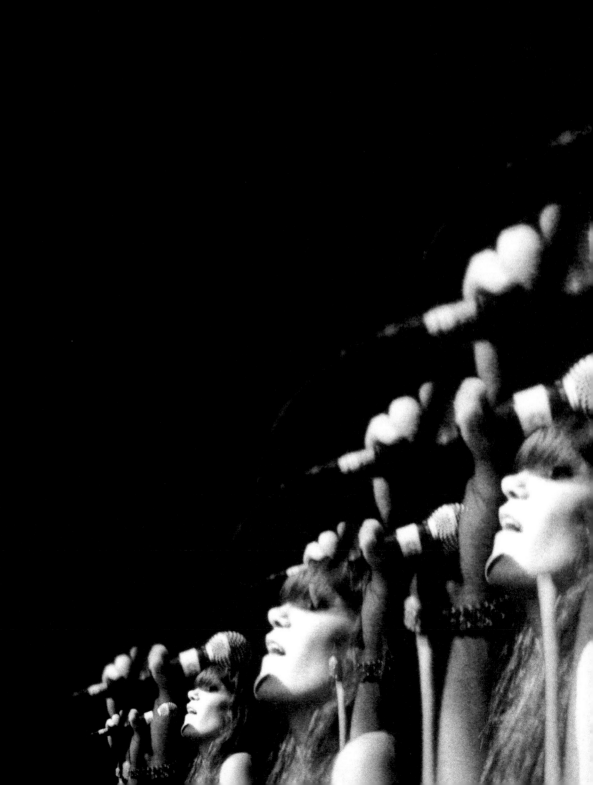

Nouvelle Vague

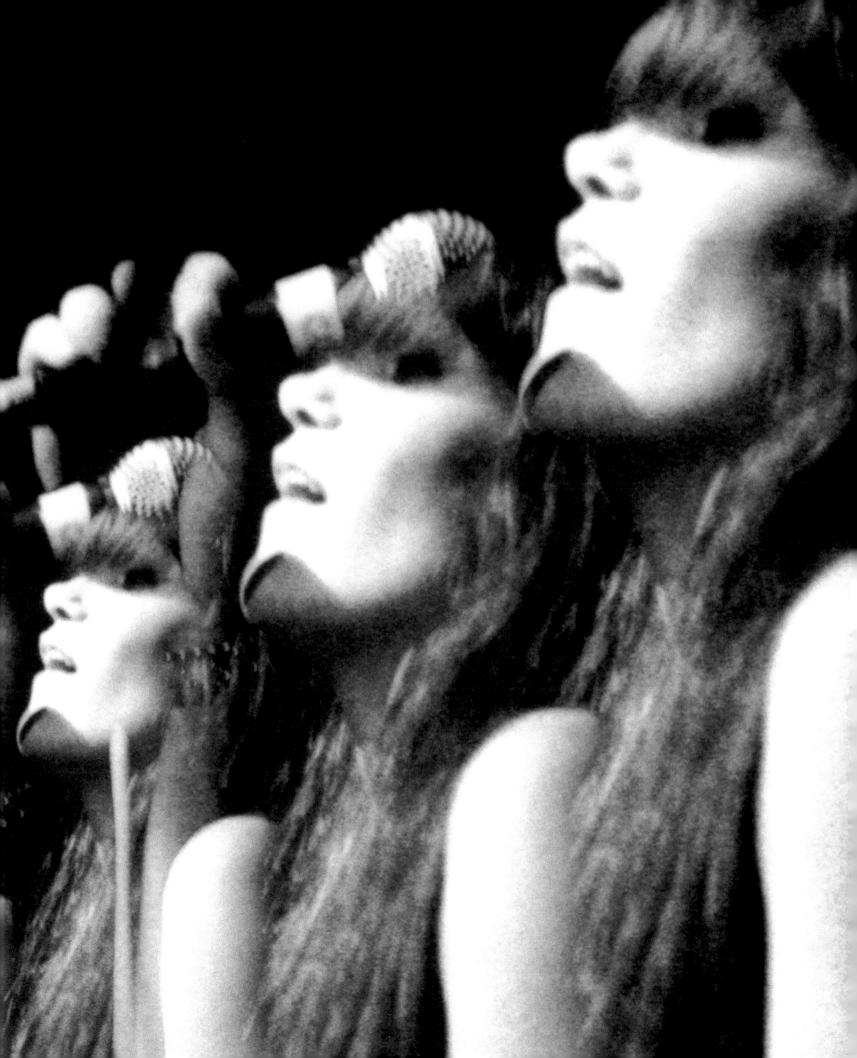

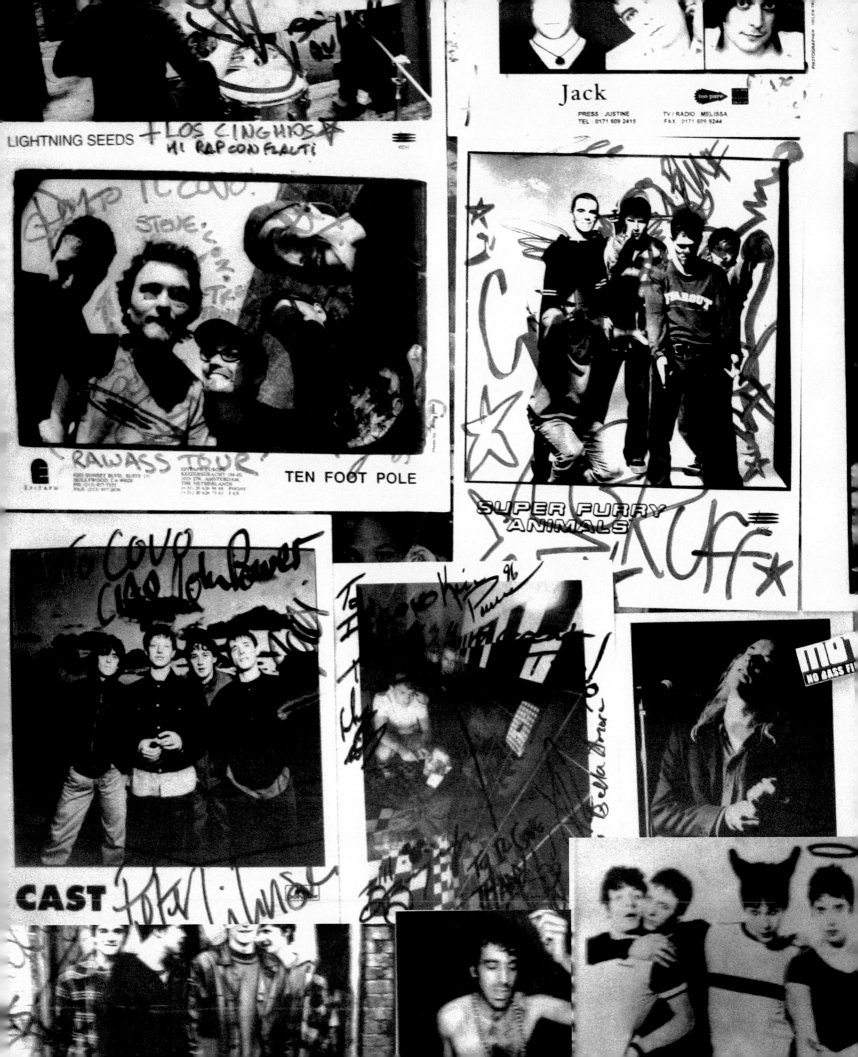

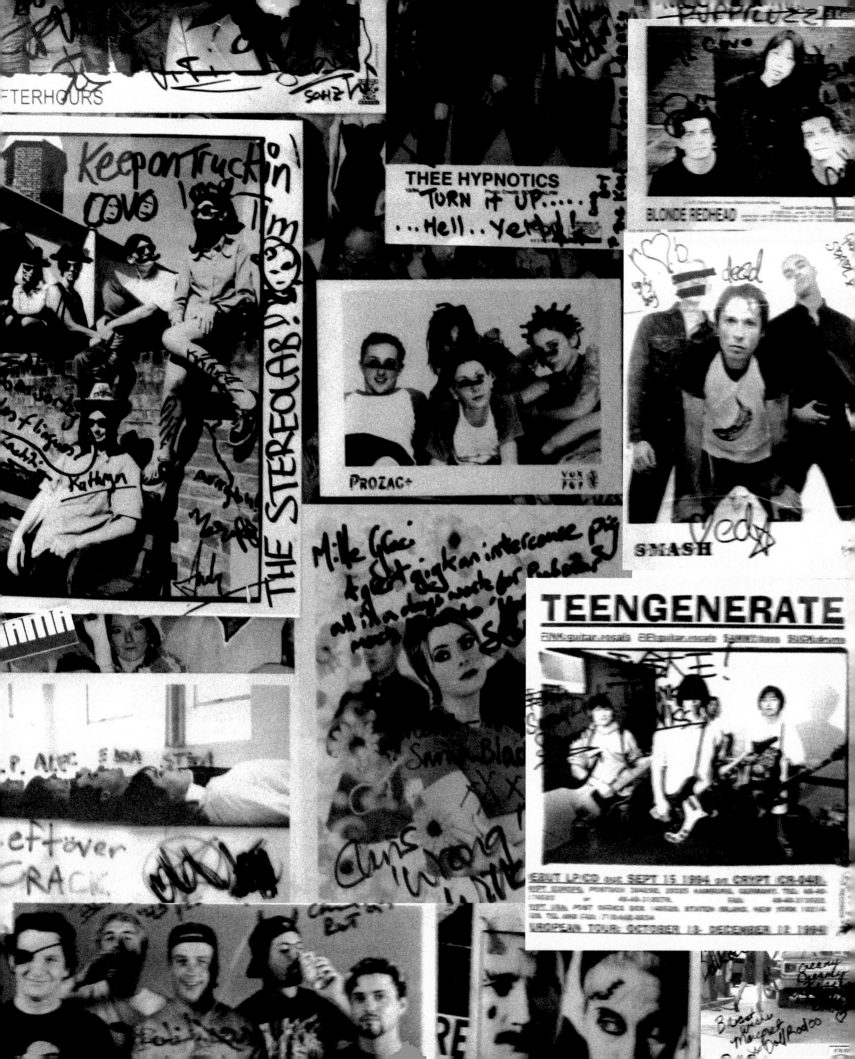

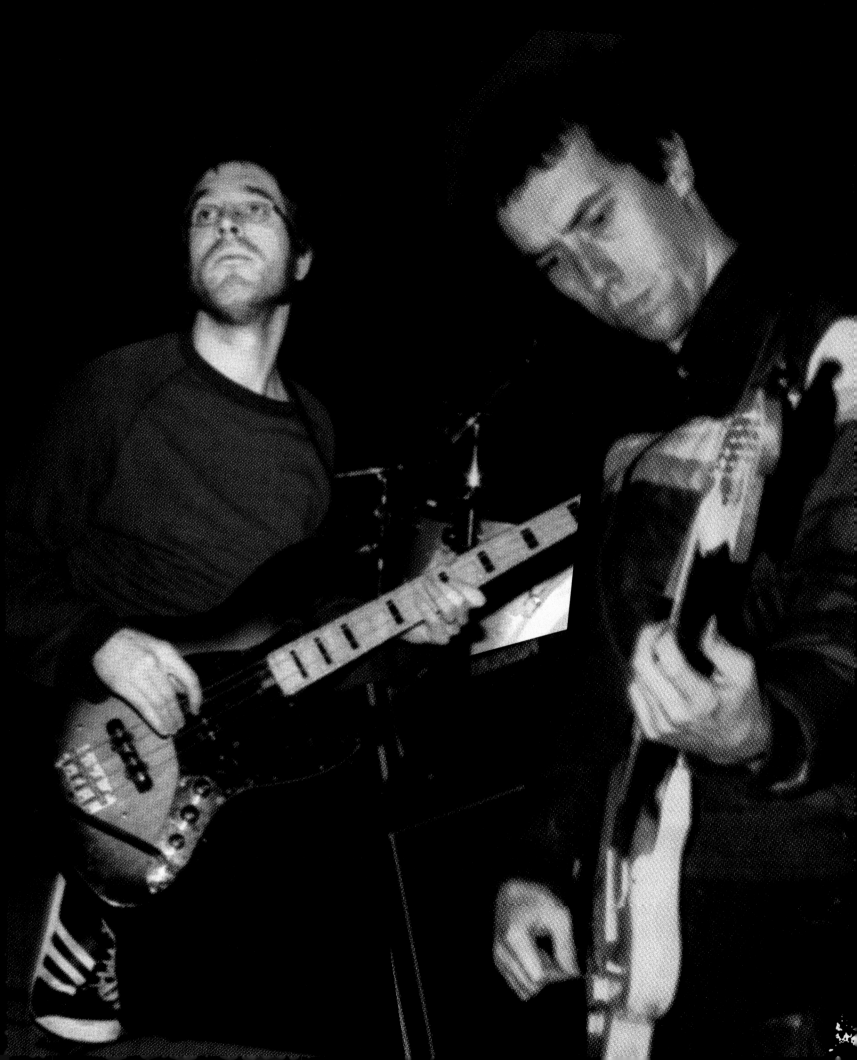

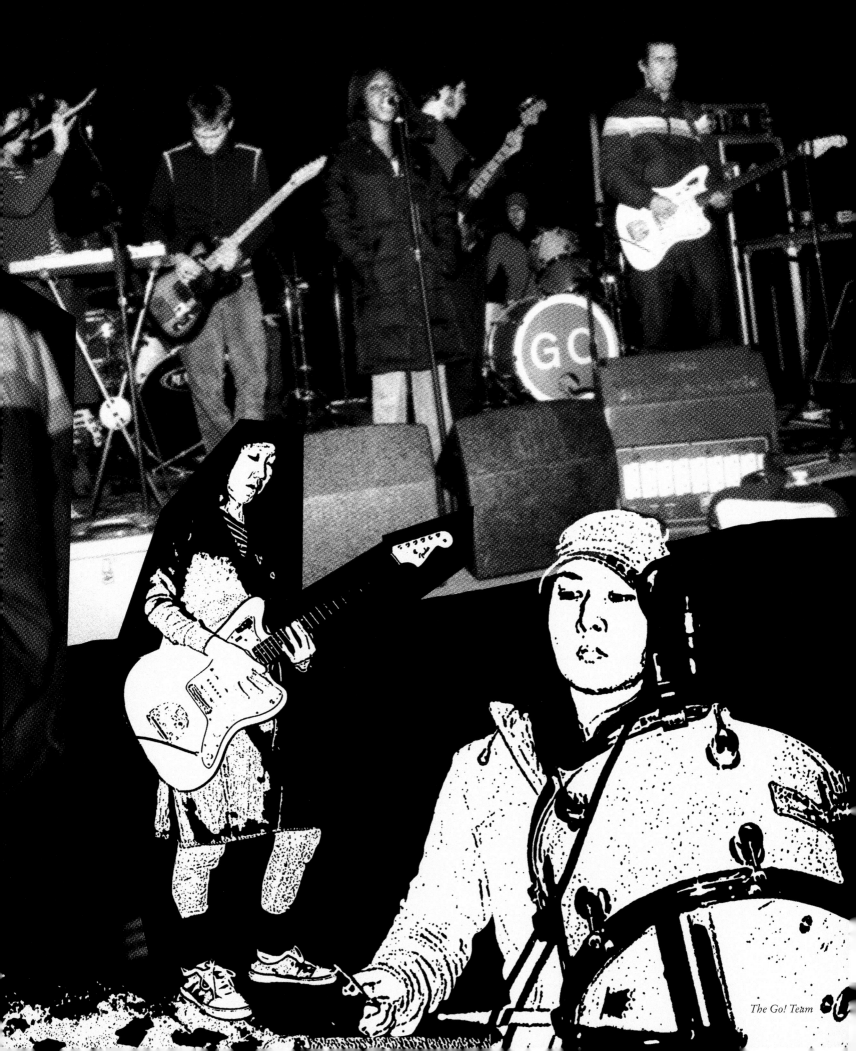

The Go! Team

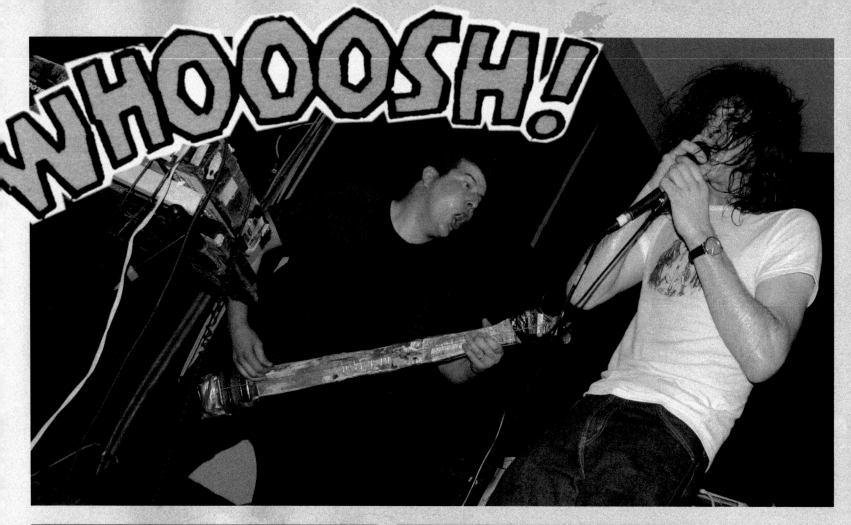
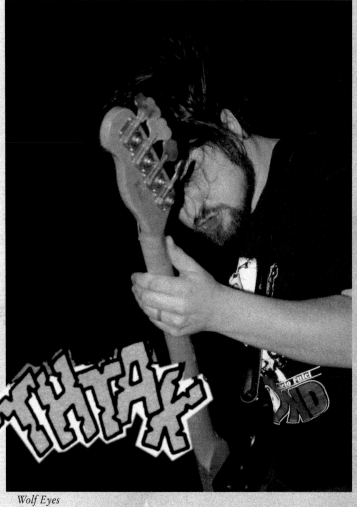
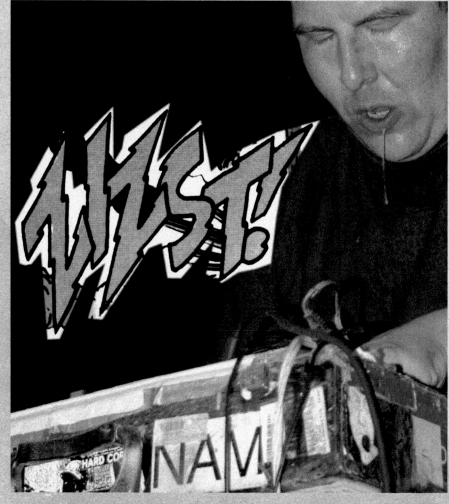

Wolf Eyes

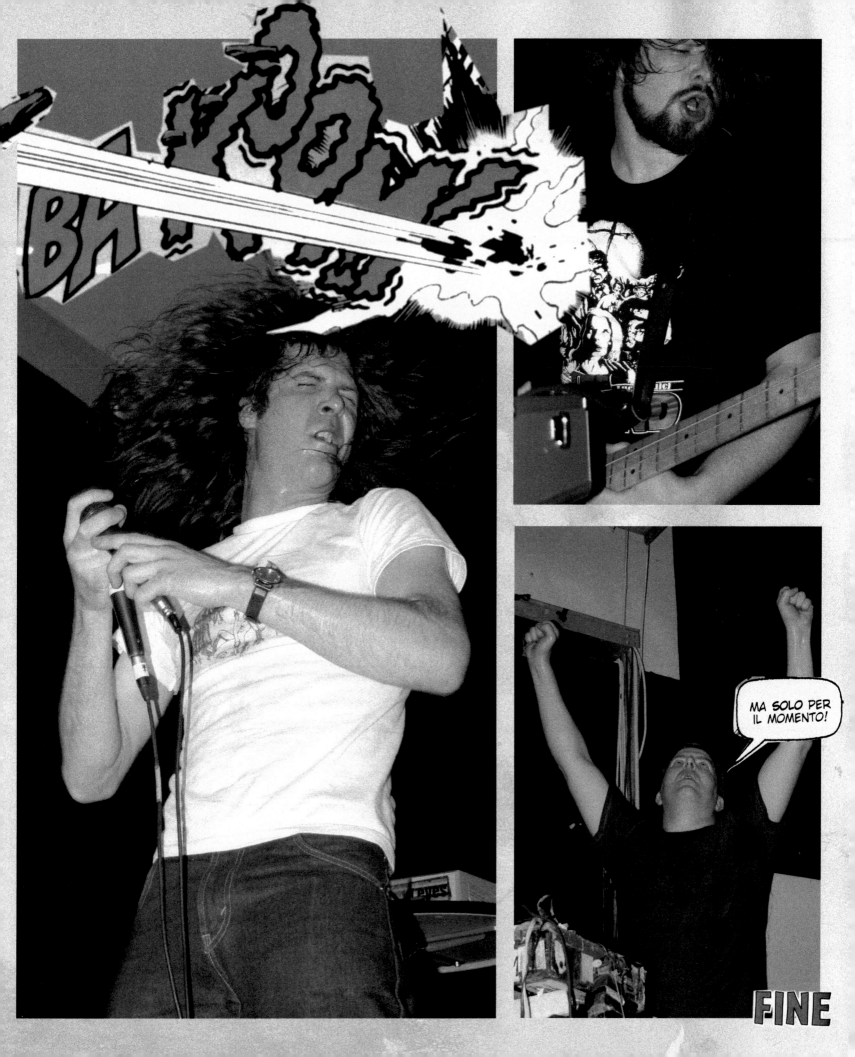

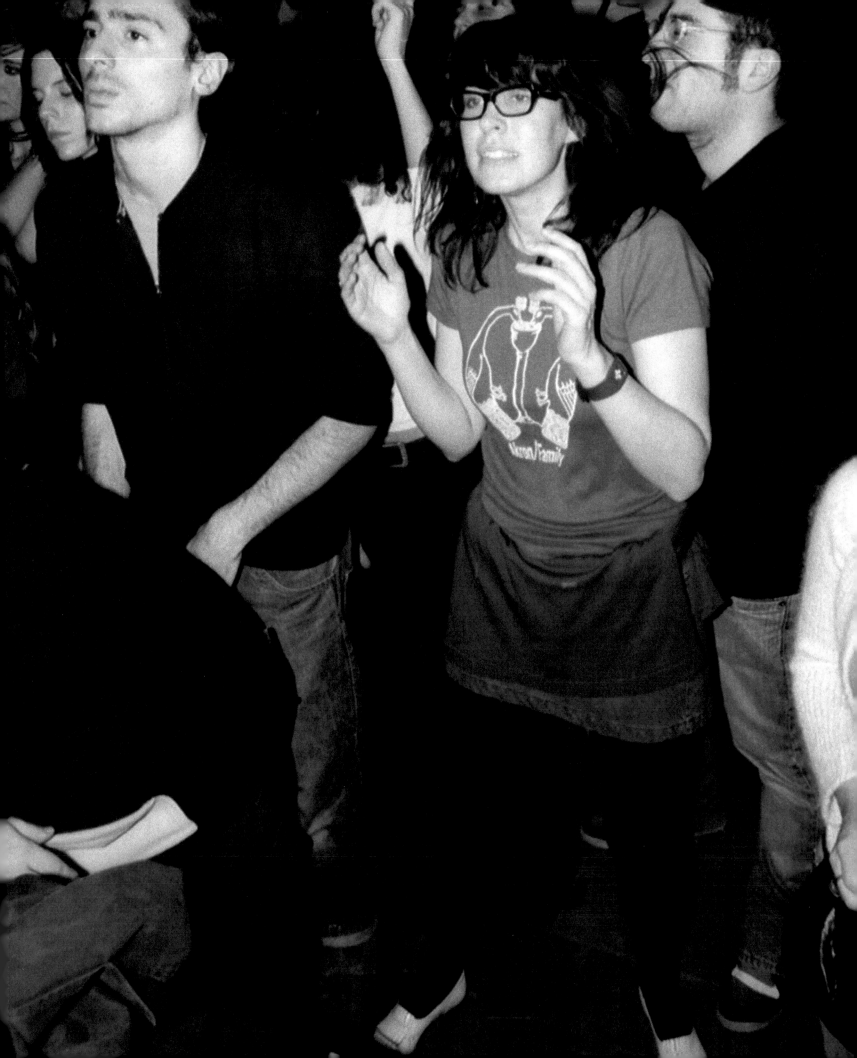

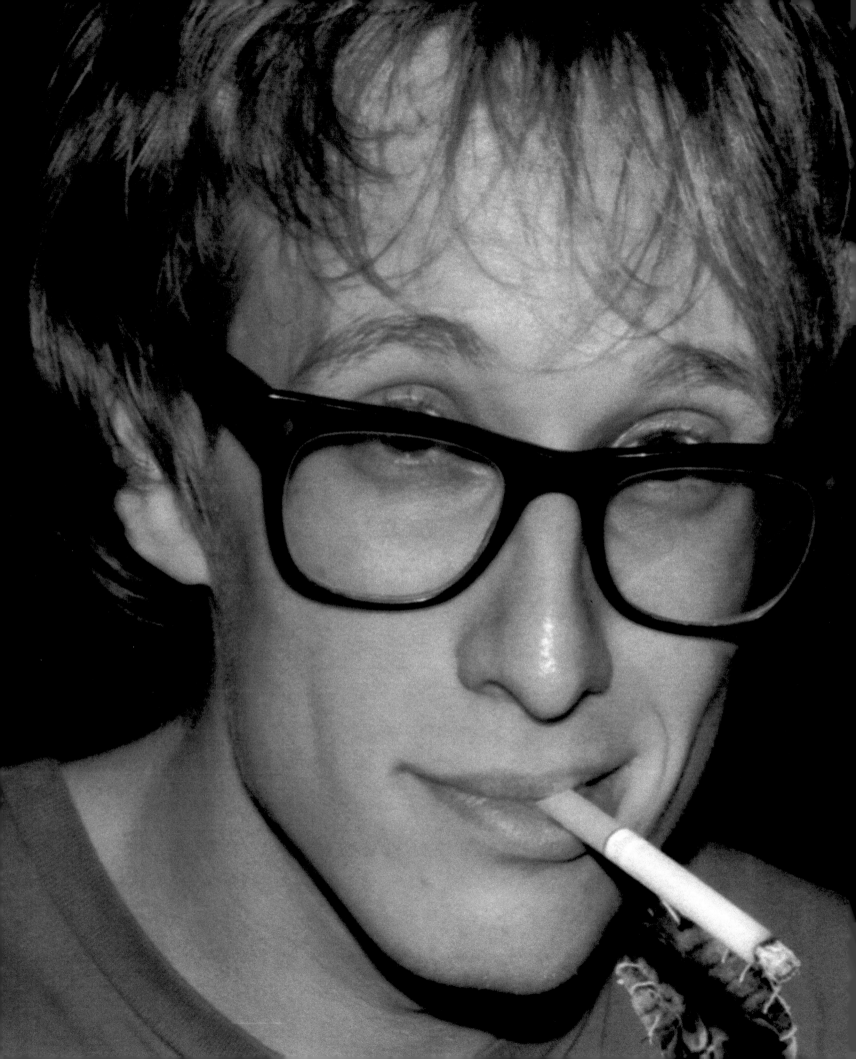

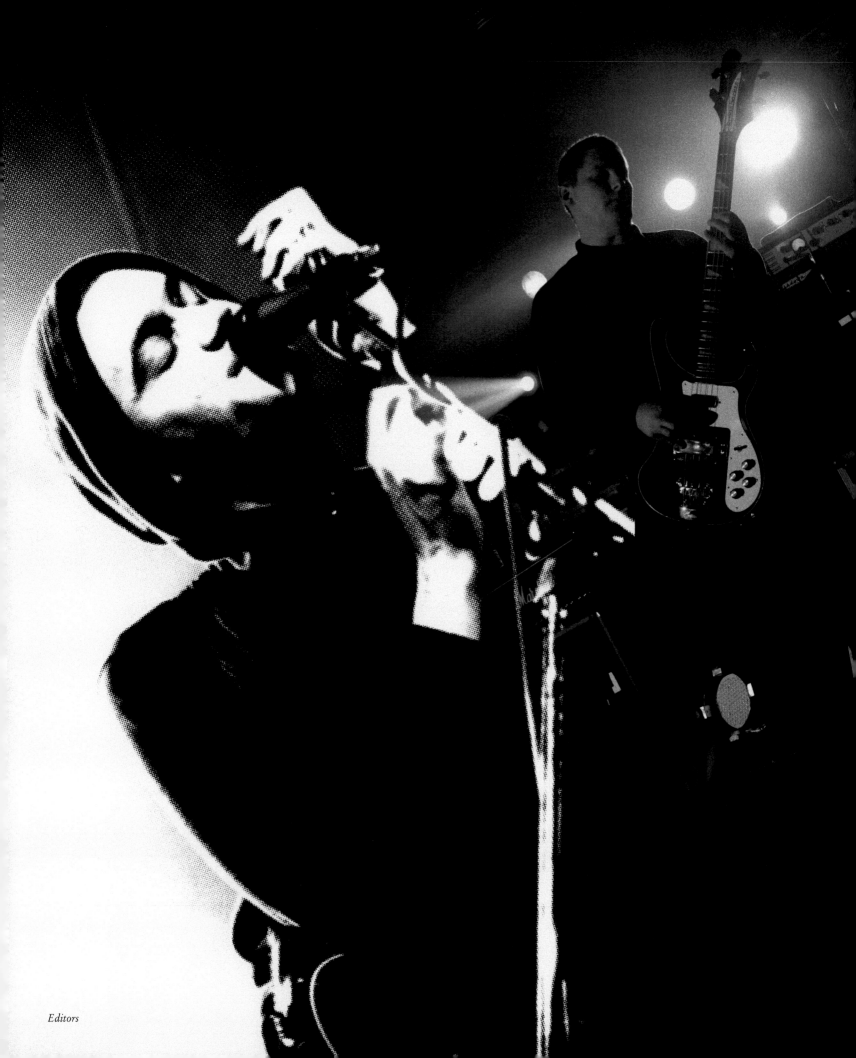

Editors

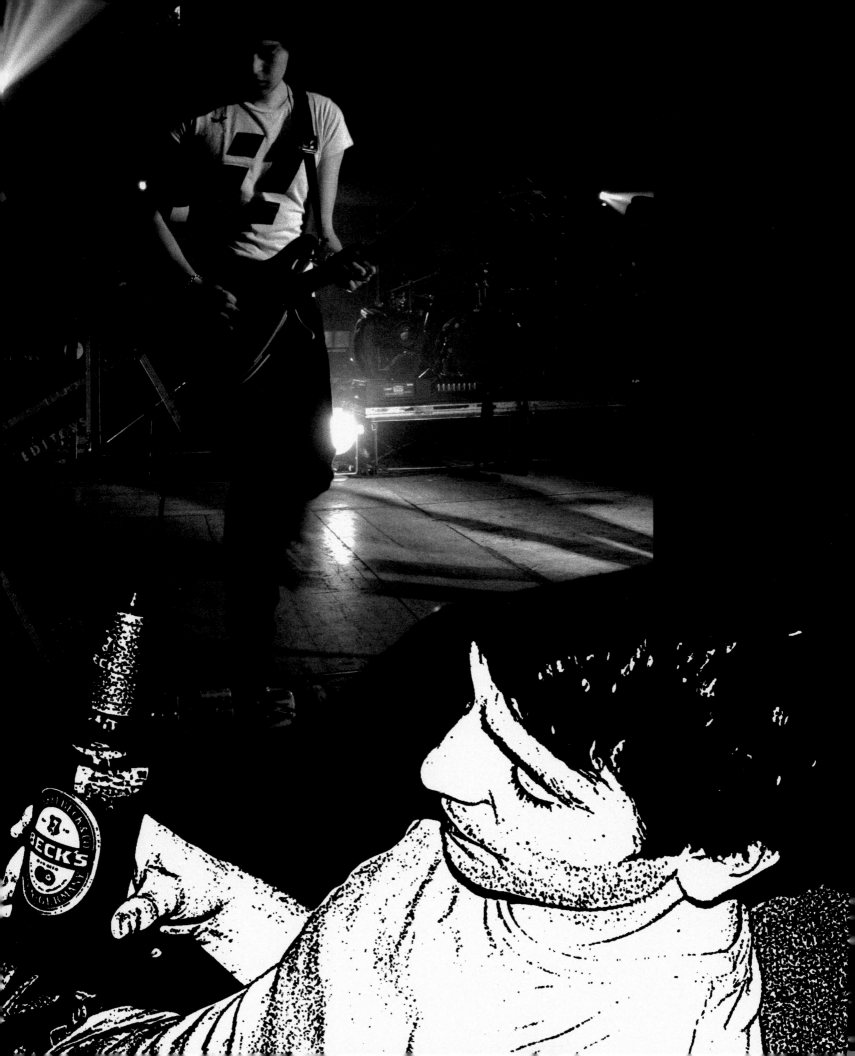

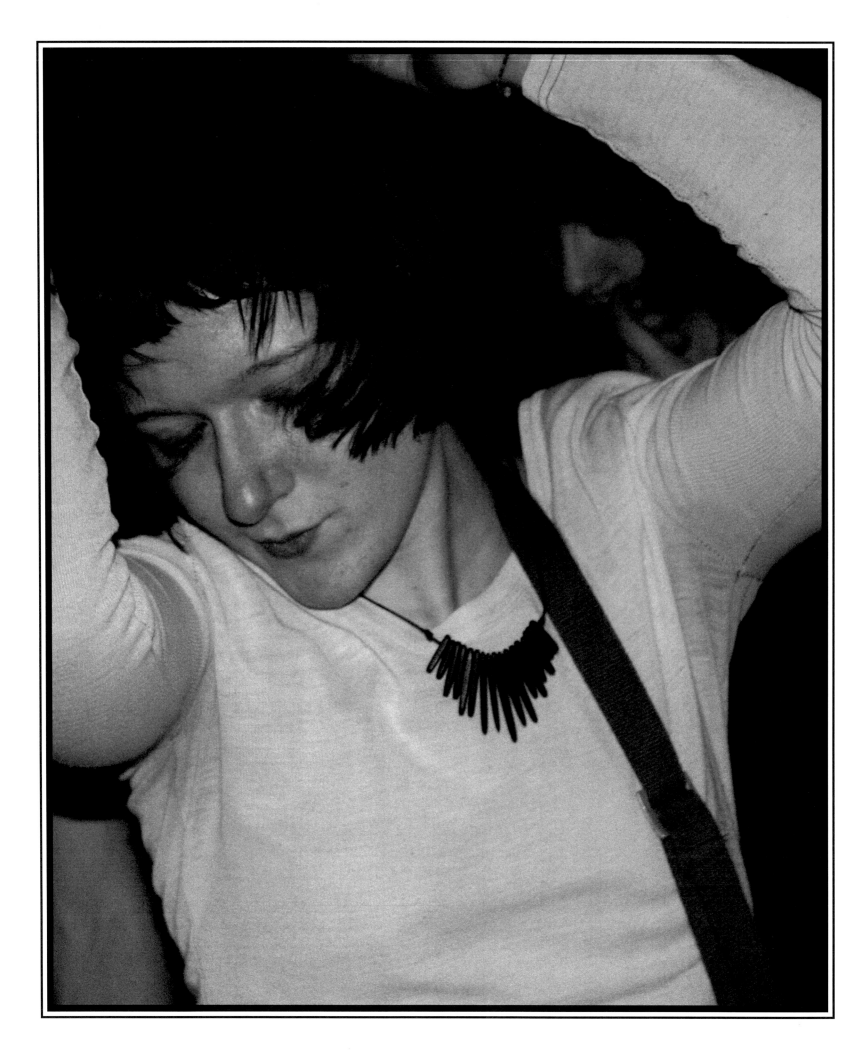

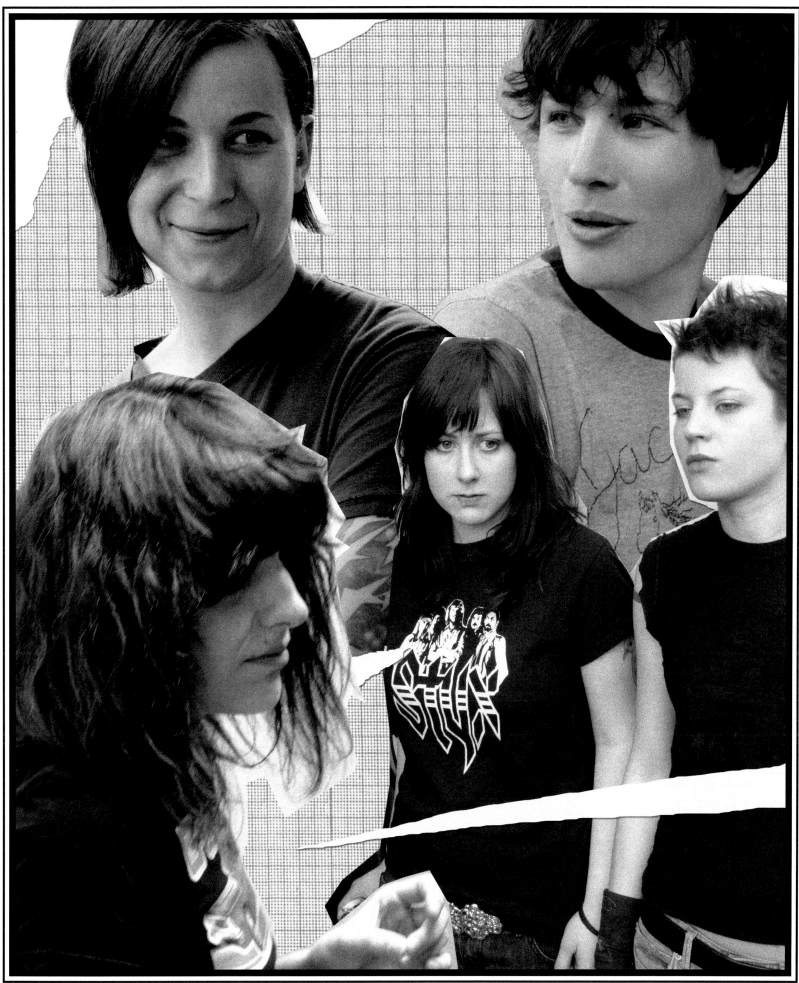

The Organ

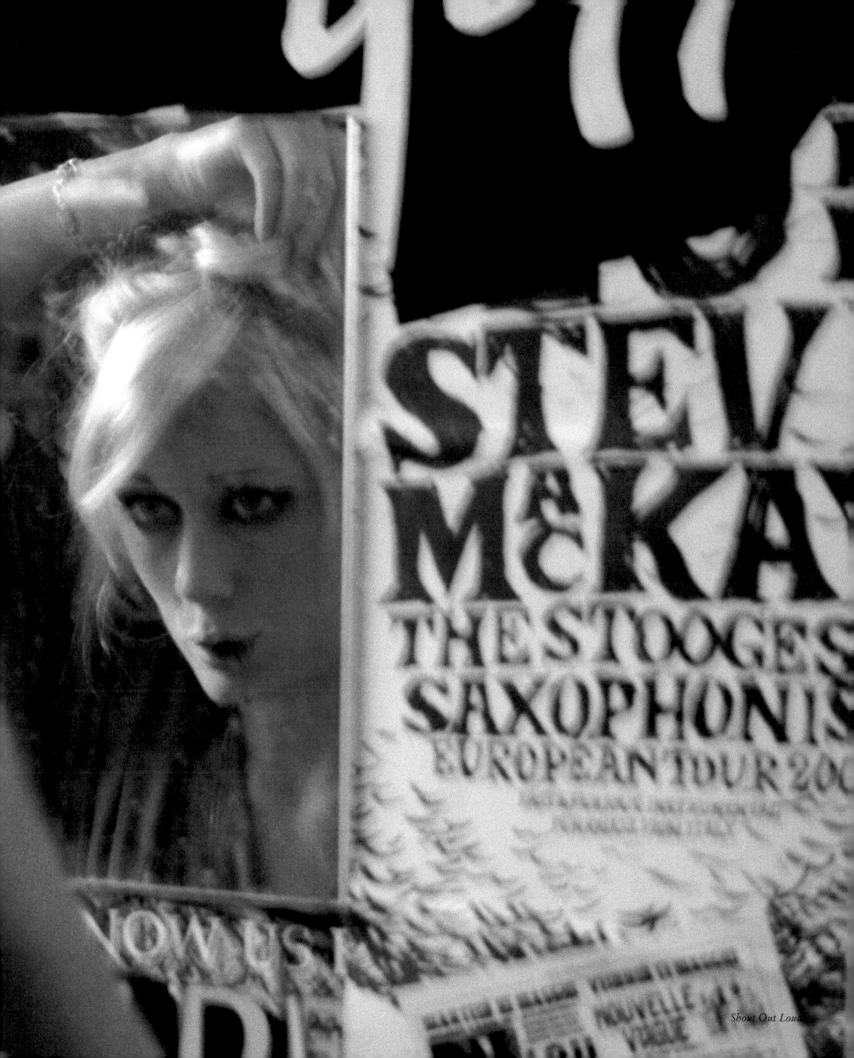

STEVE
McKAY
THE STOOGES
SAXOPHONIS
EUROPEAN TOUR 200

Shout Out Loud

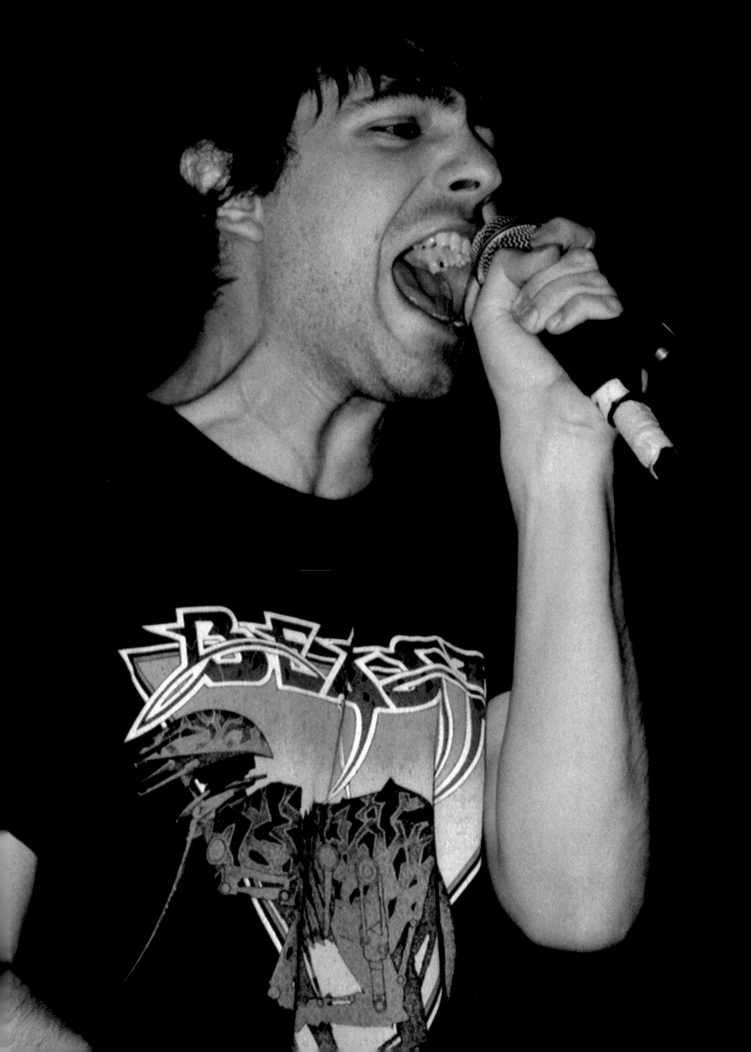

Supersystem

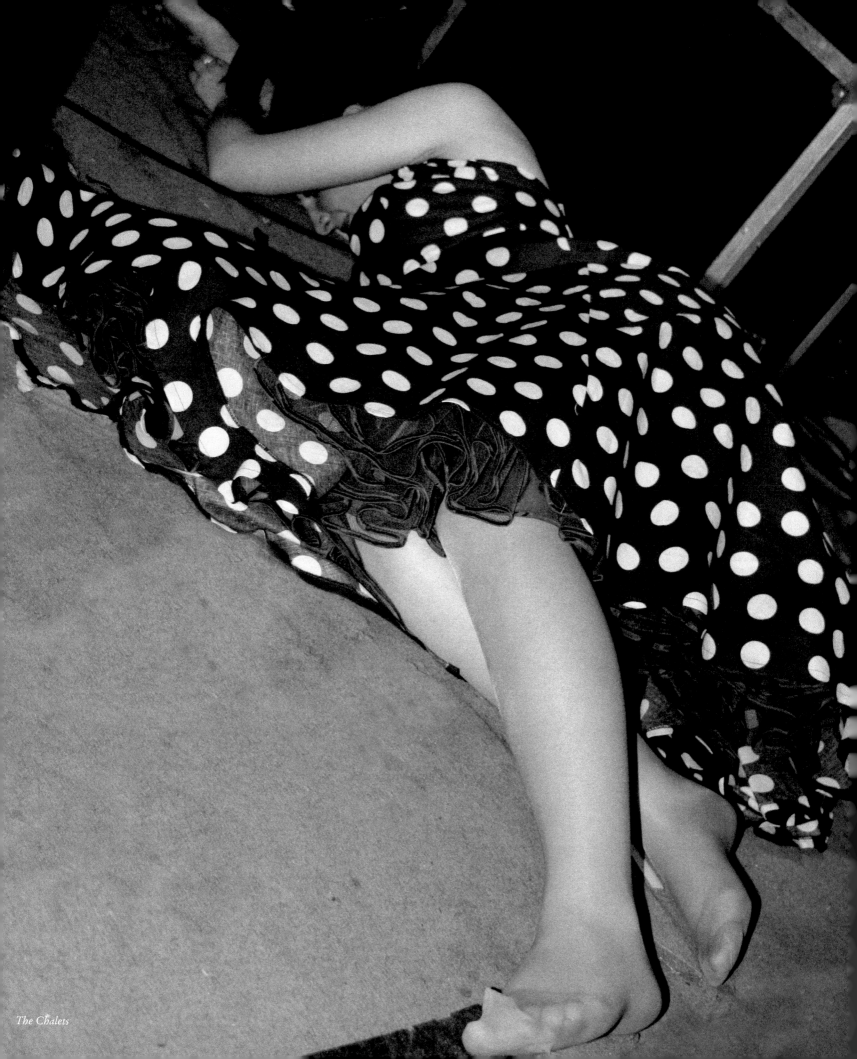

The Chalets

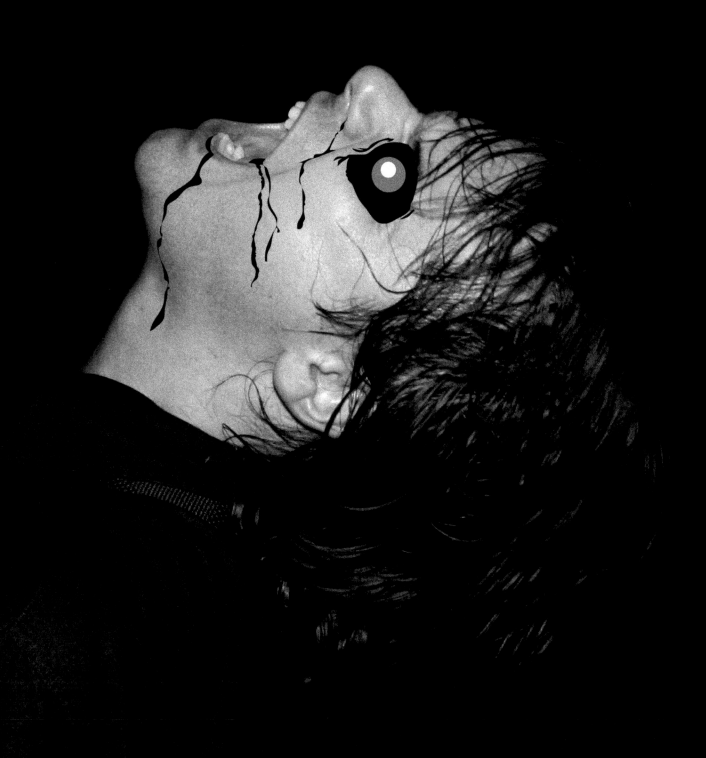

Cut

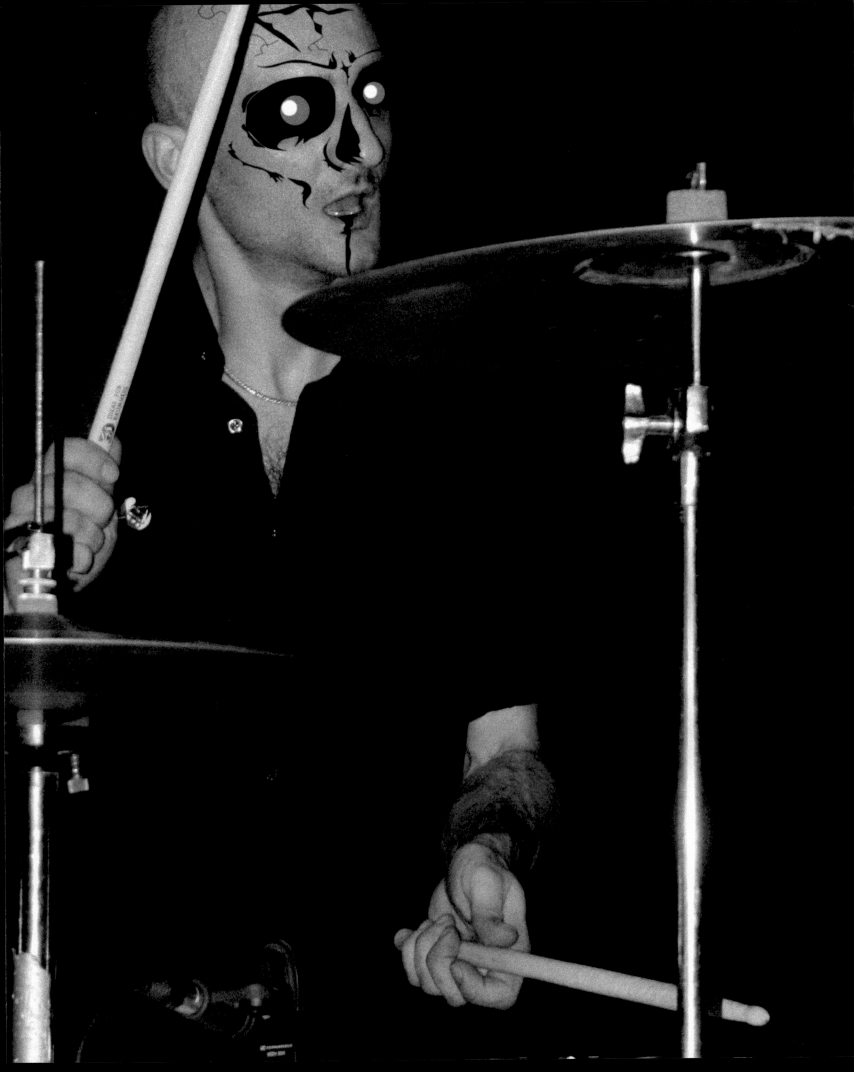

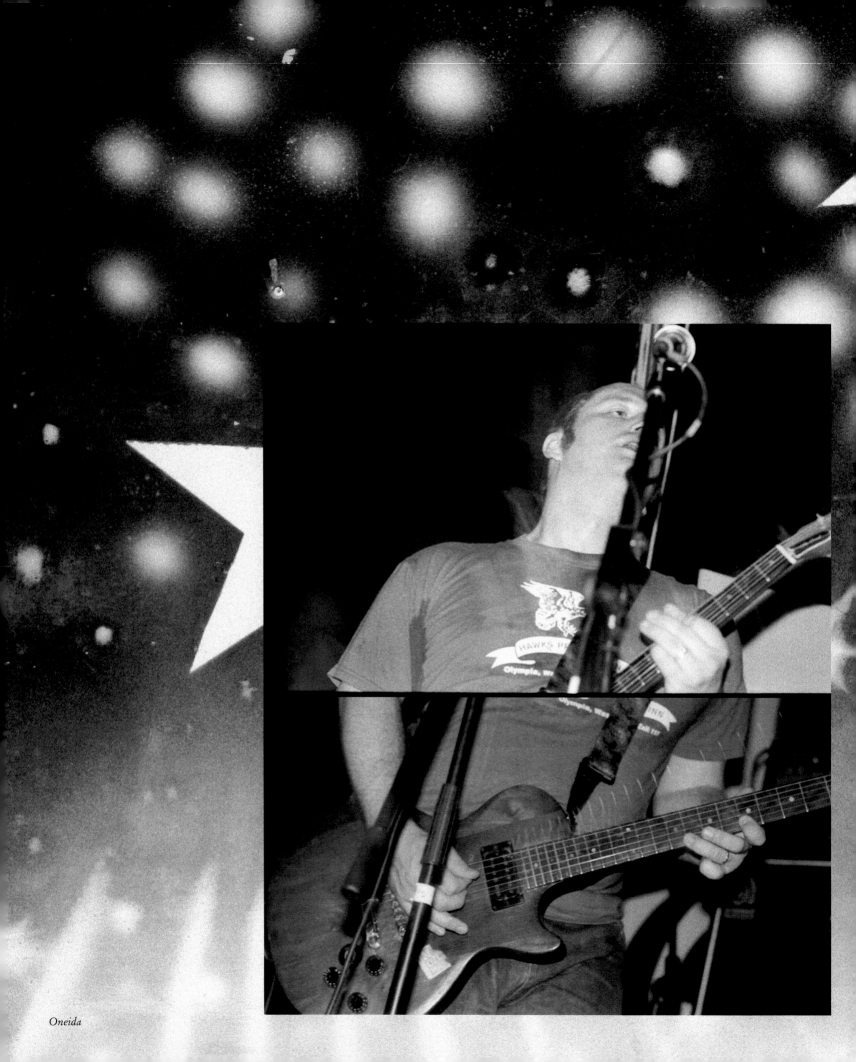

Oneida

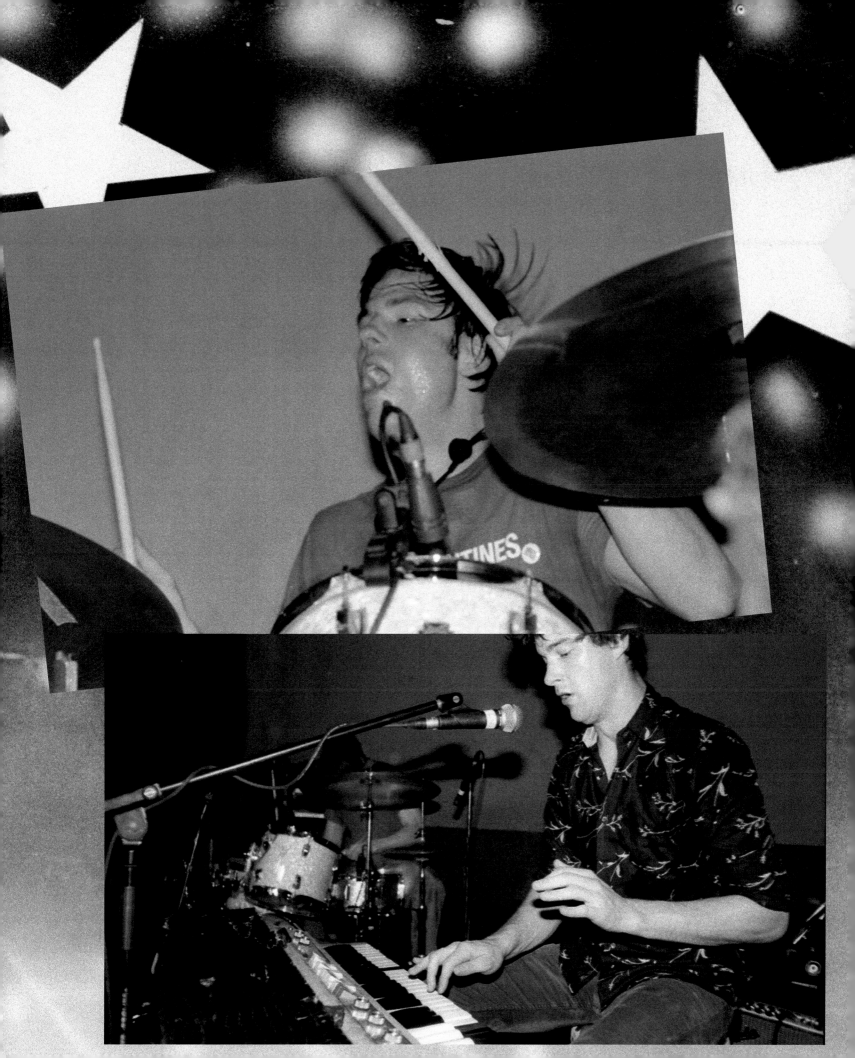

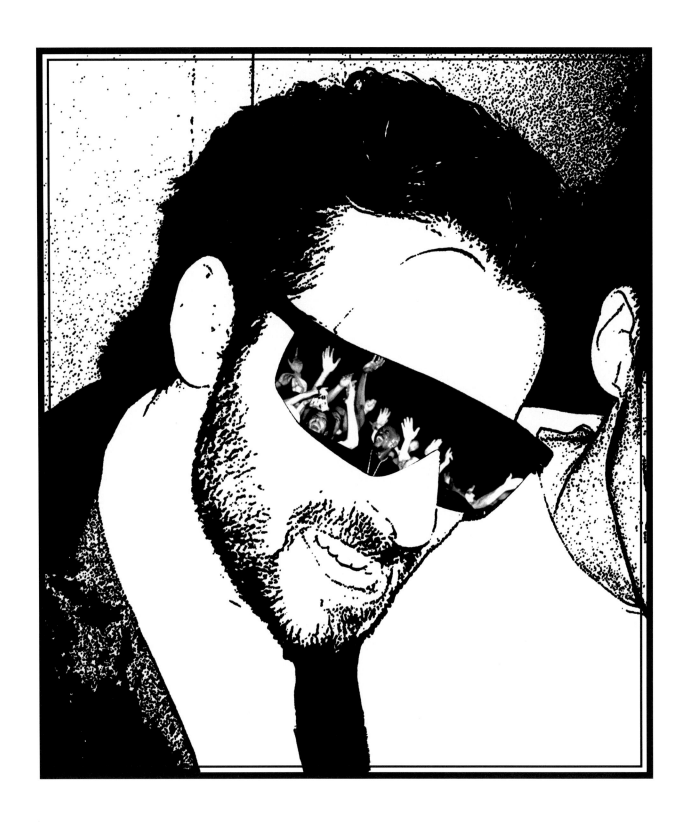

MURATO!

Bolognaise slang for "packed". When in town, ask for a MURATO venue.

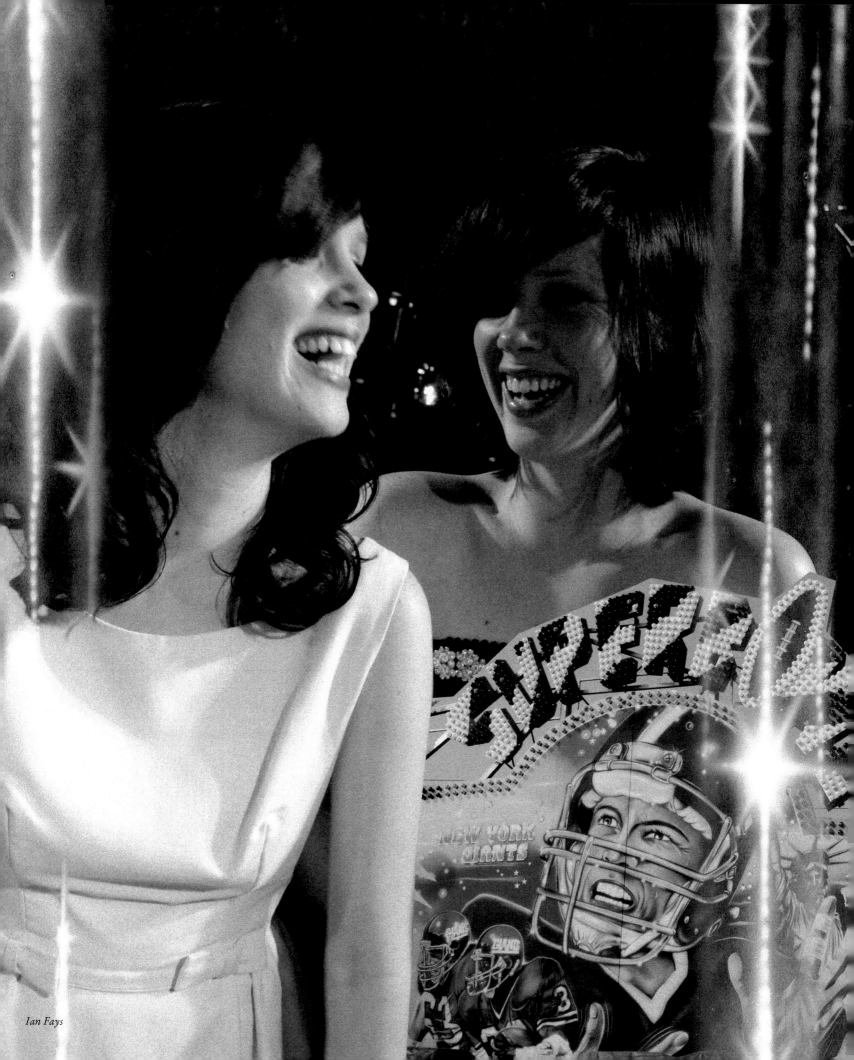

Ian Fays

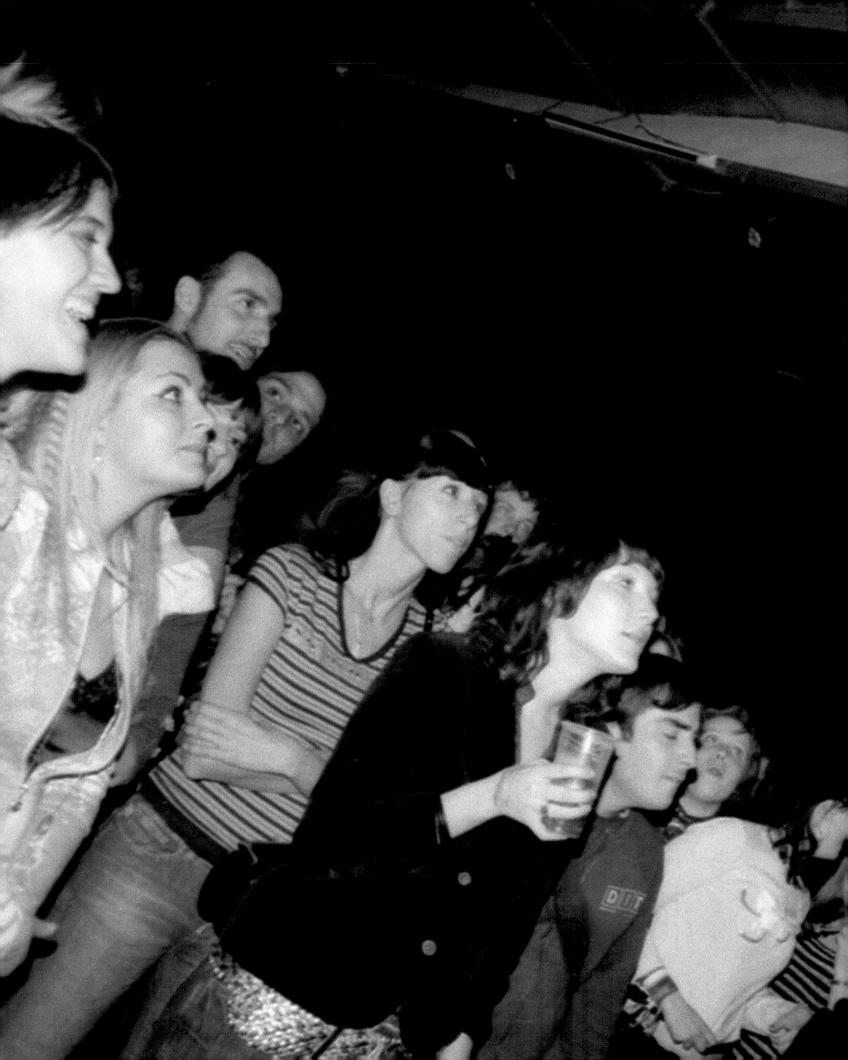

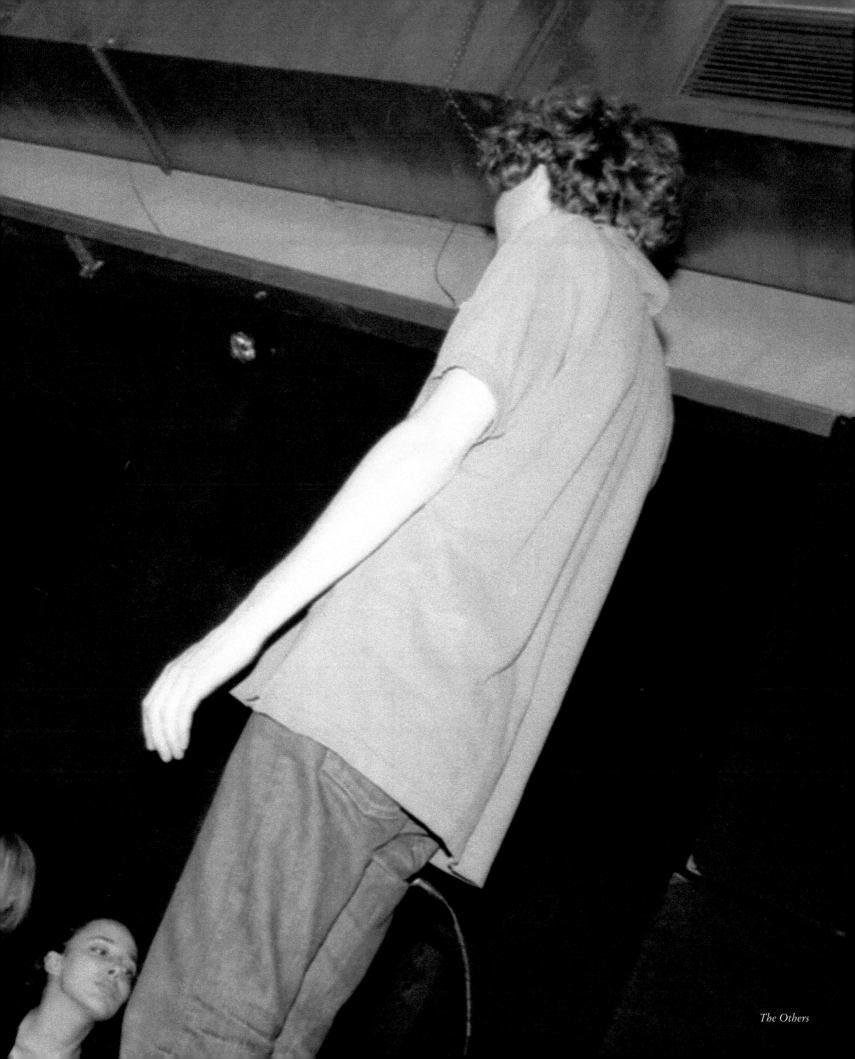

The Others

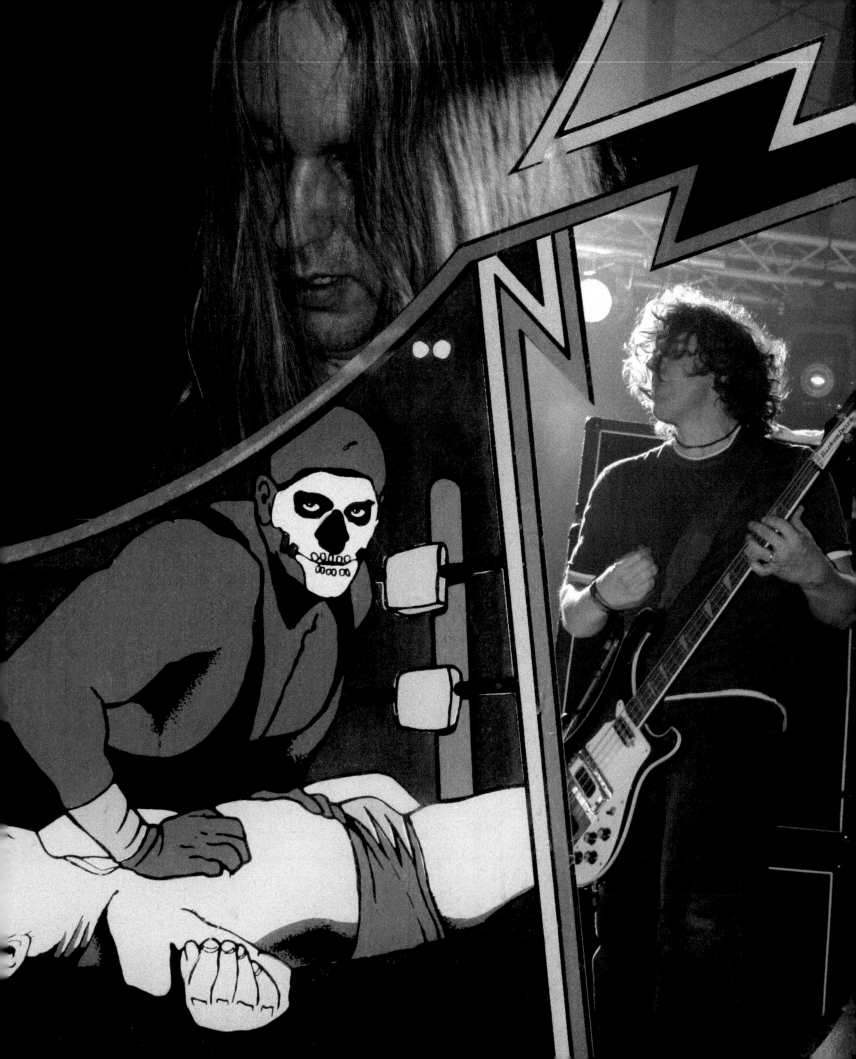

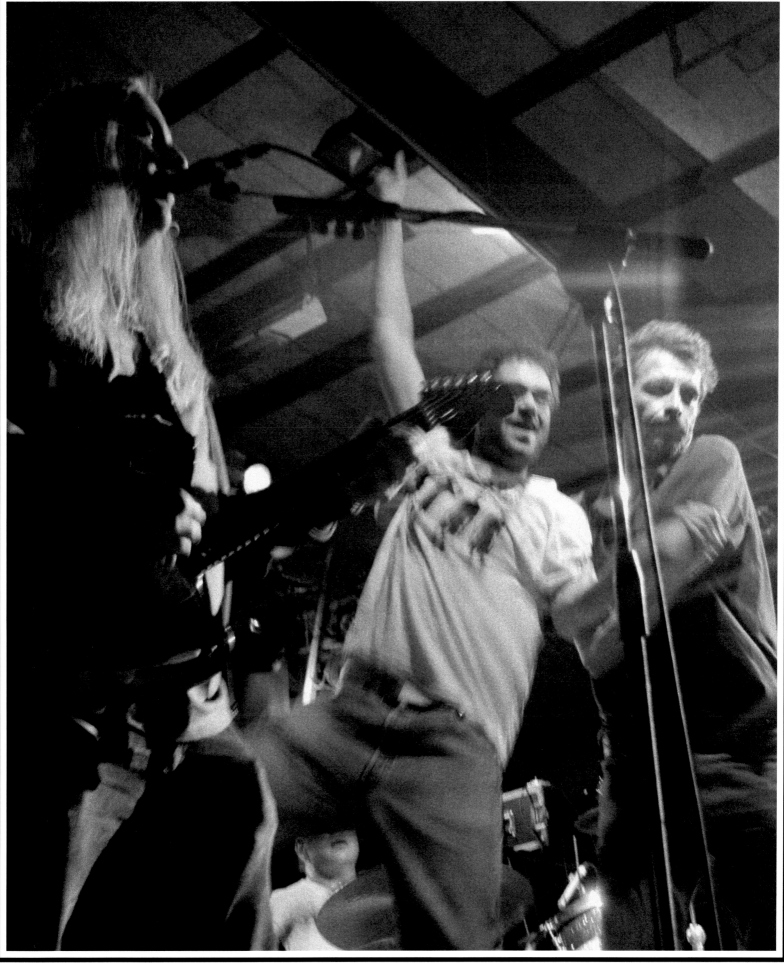

Dinosaur Jr

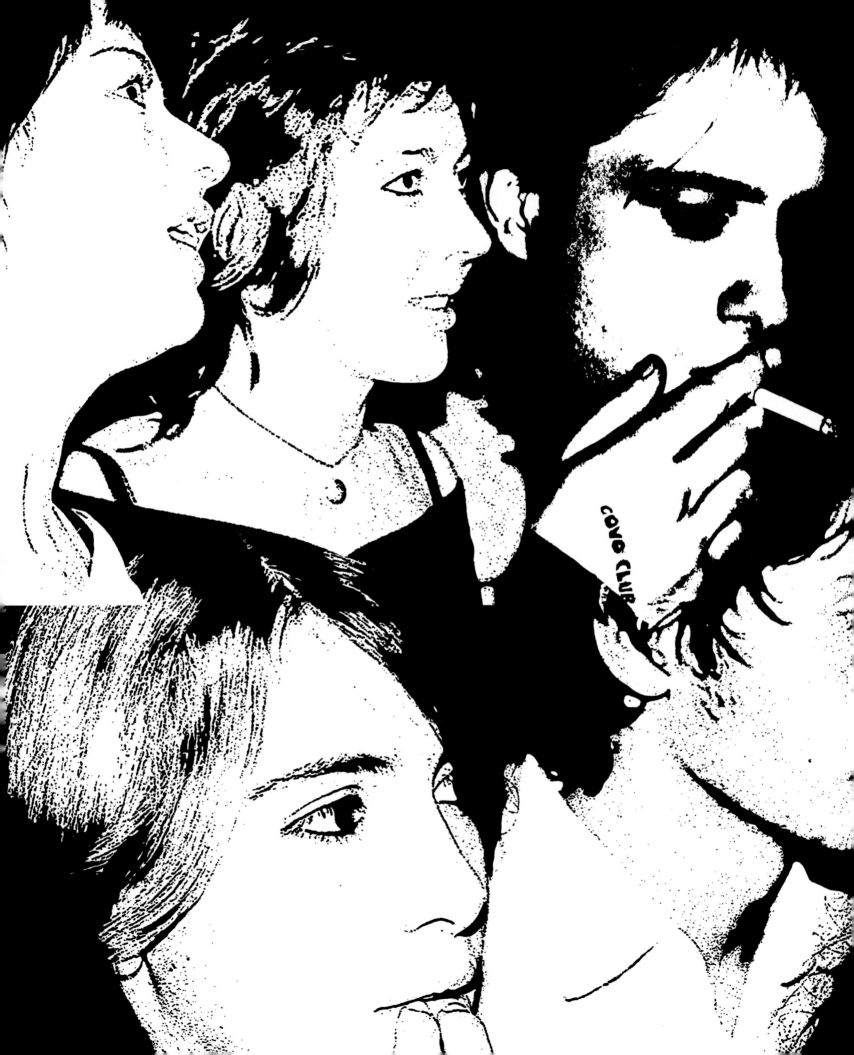

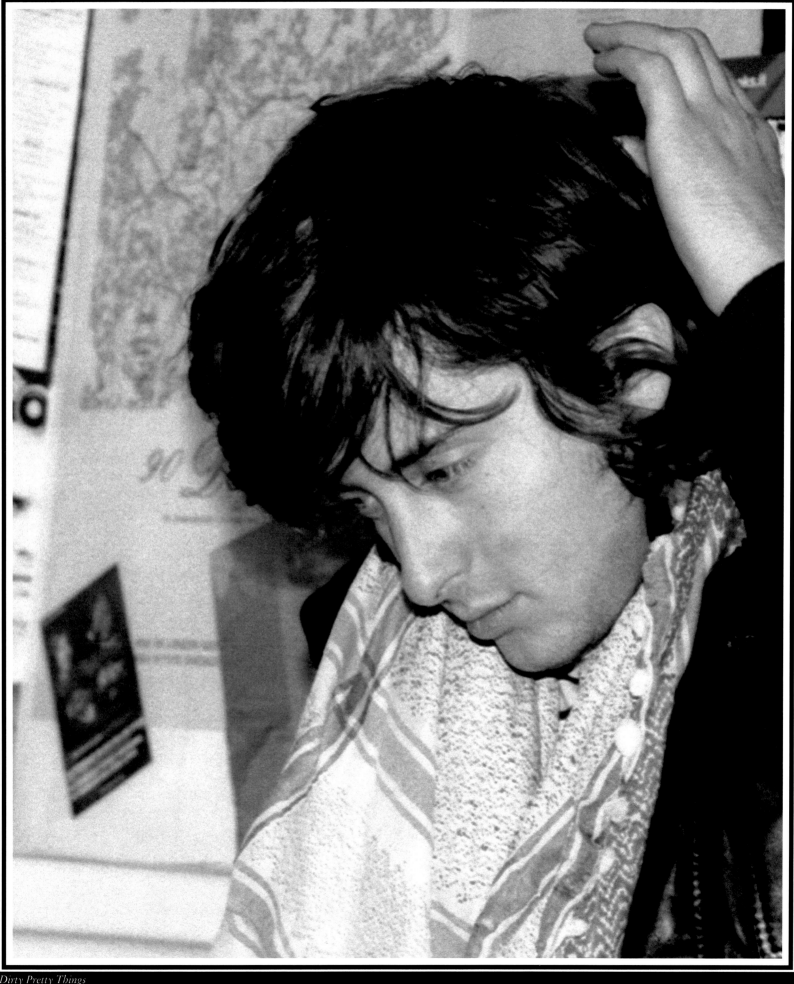

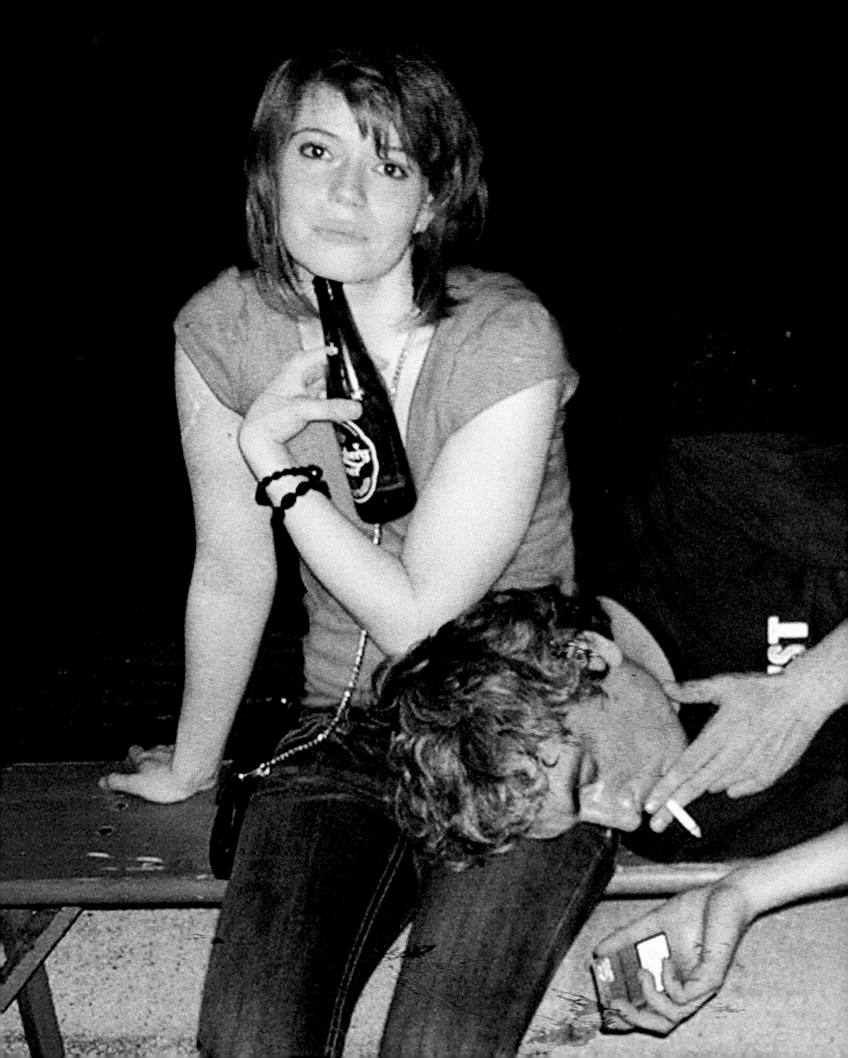

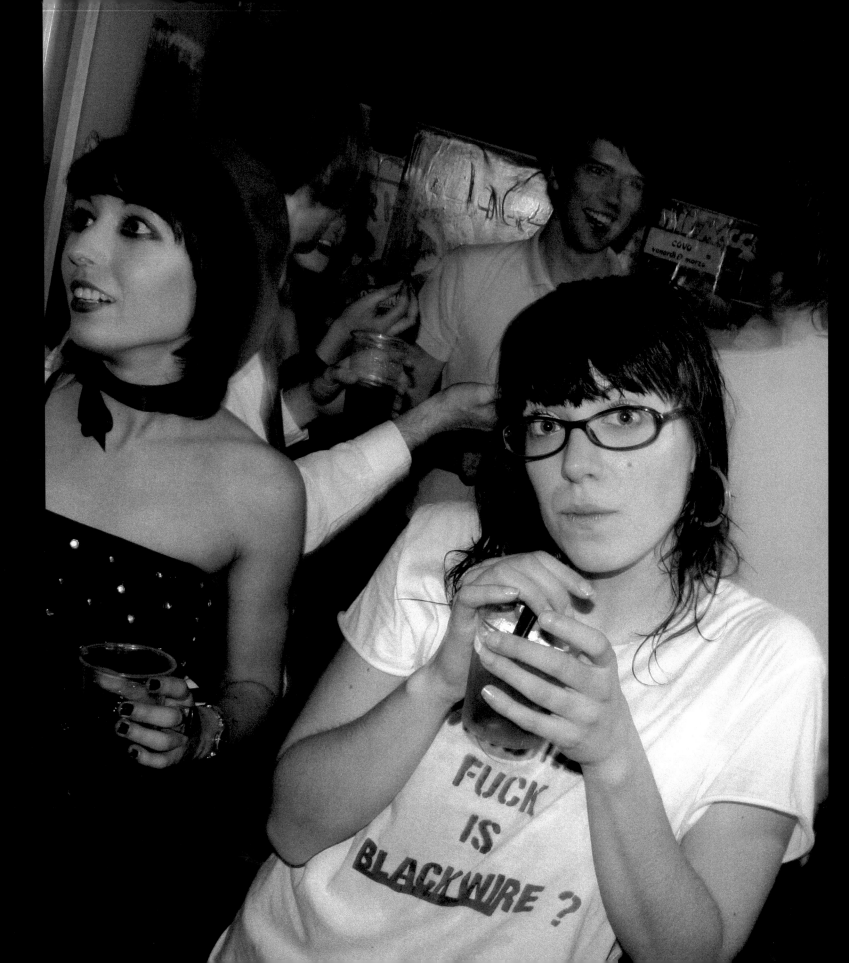

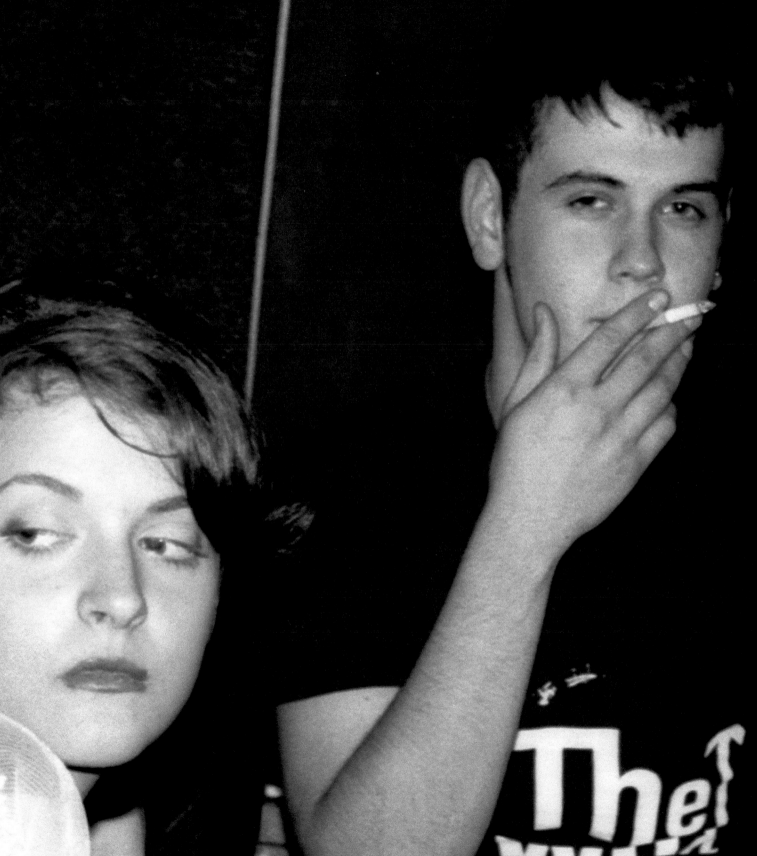

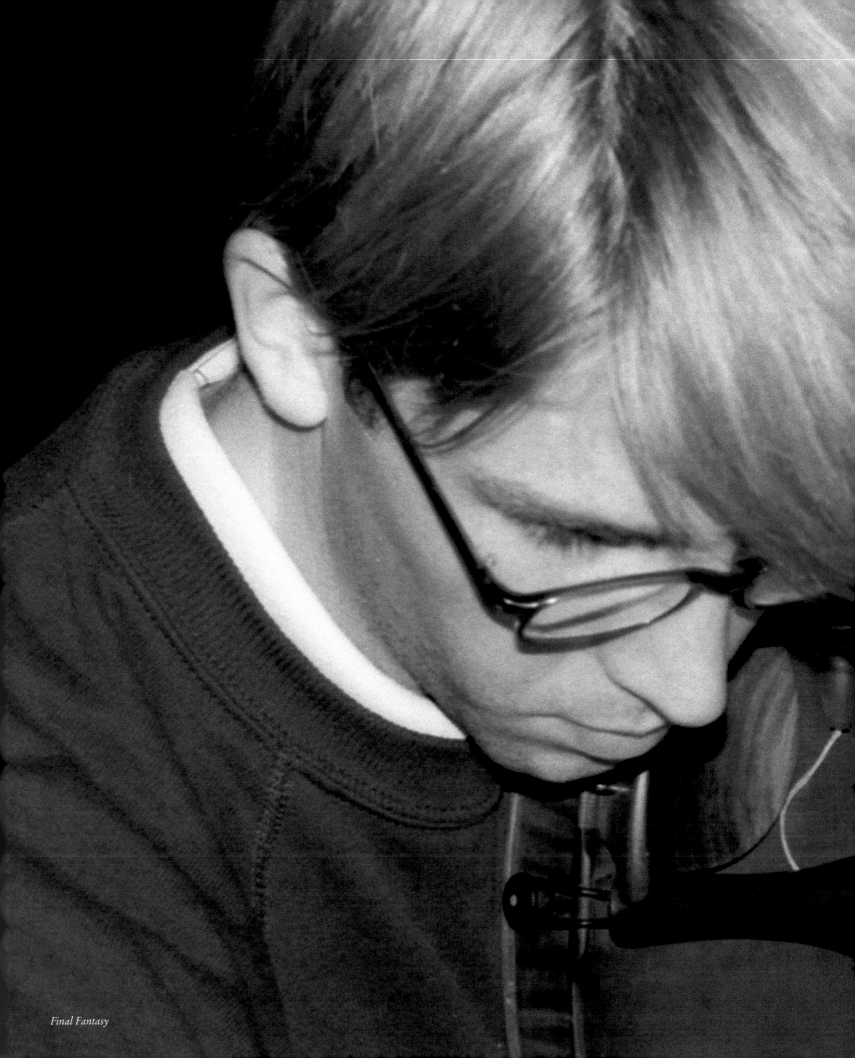

Final Fantasy

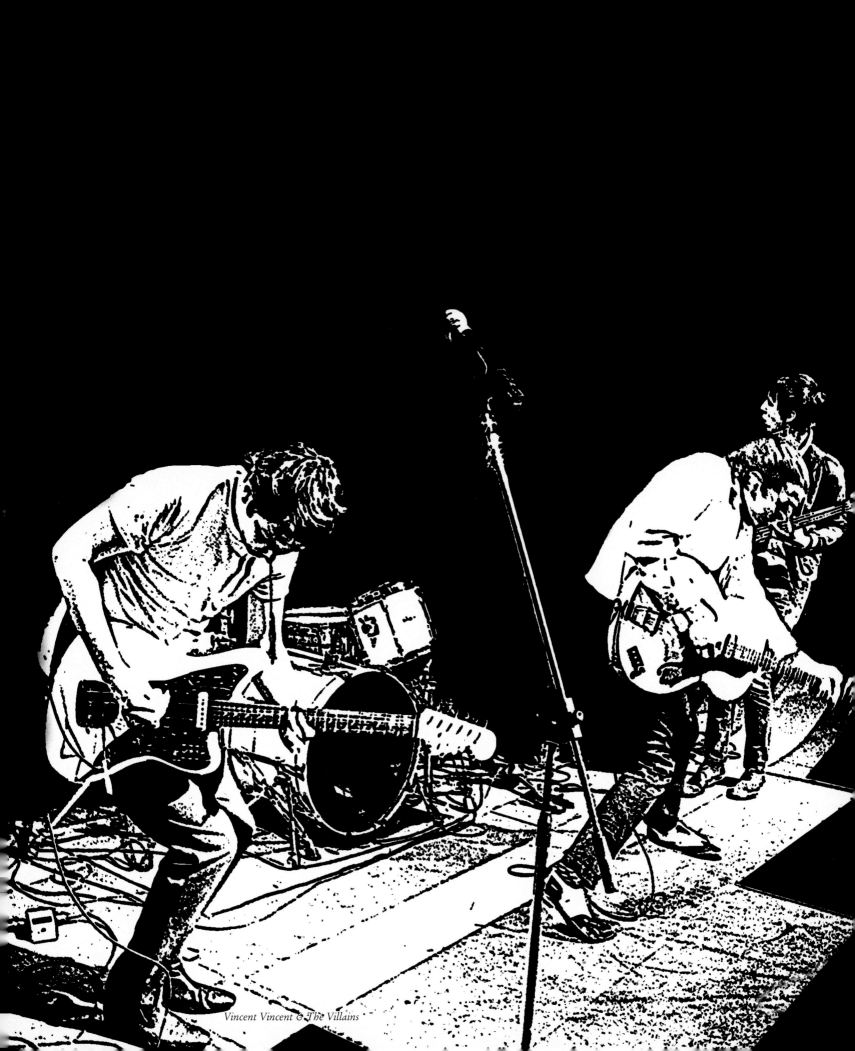

Vincent Vincent & The Villains

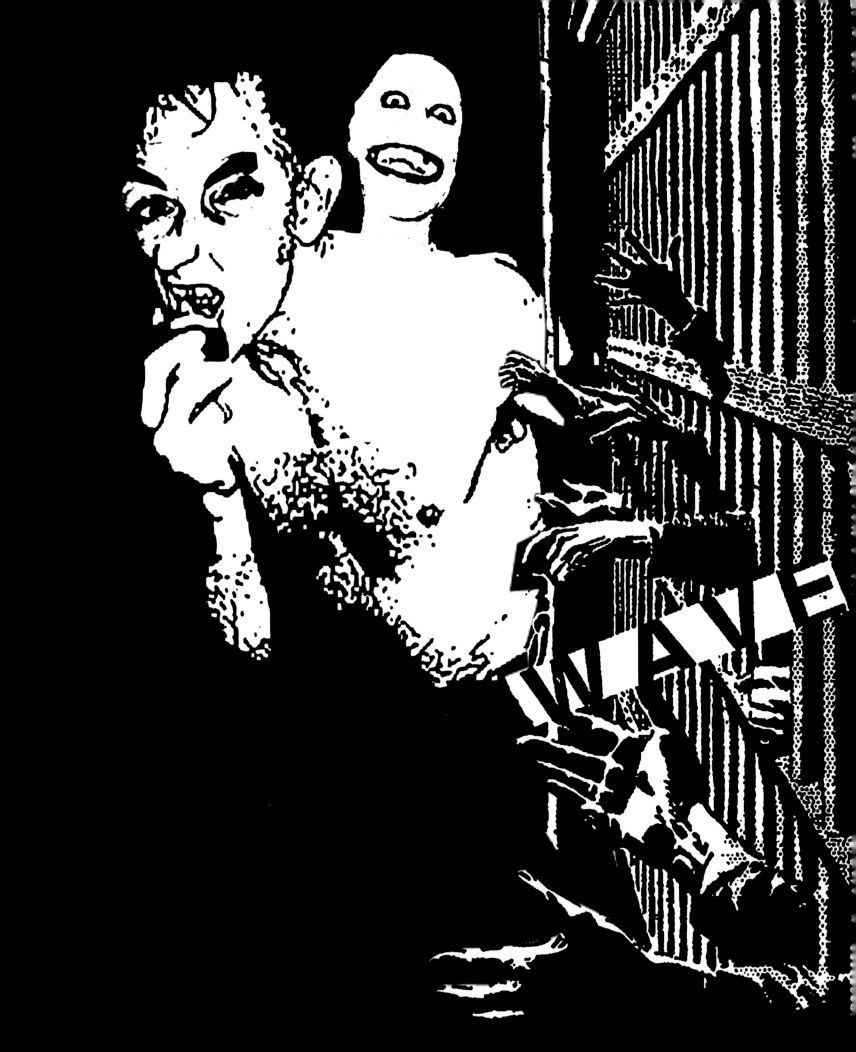

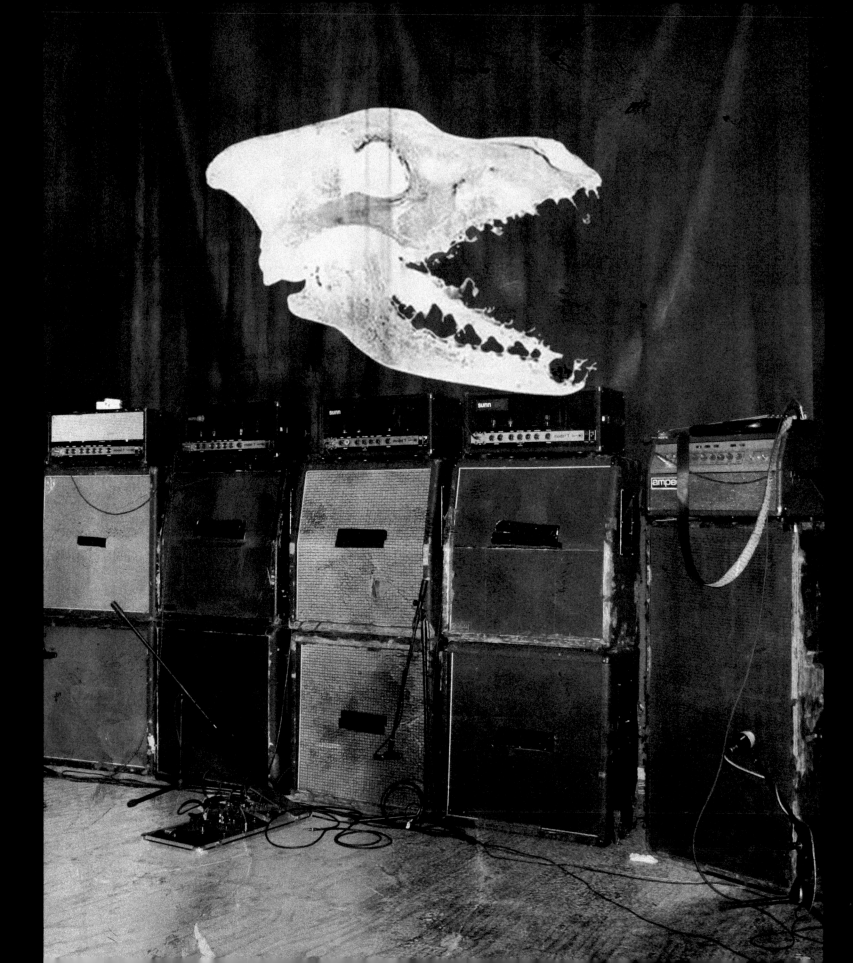

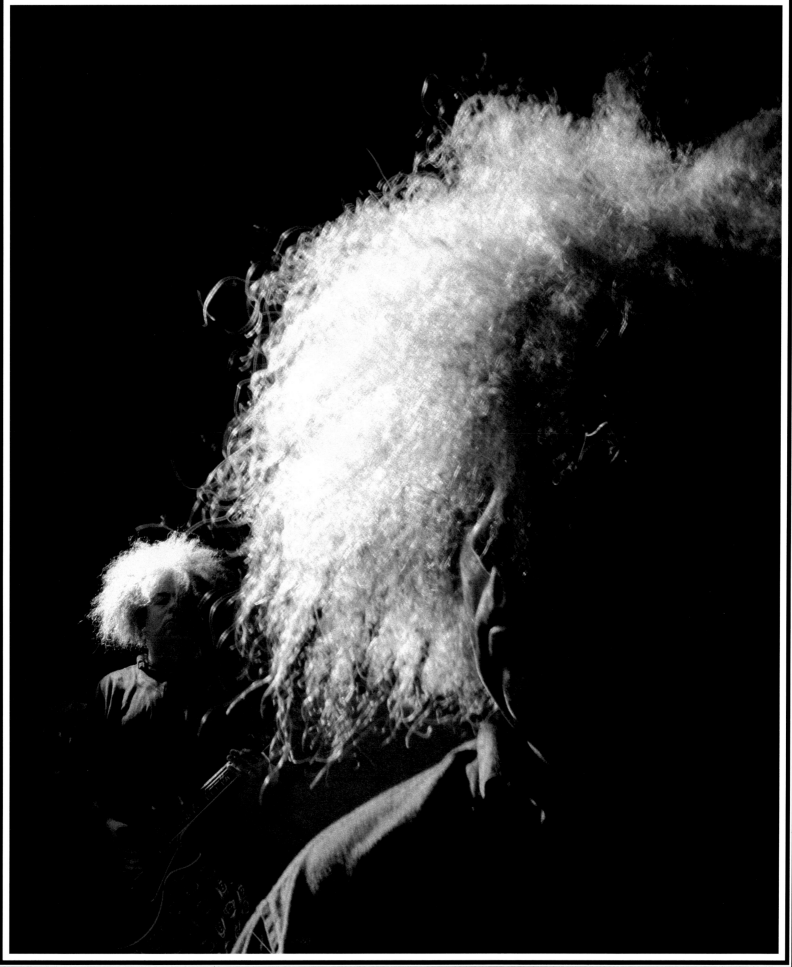

Melvins

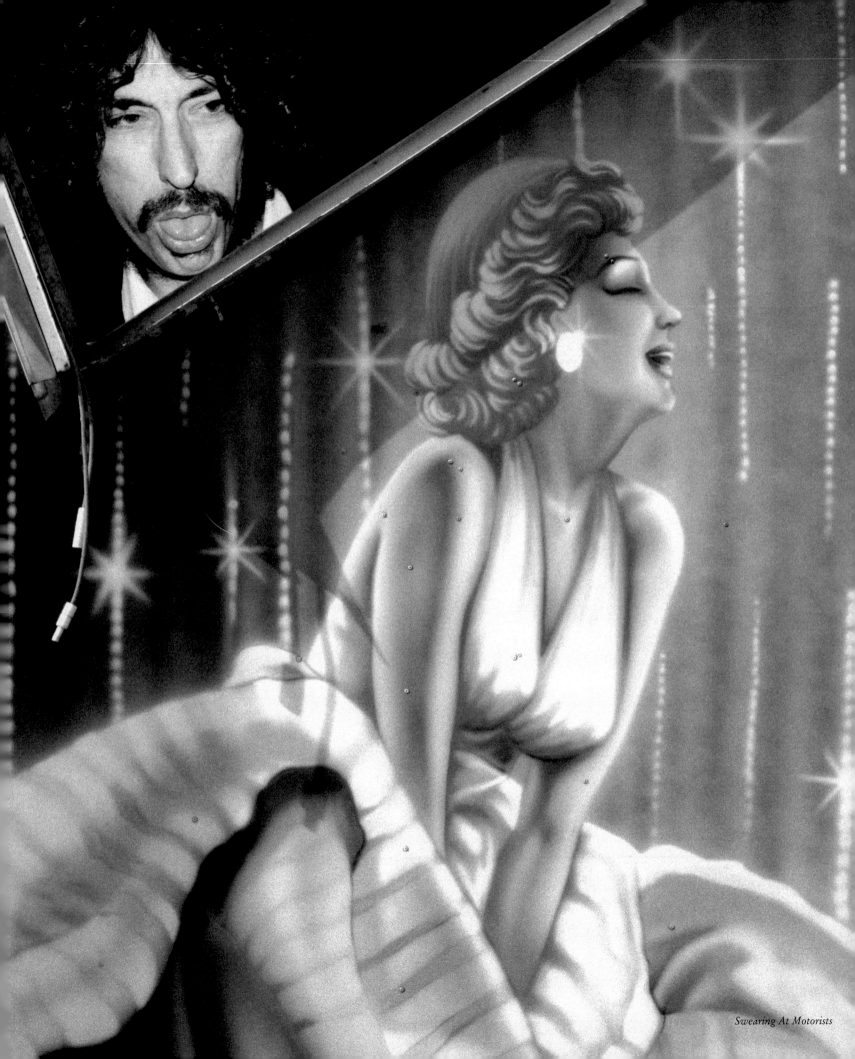

Swearing At Motorists

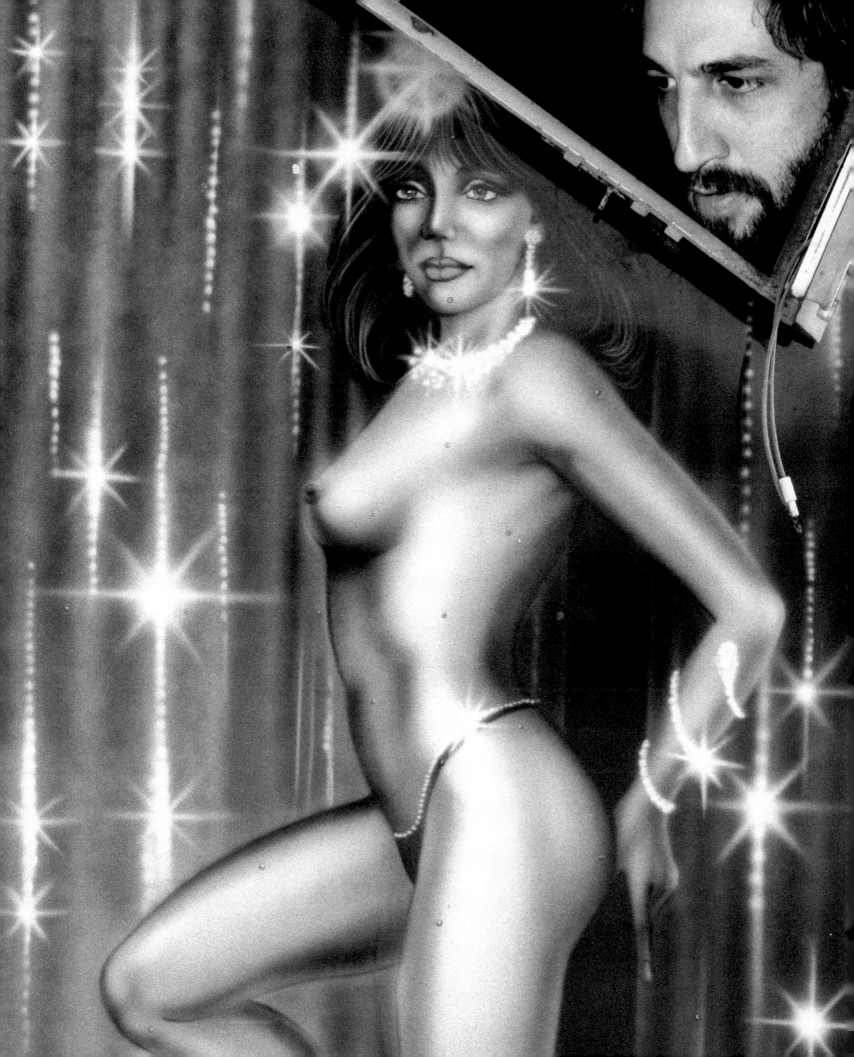

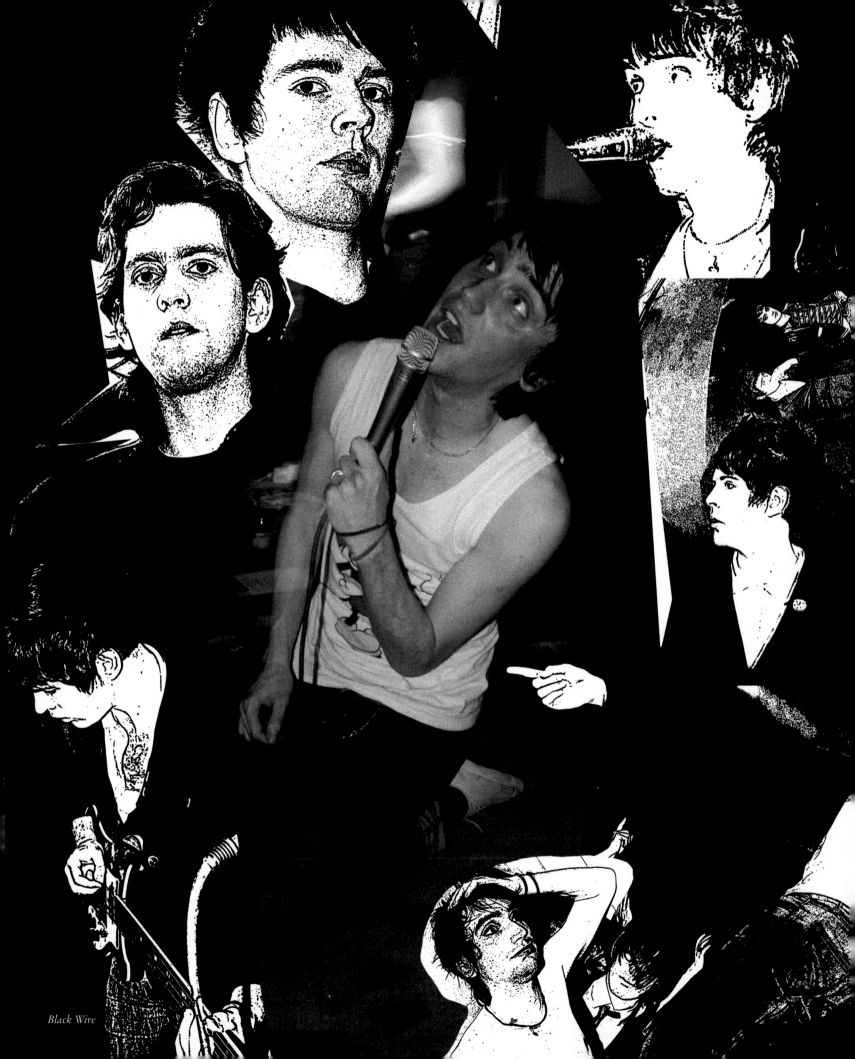

Black Wire

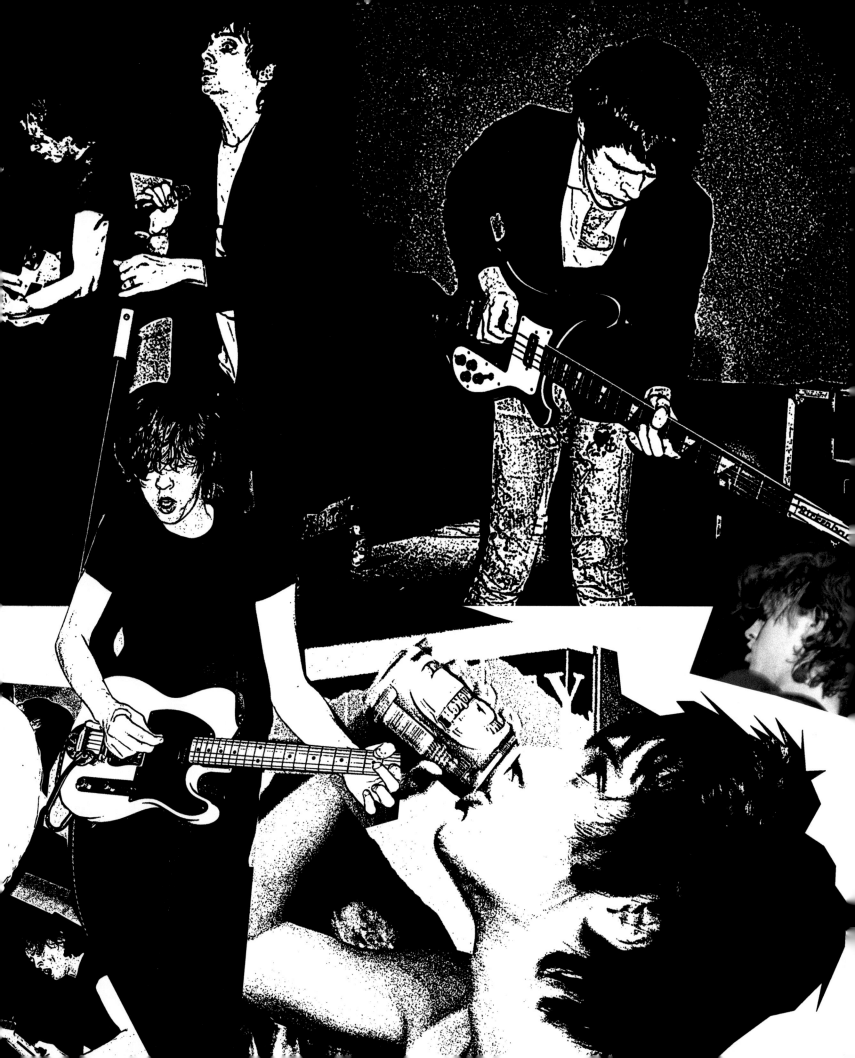

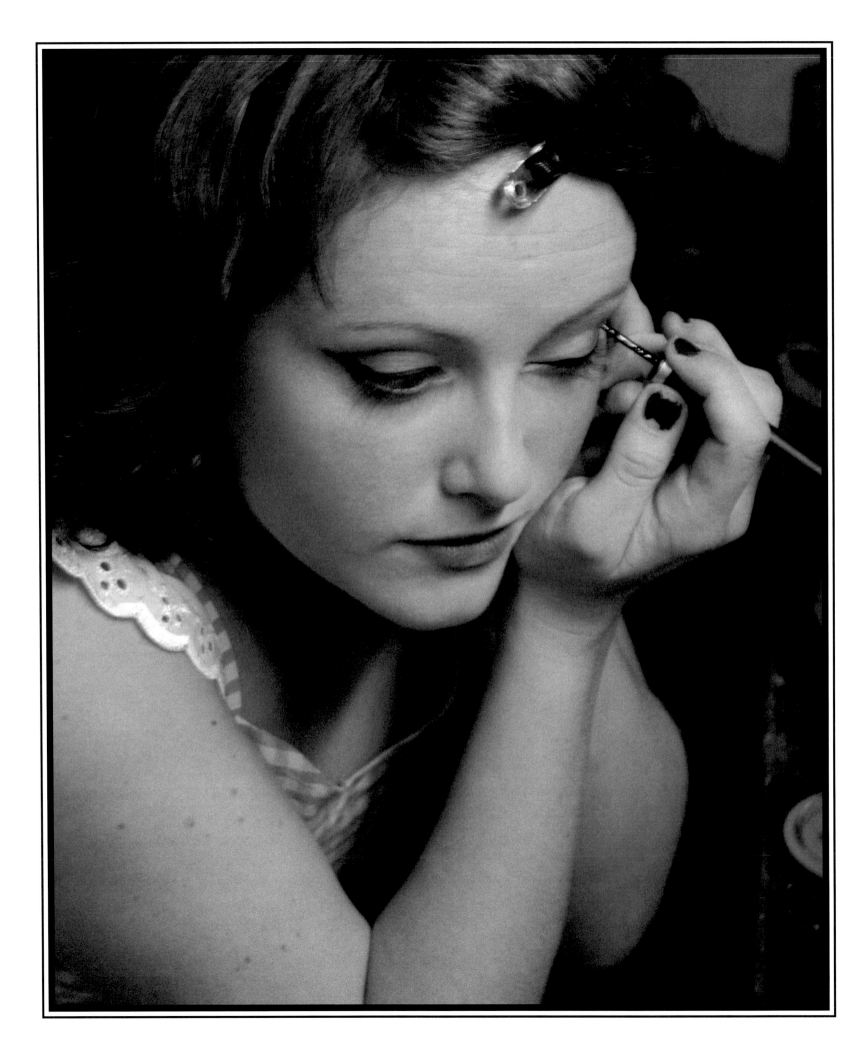

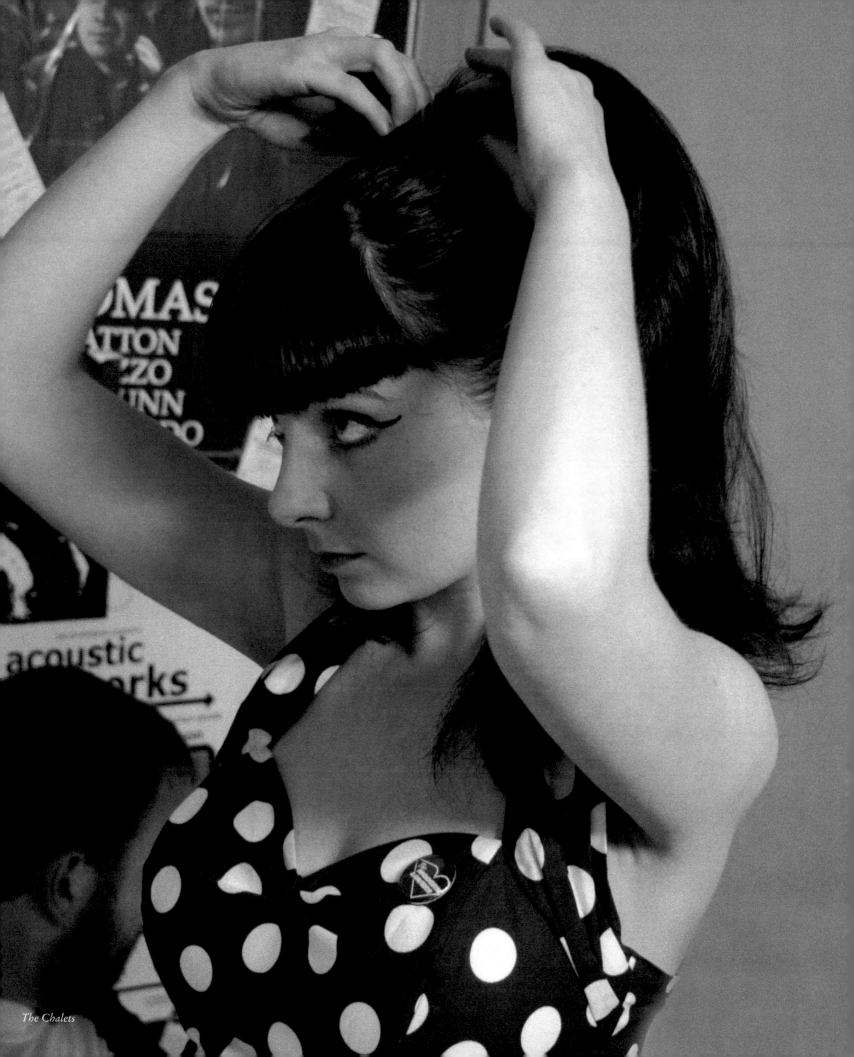

The Chalets

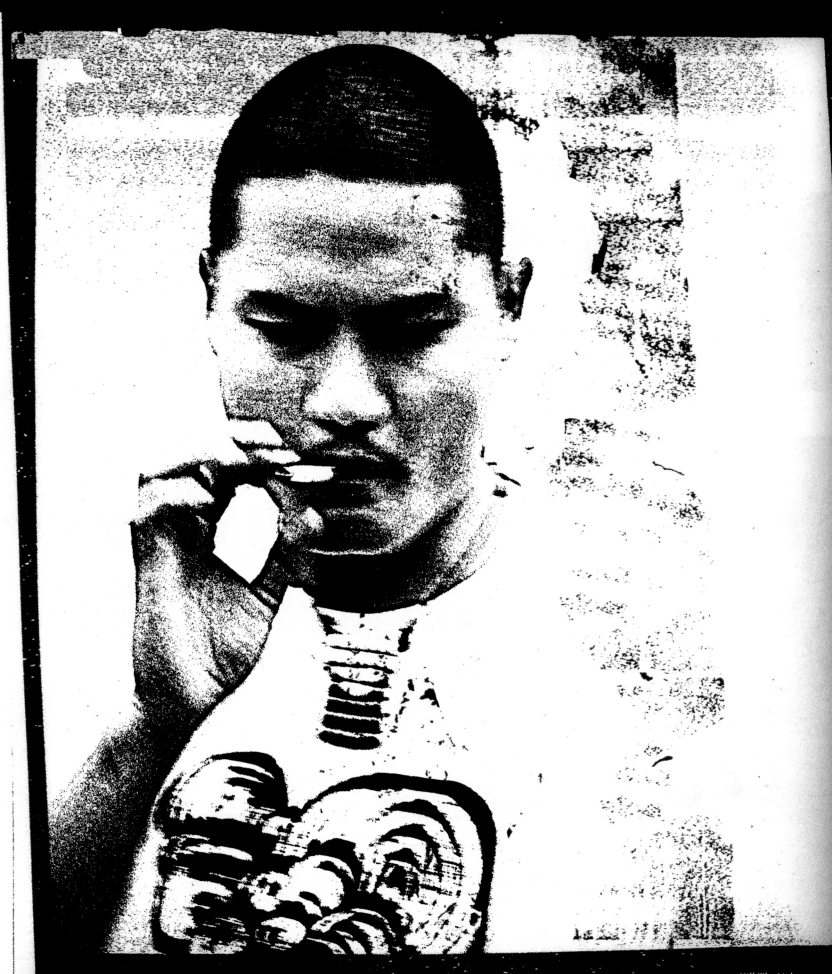

Kill The Vultures

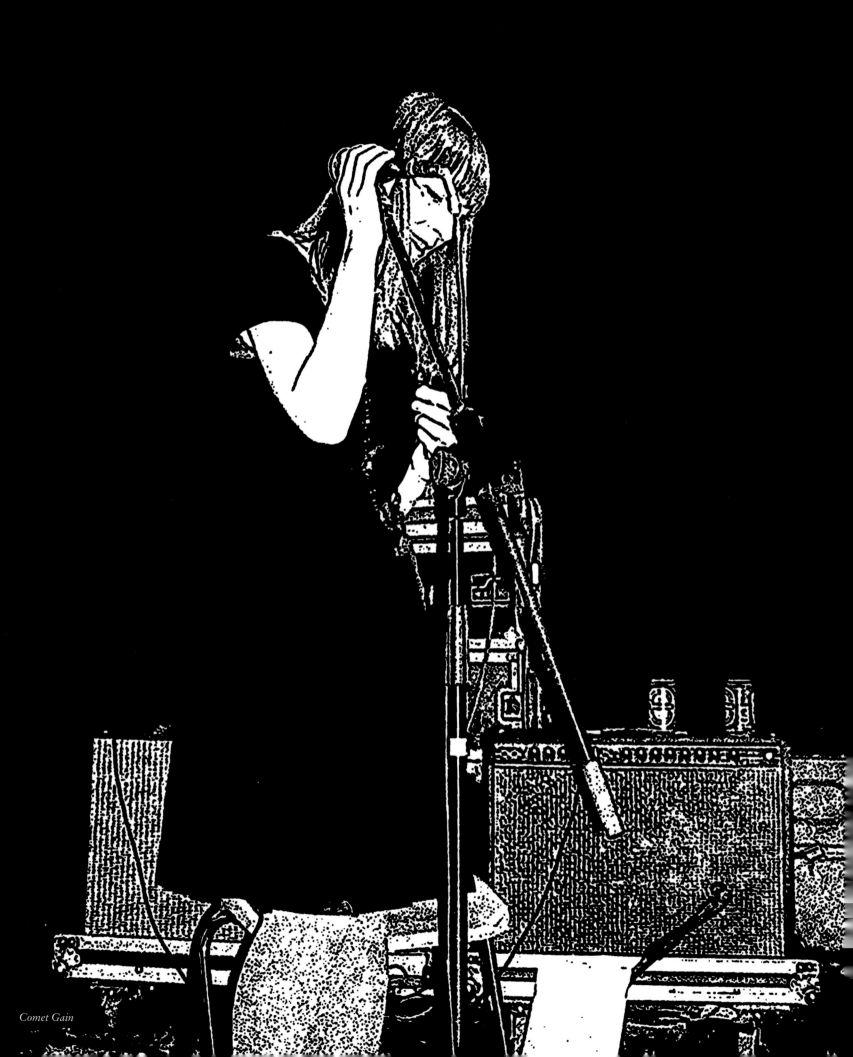

Comet Gain

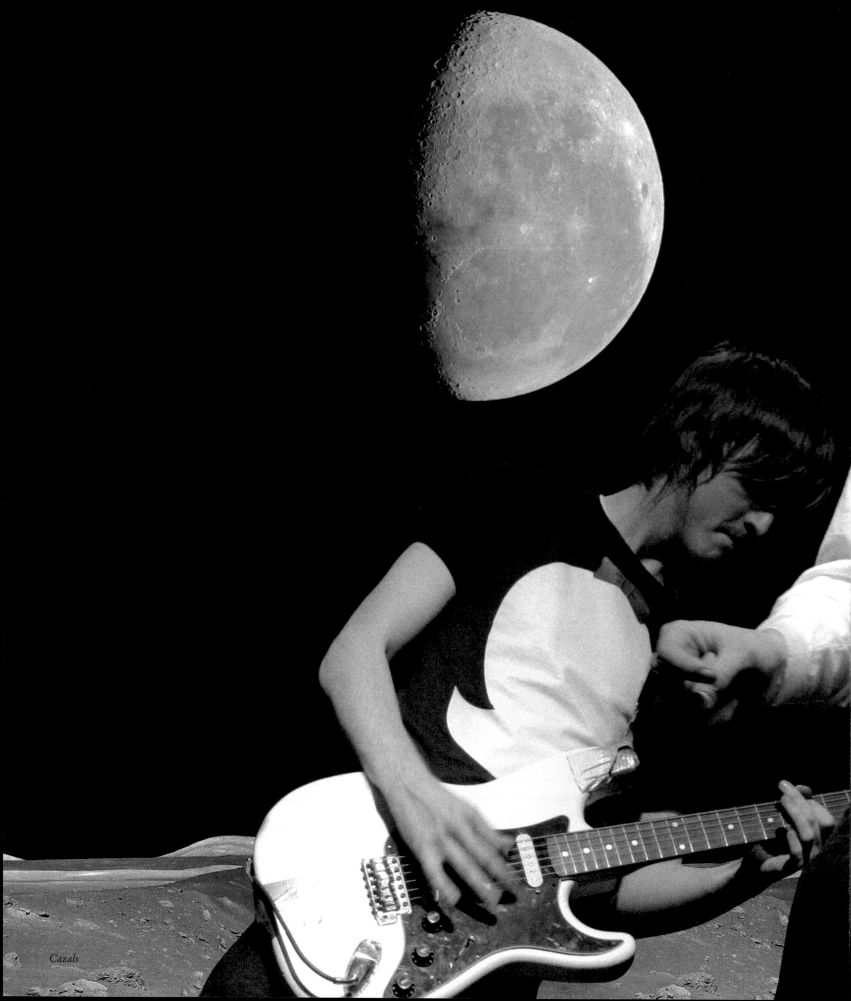

Cazals

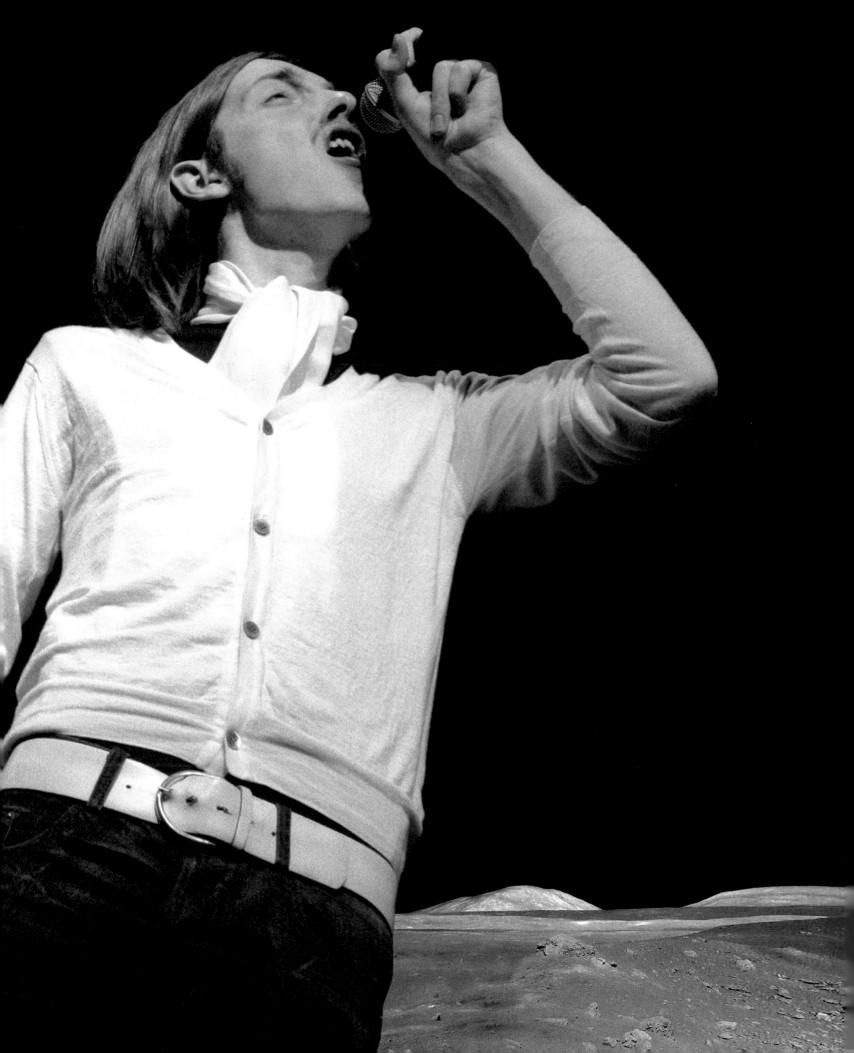

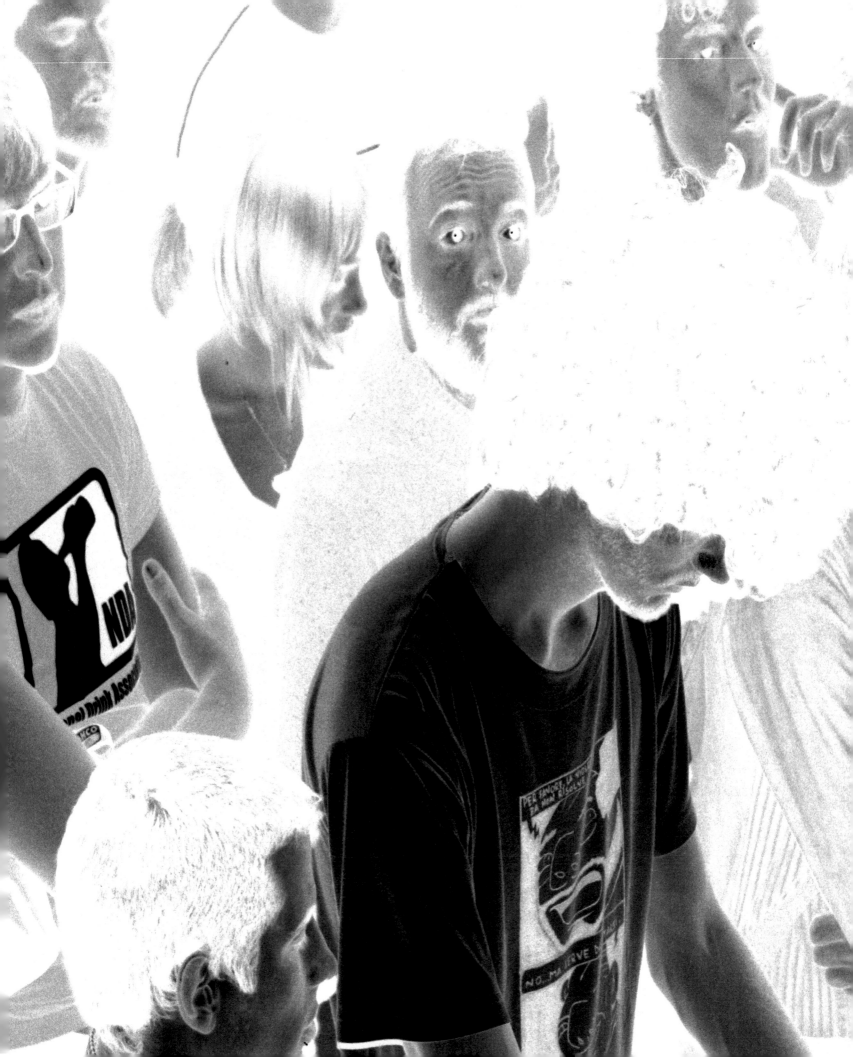

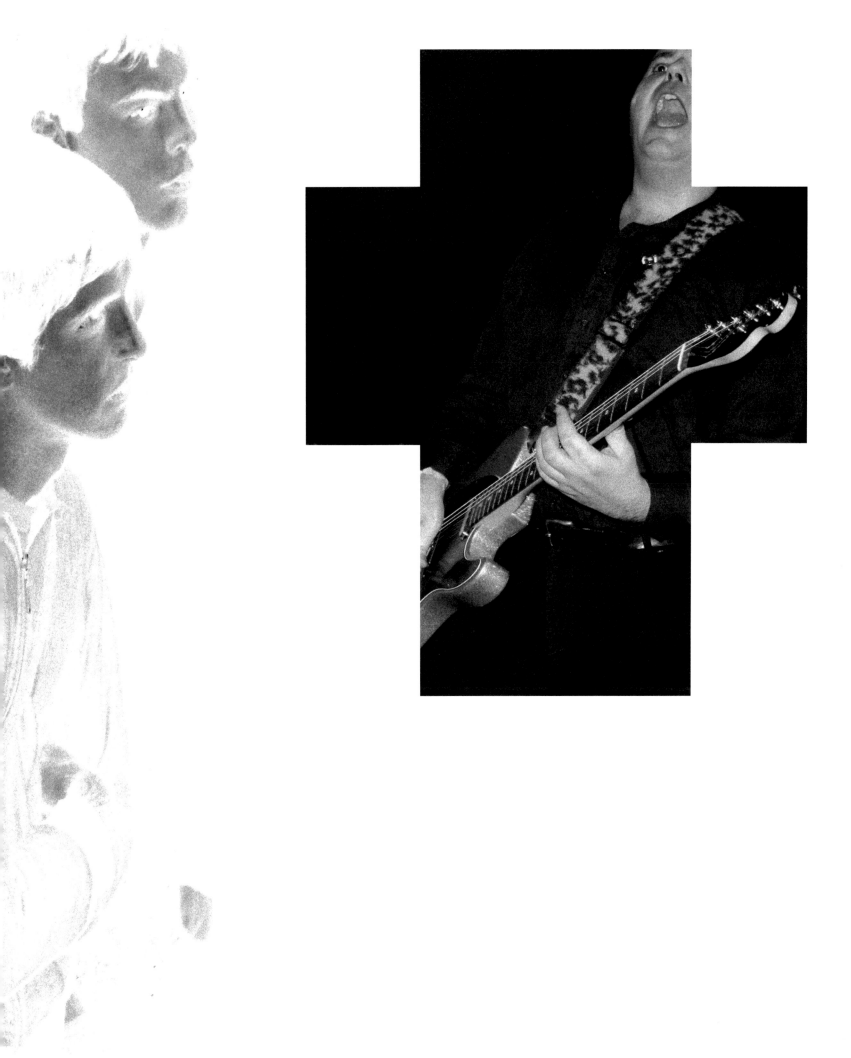

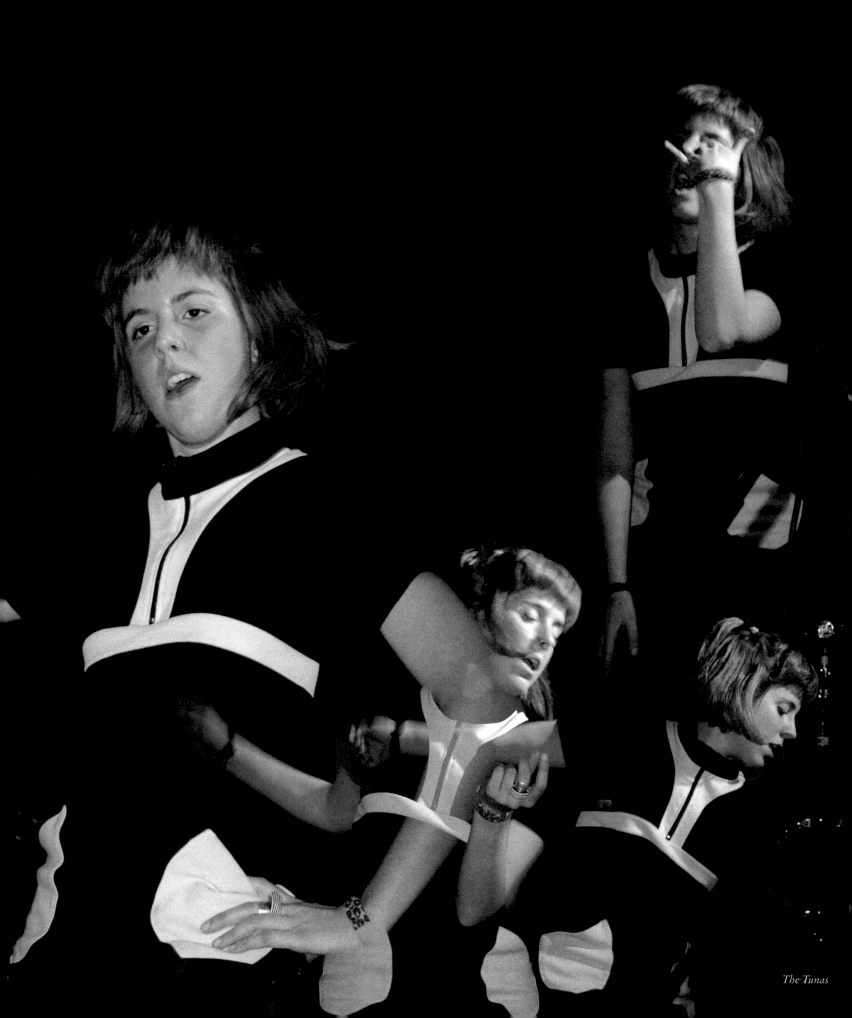

The Tunas

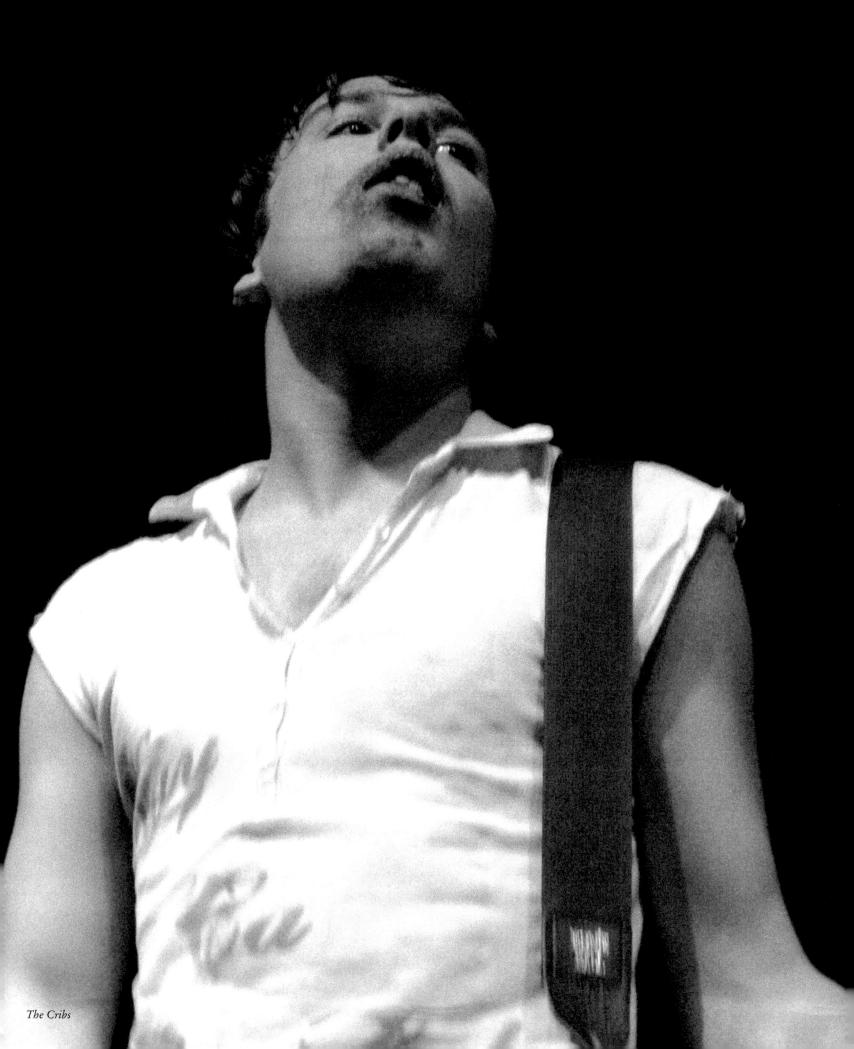

The Cribs

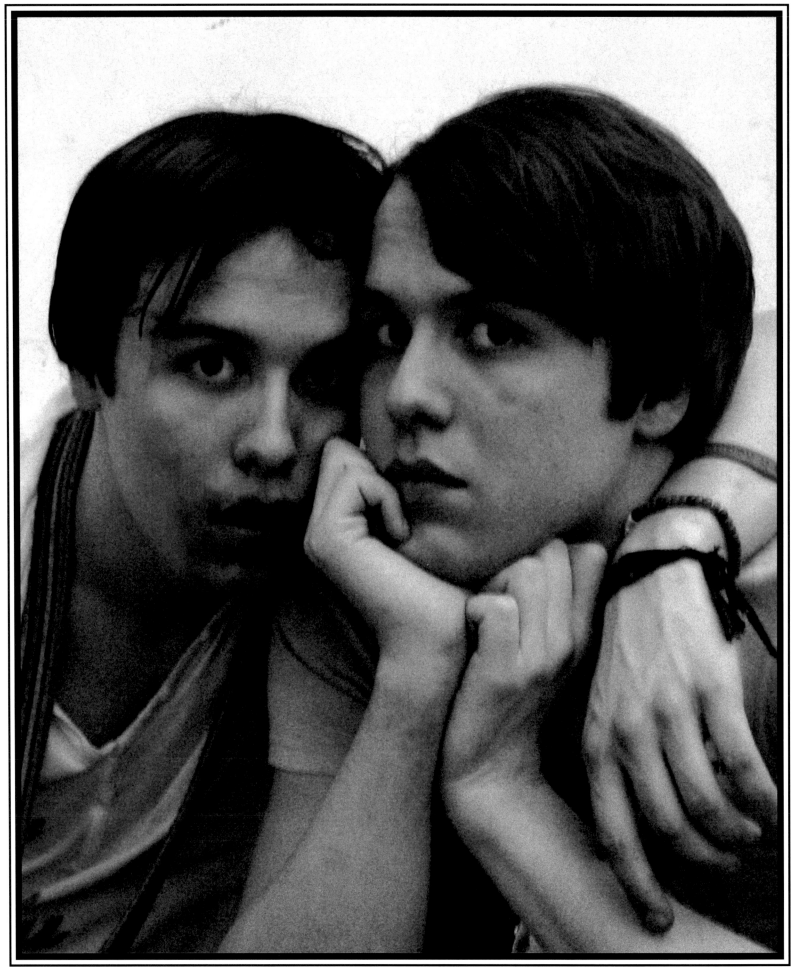

The Cribs

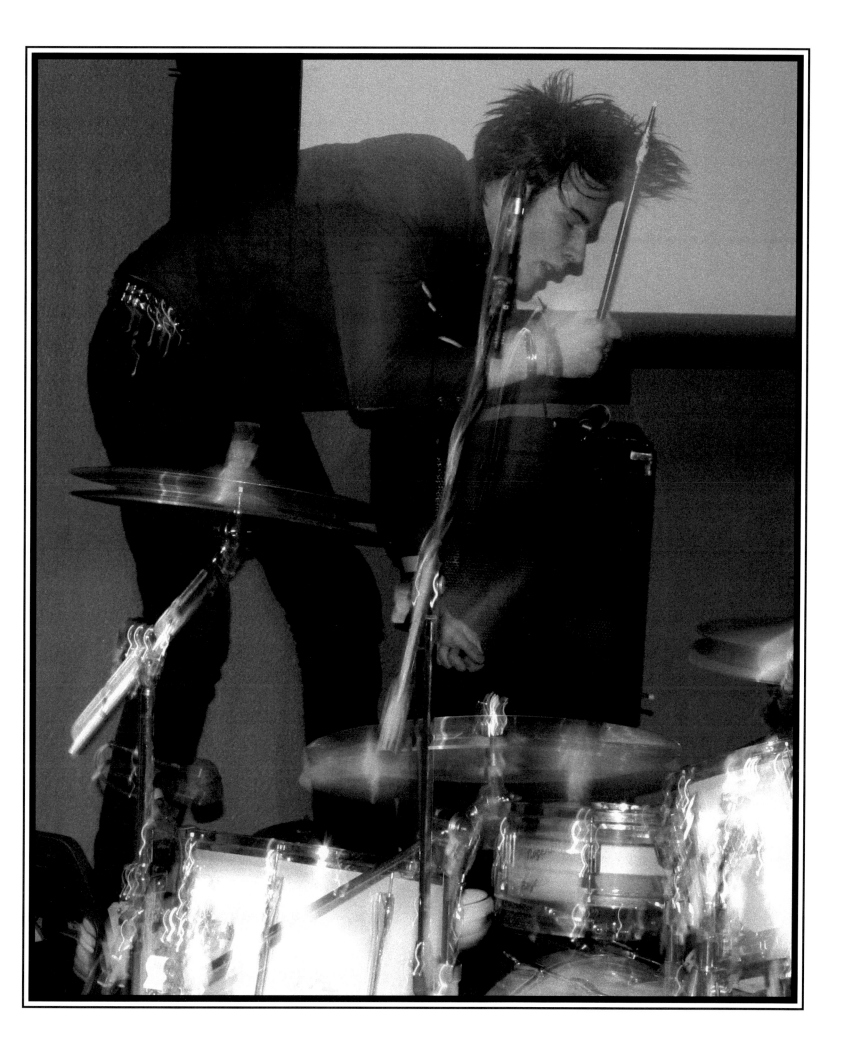

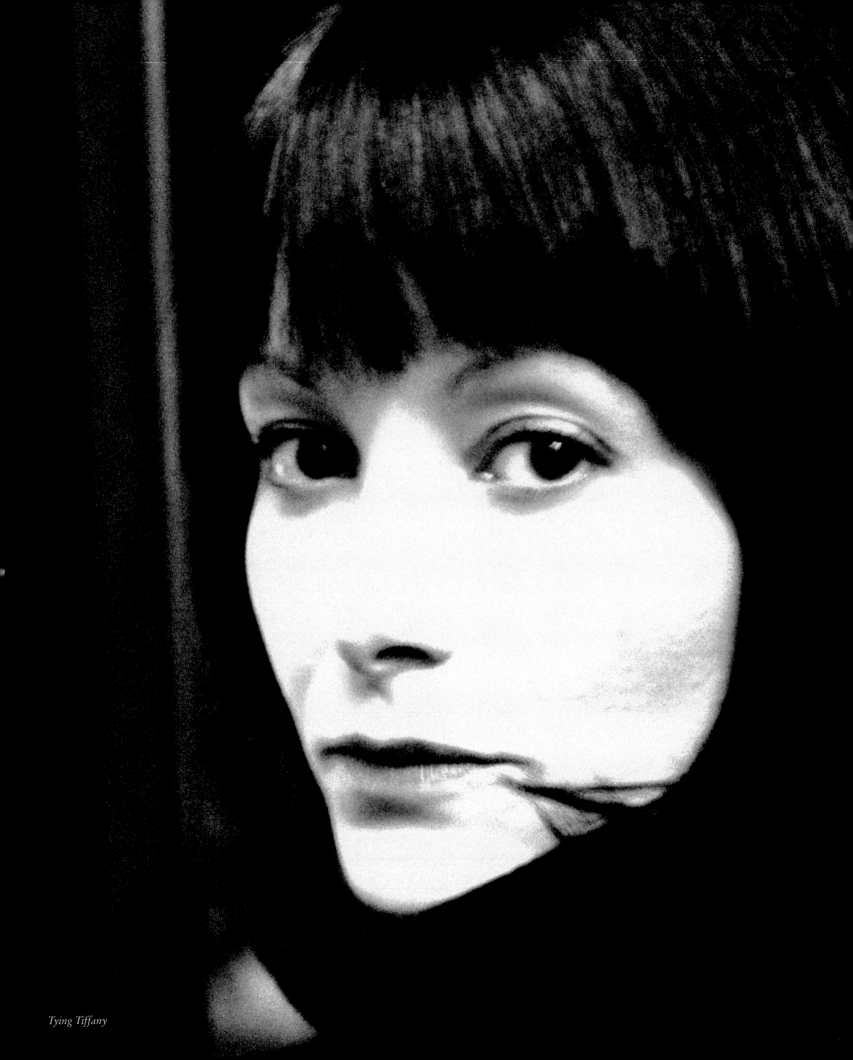

Tying Tiffany

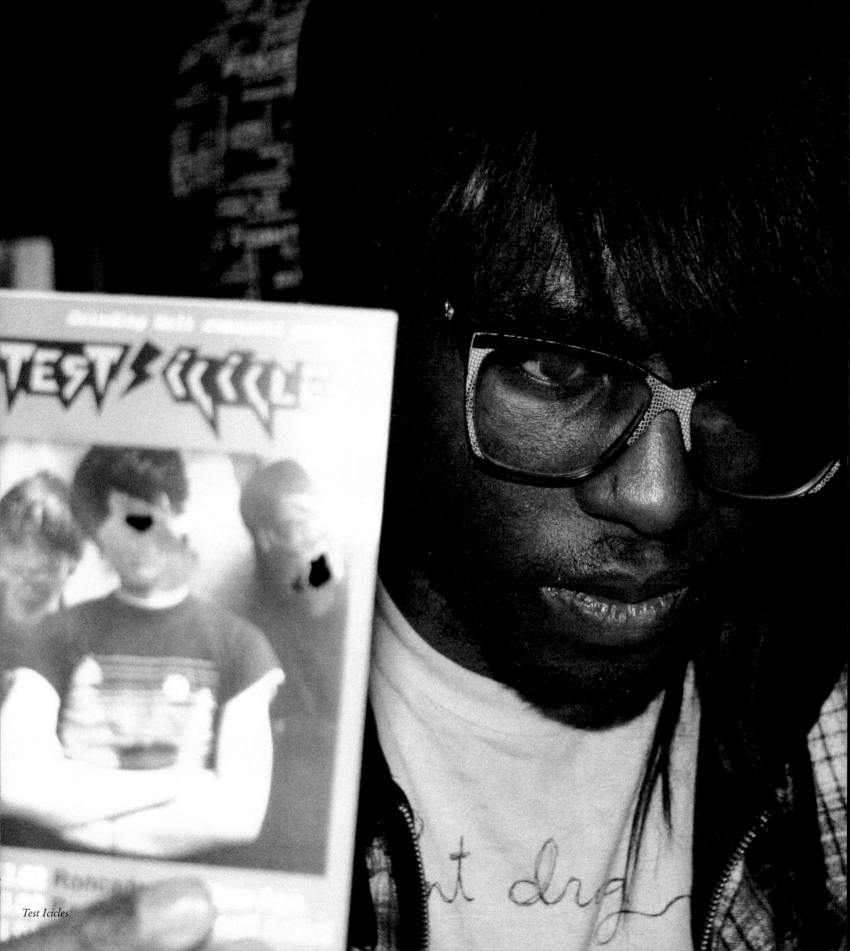

Test Icicles

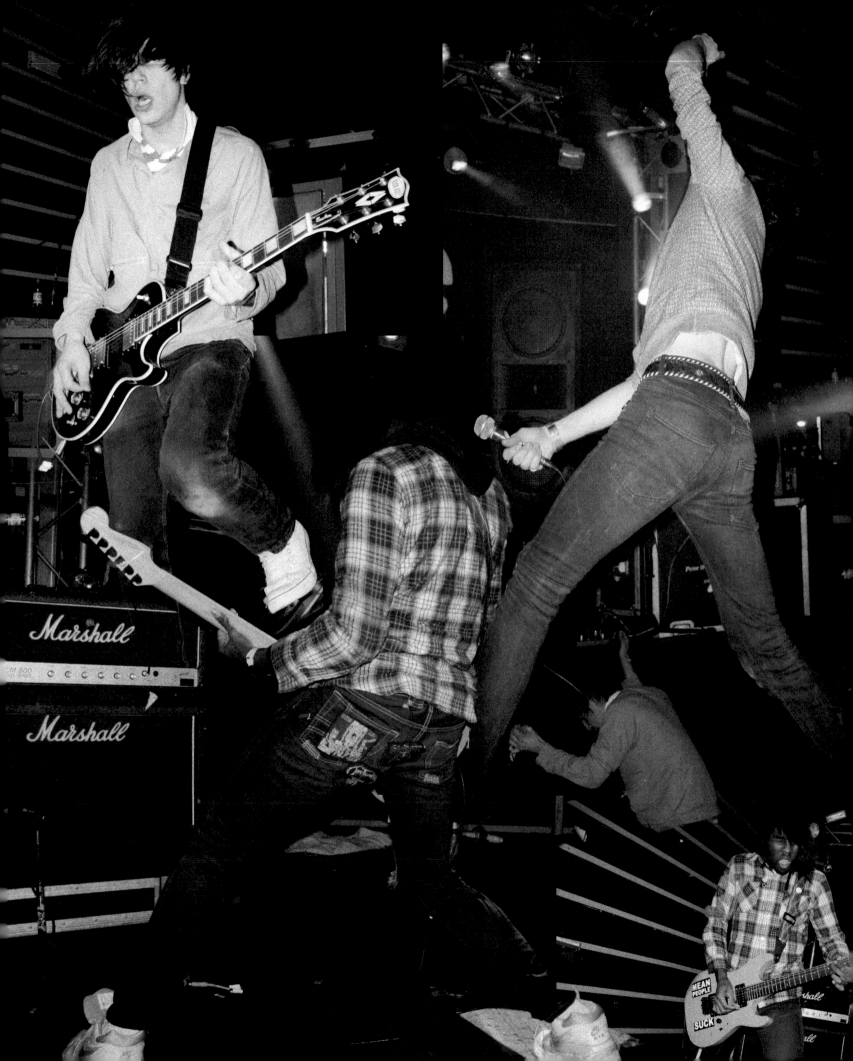

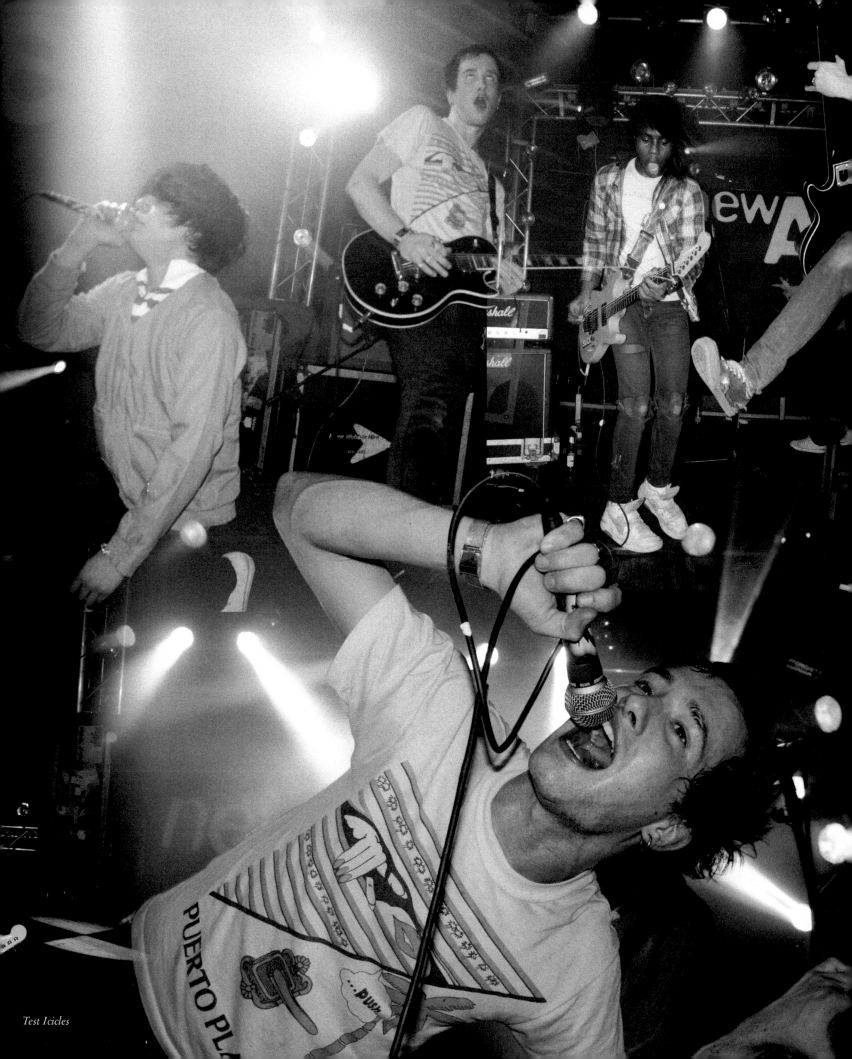

Test Icicles

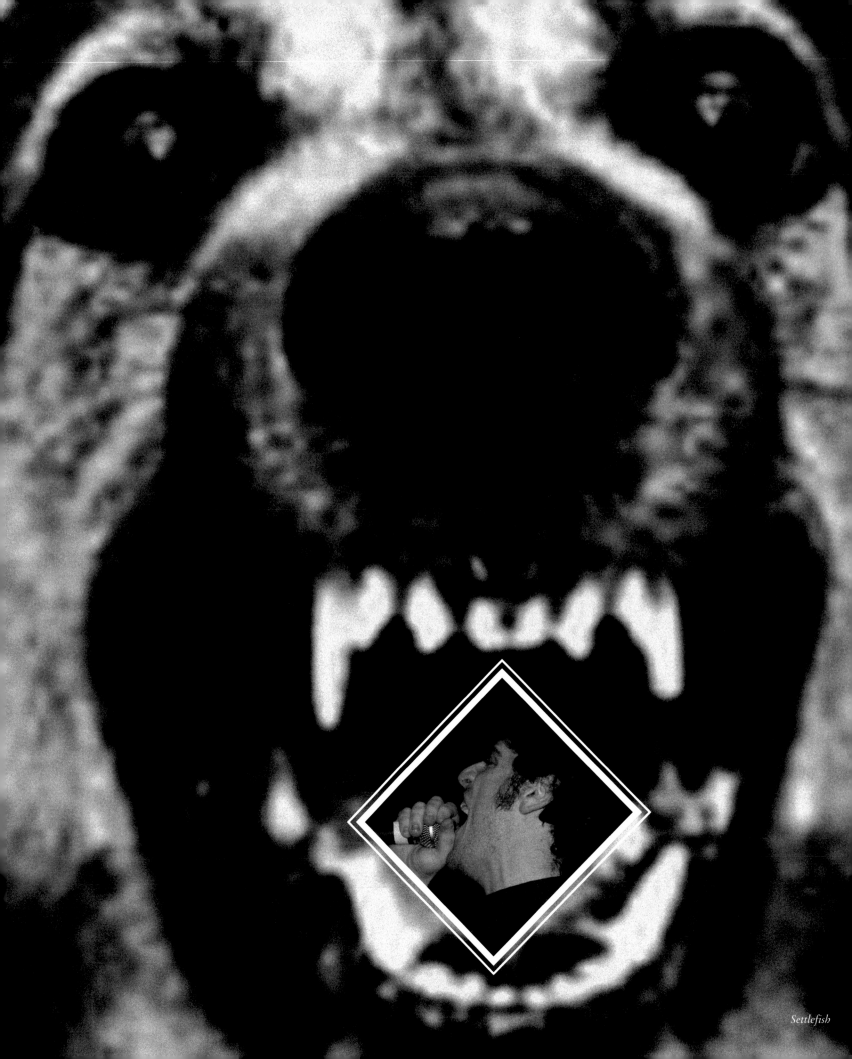

Settlefish

ANTI PASTI

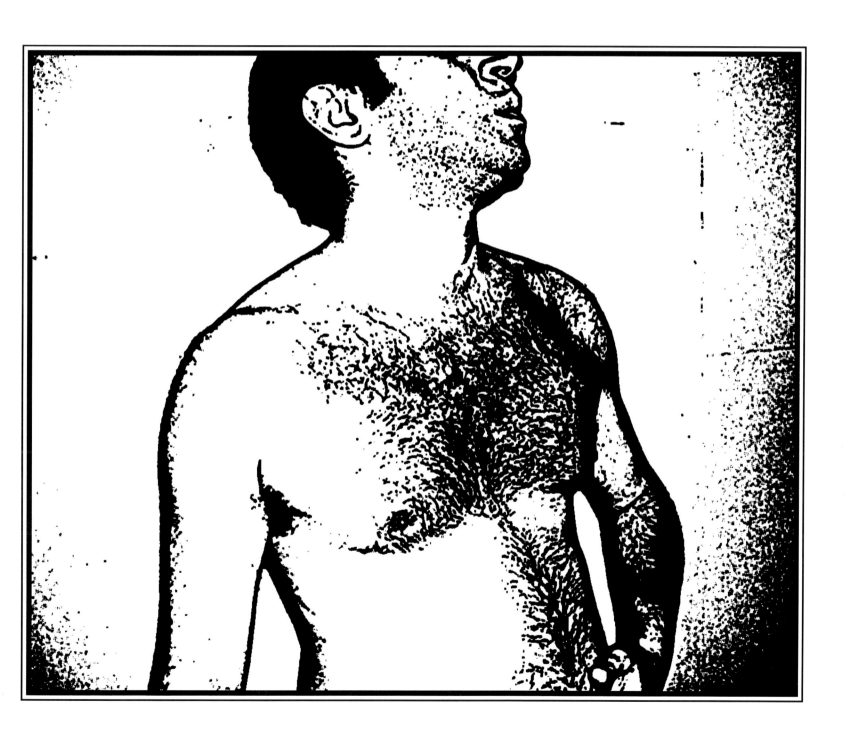

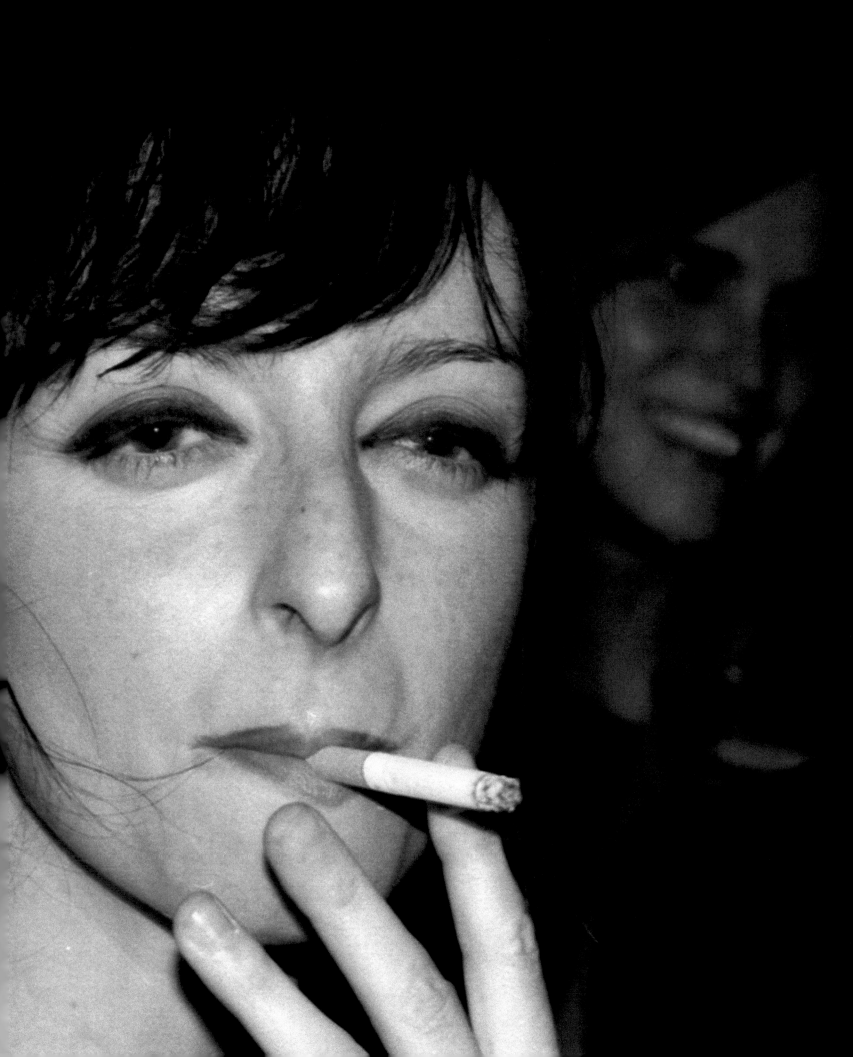

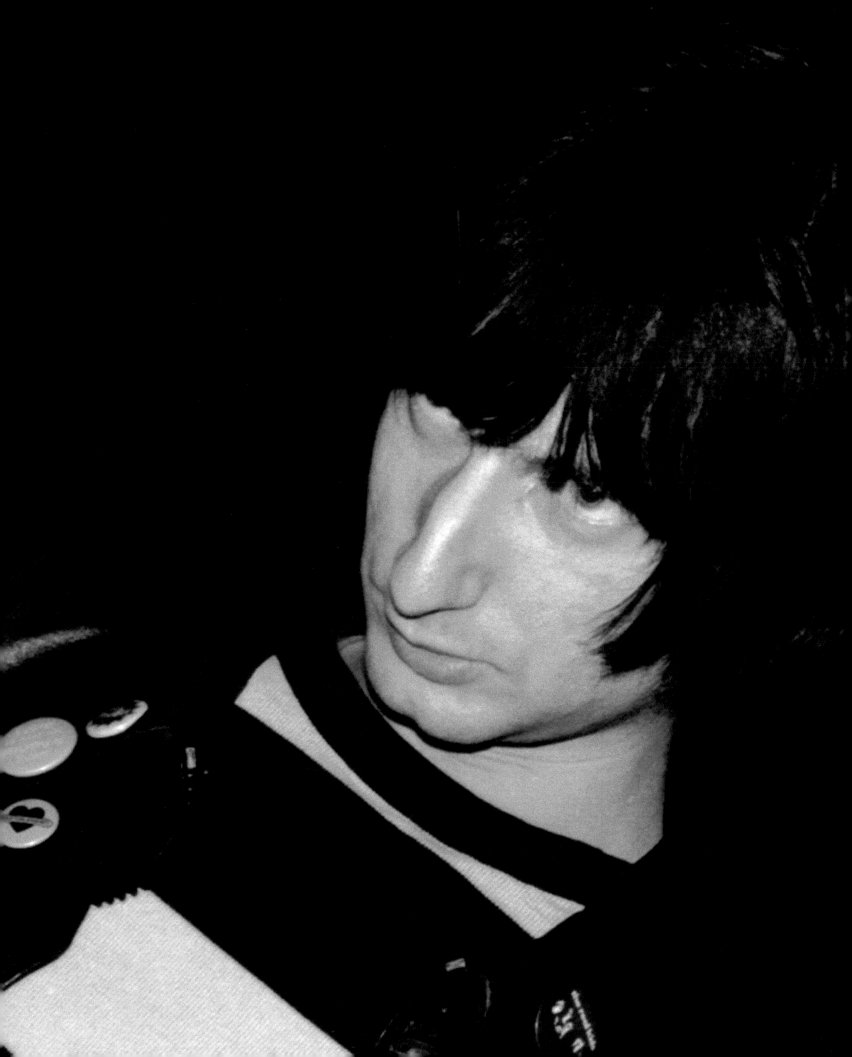

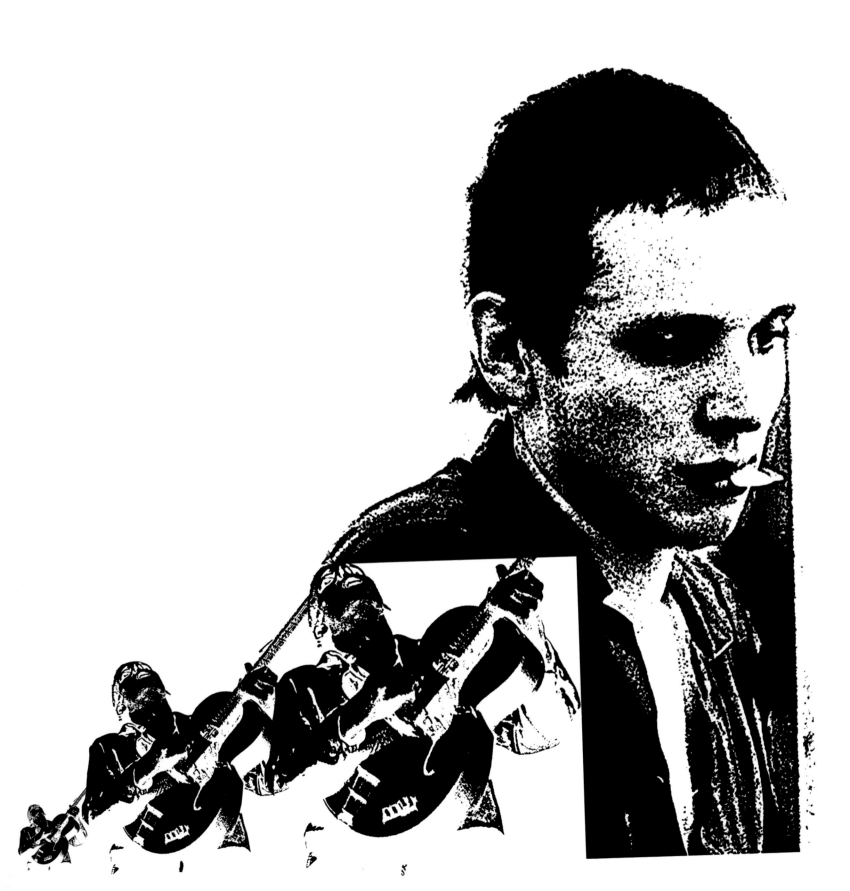

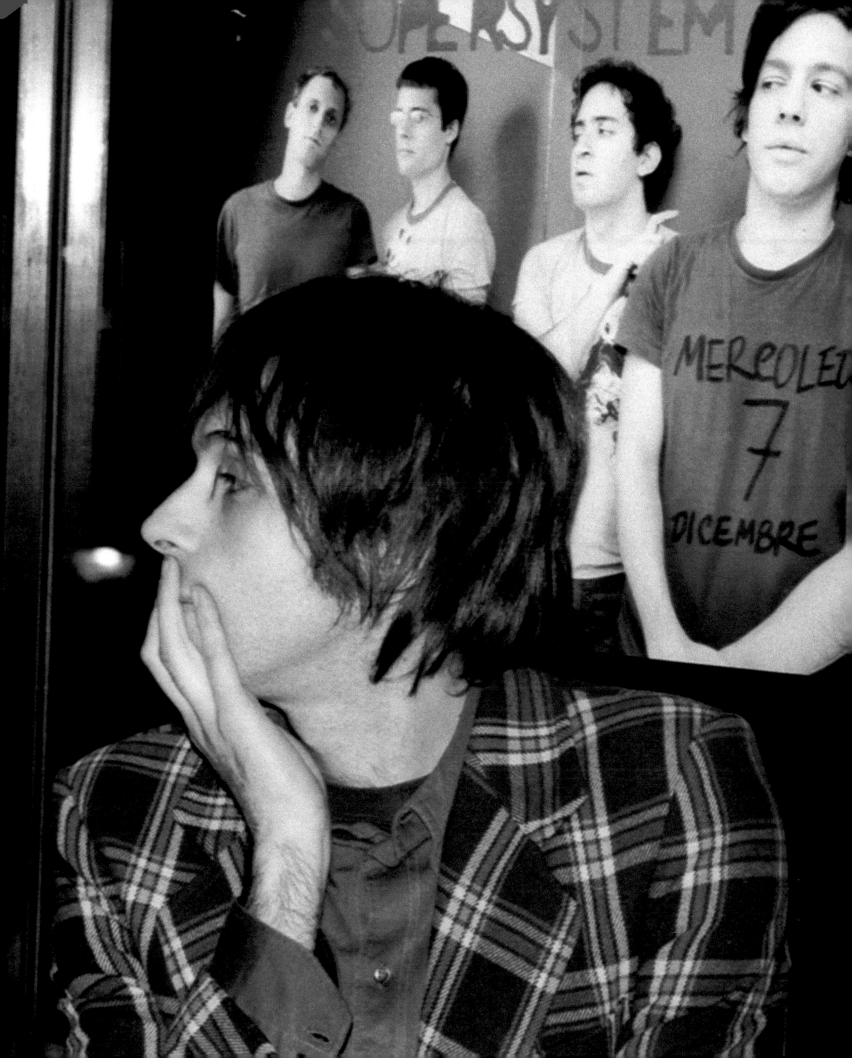

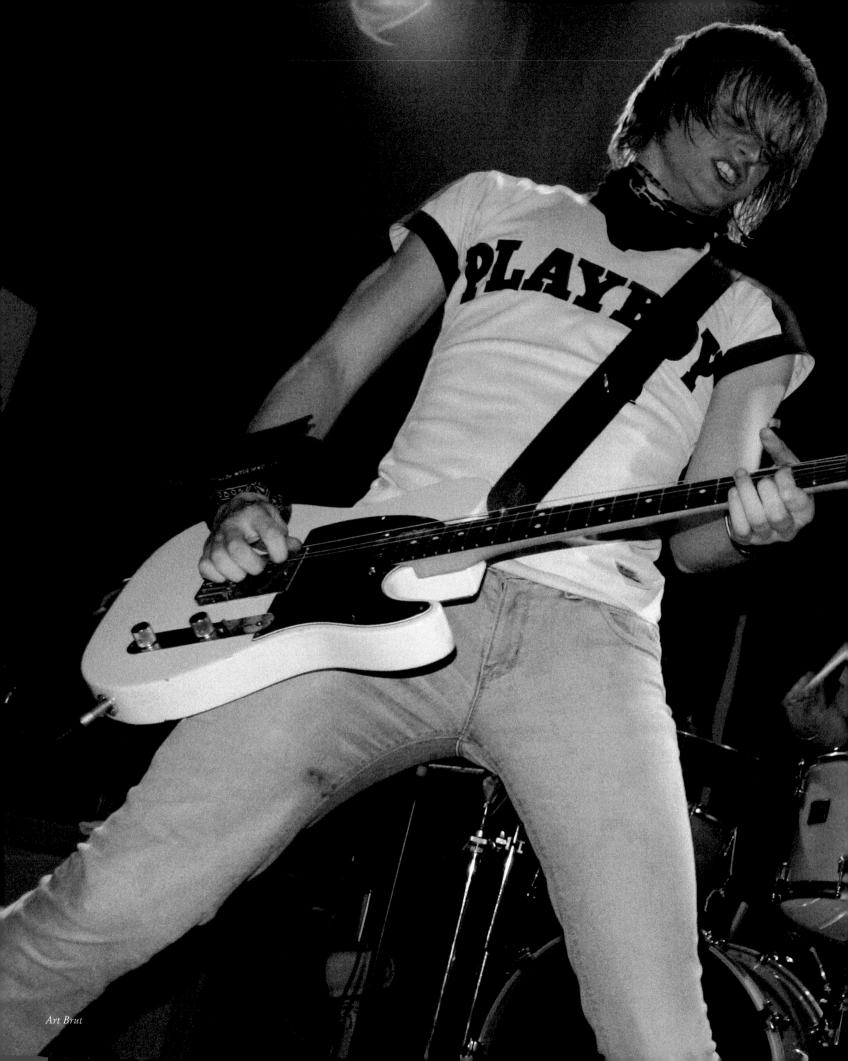

Art Brut

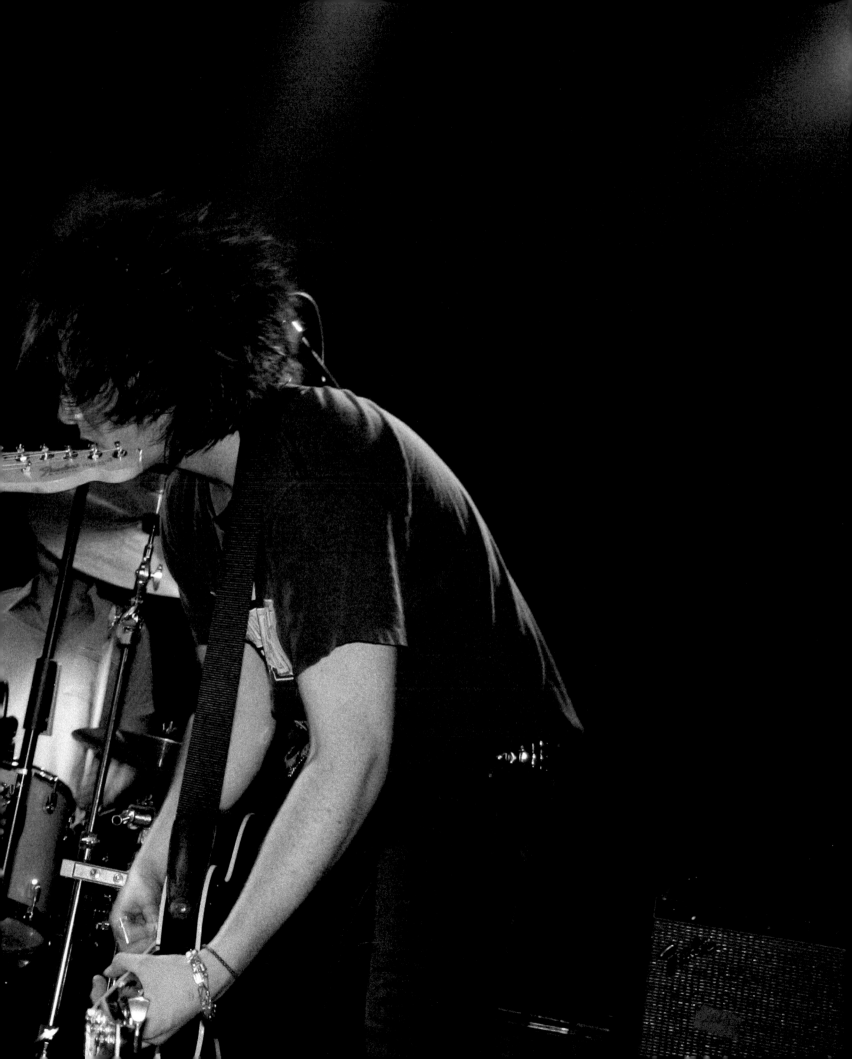

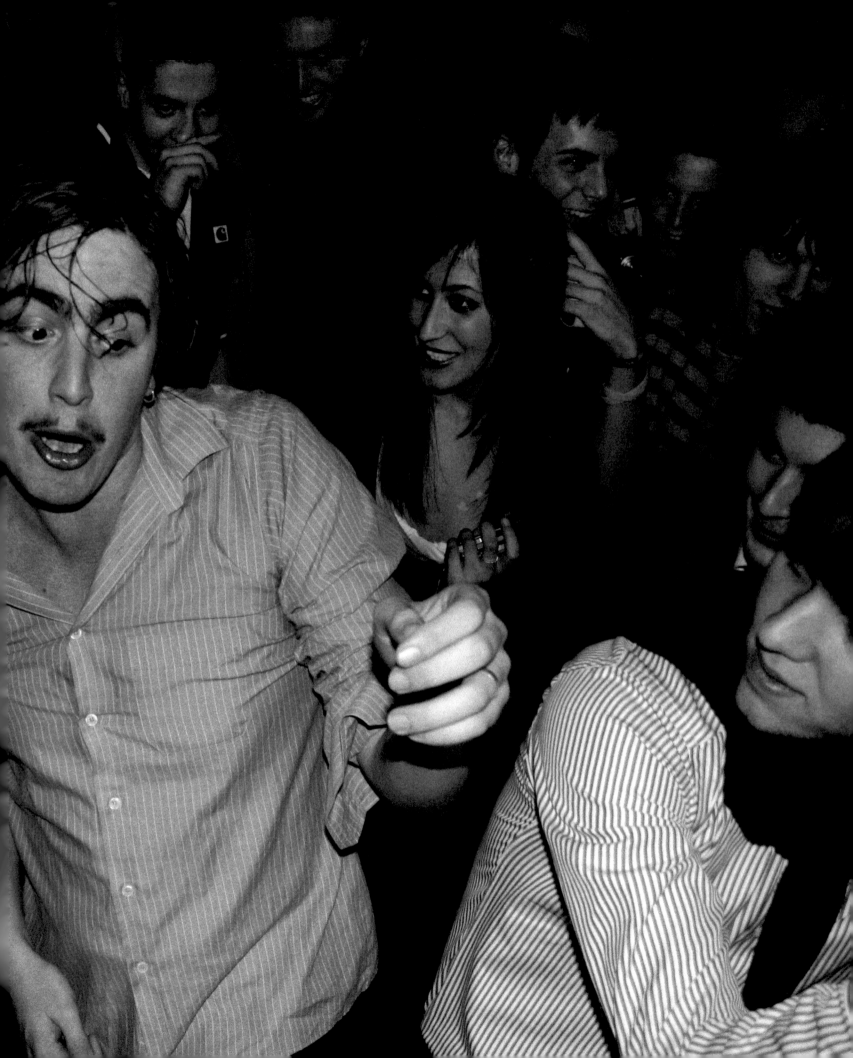

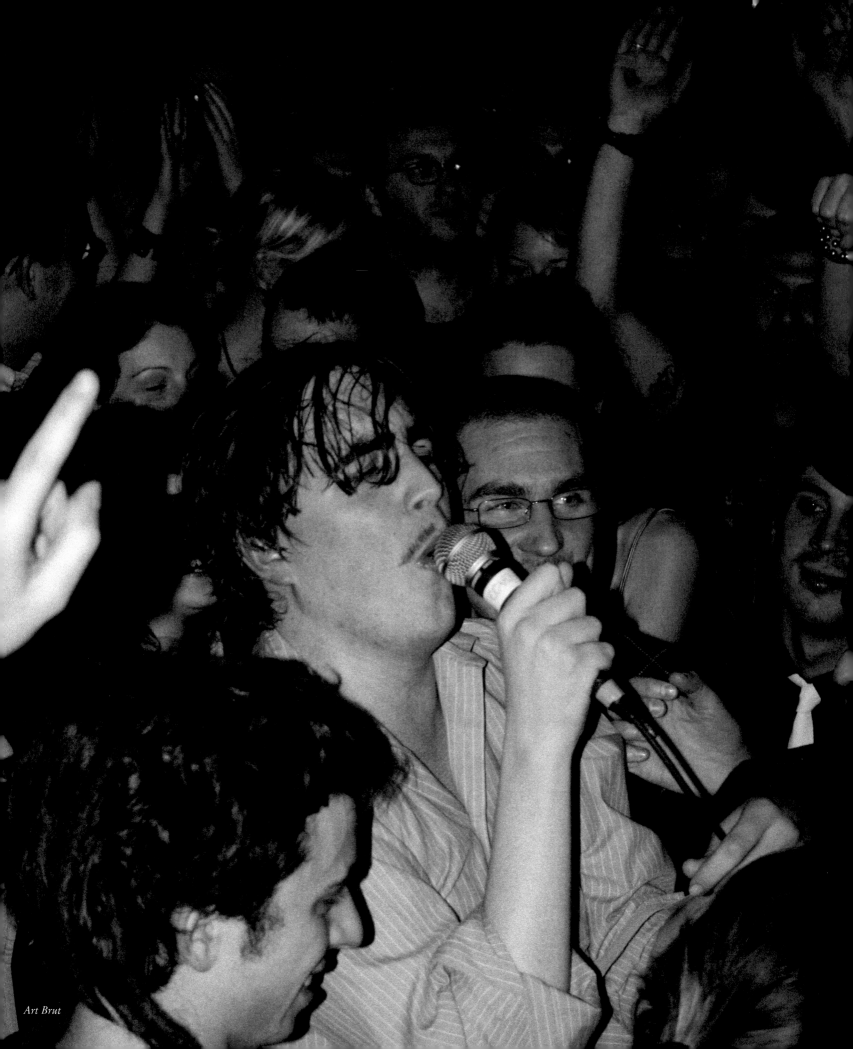

Art Brut

local black death metalcore

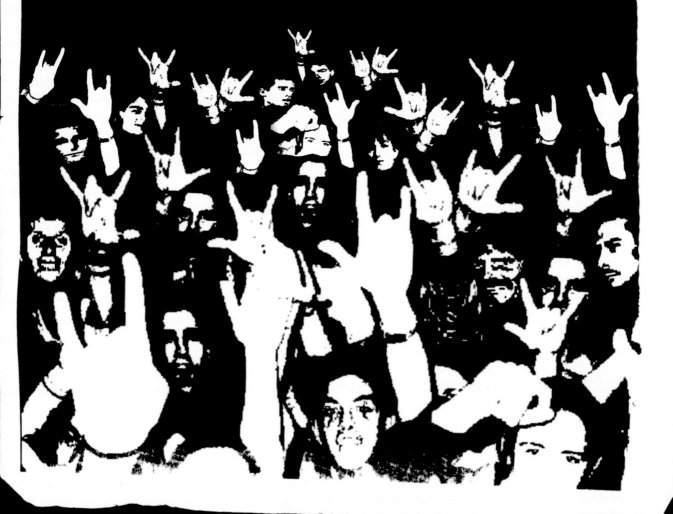

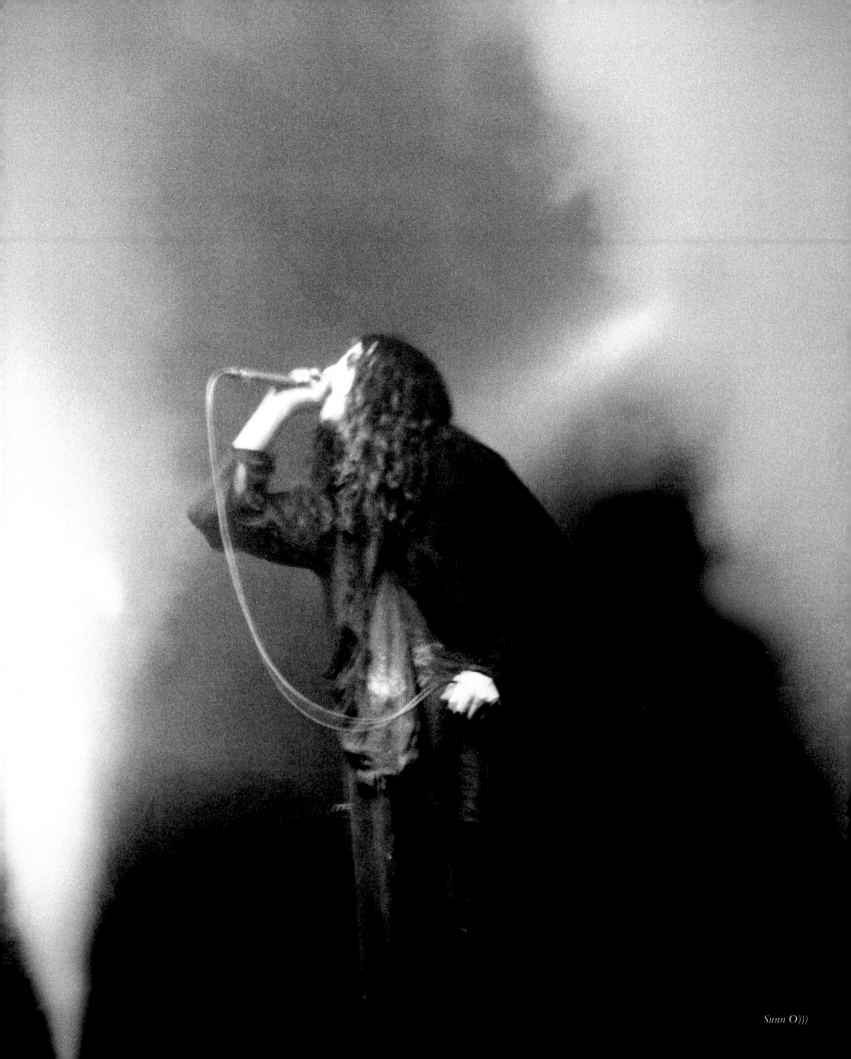

Sunn O)))

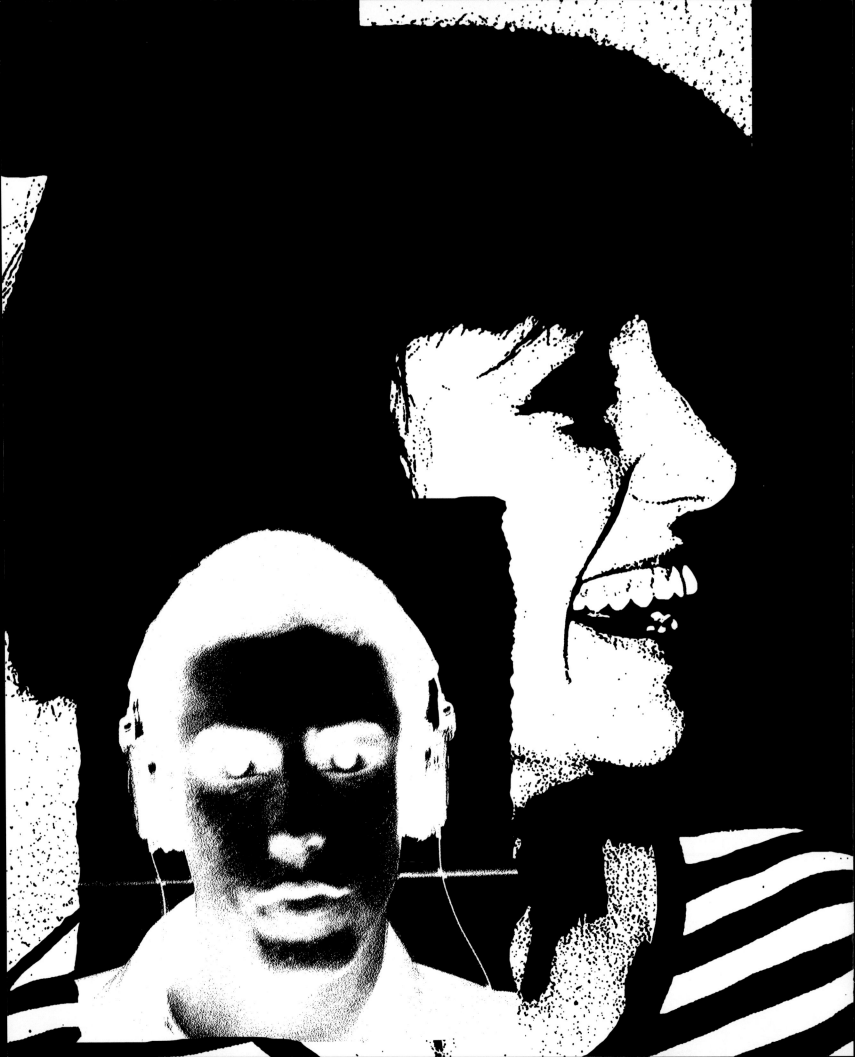

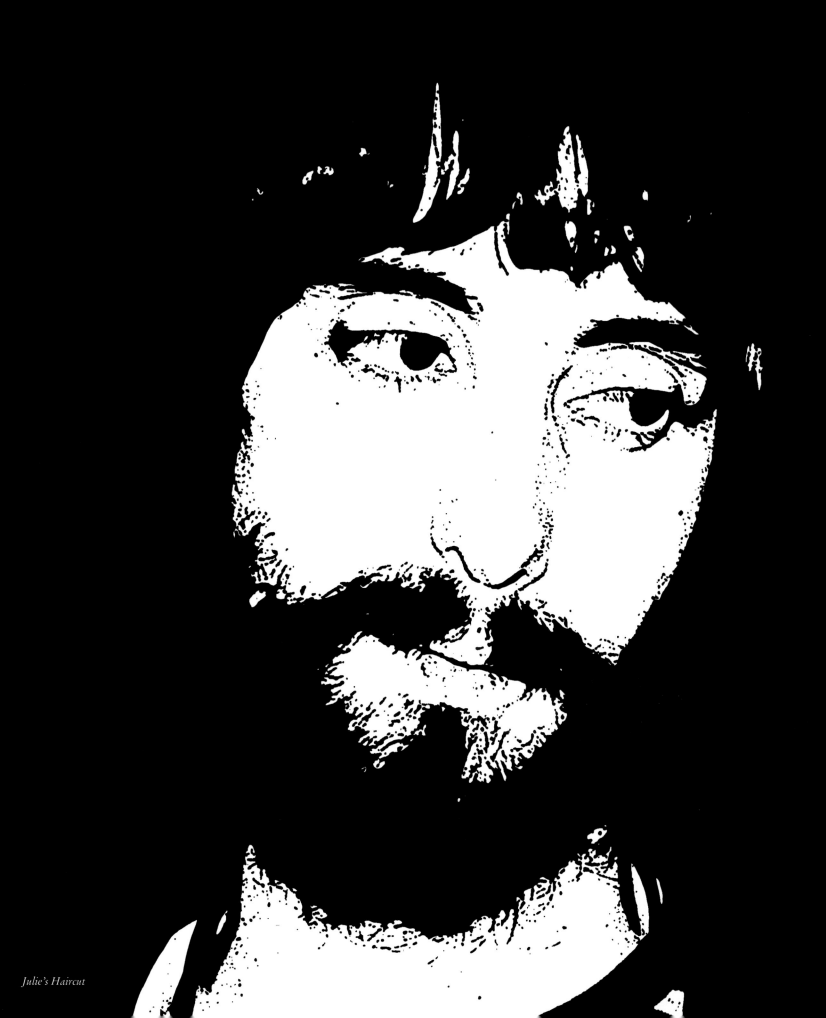

Julie's Haircut

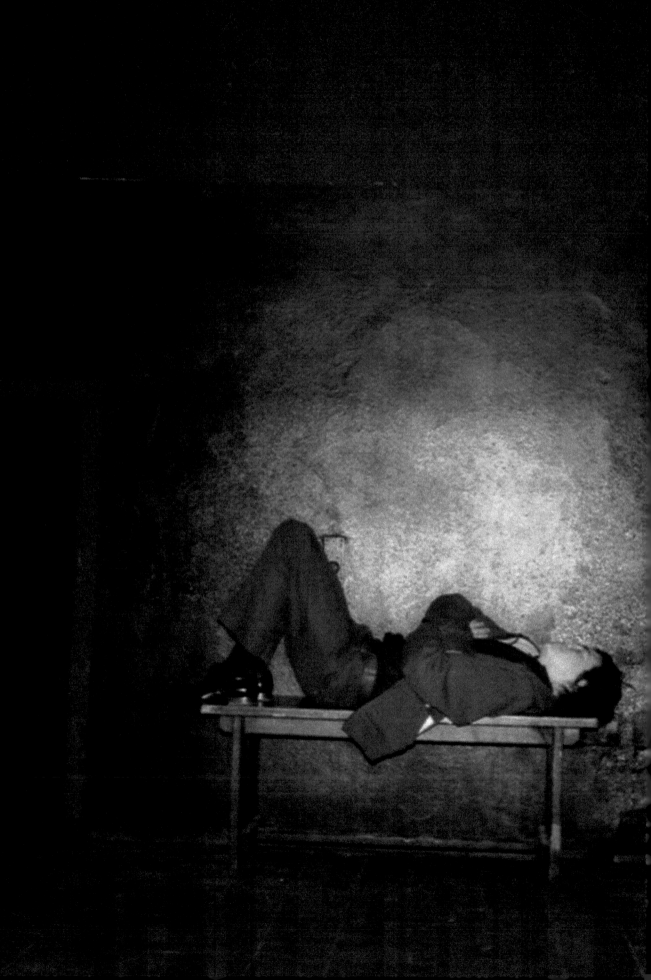

Boxer Rebellion

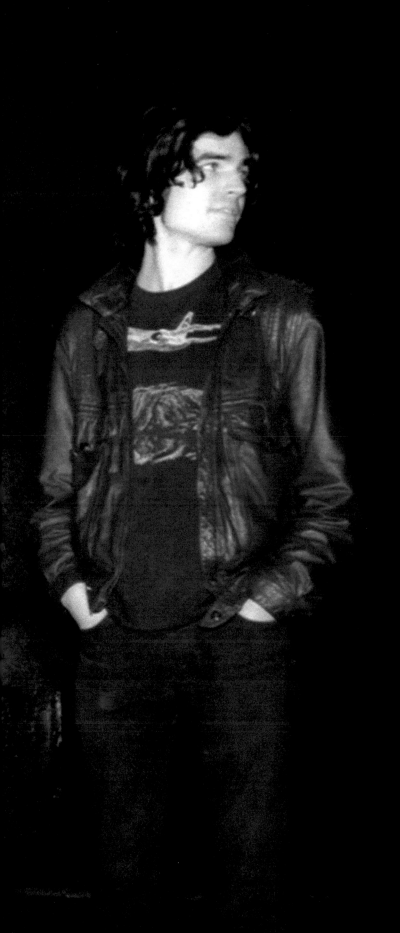

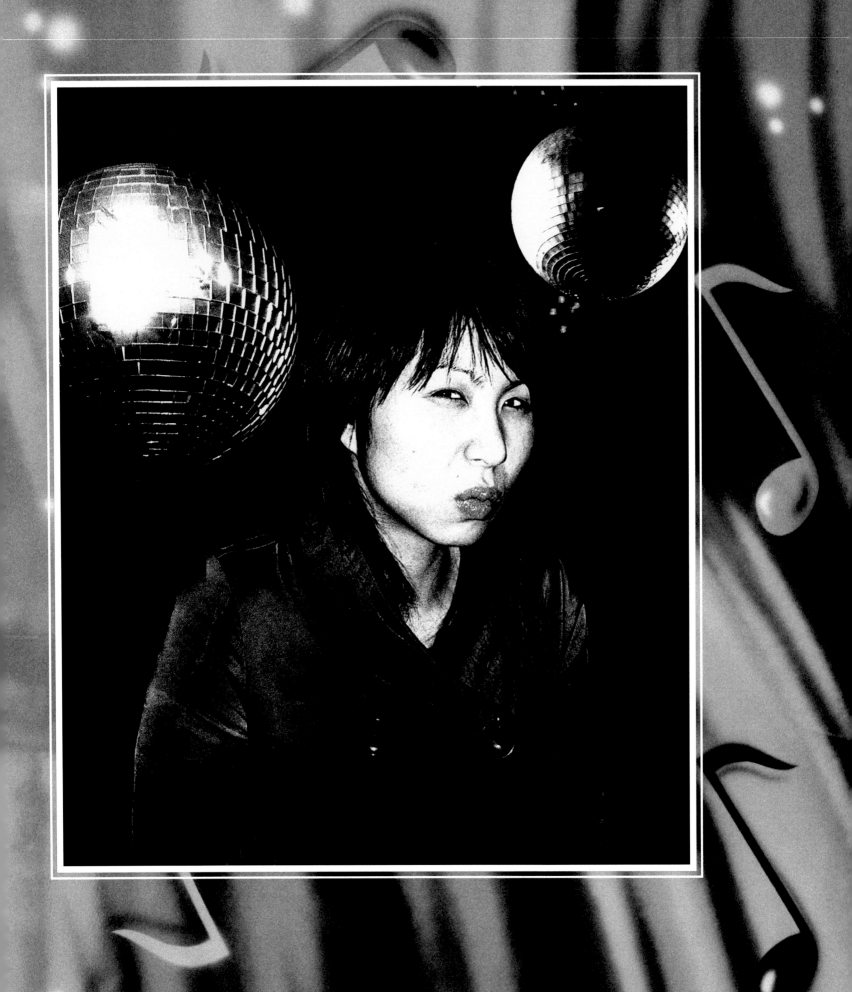

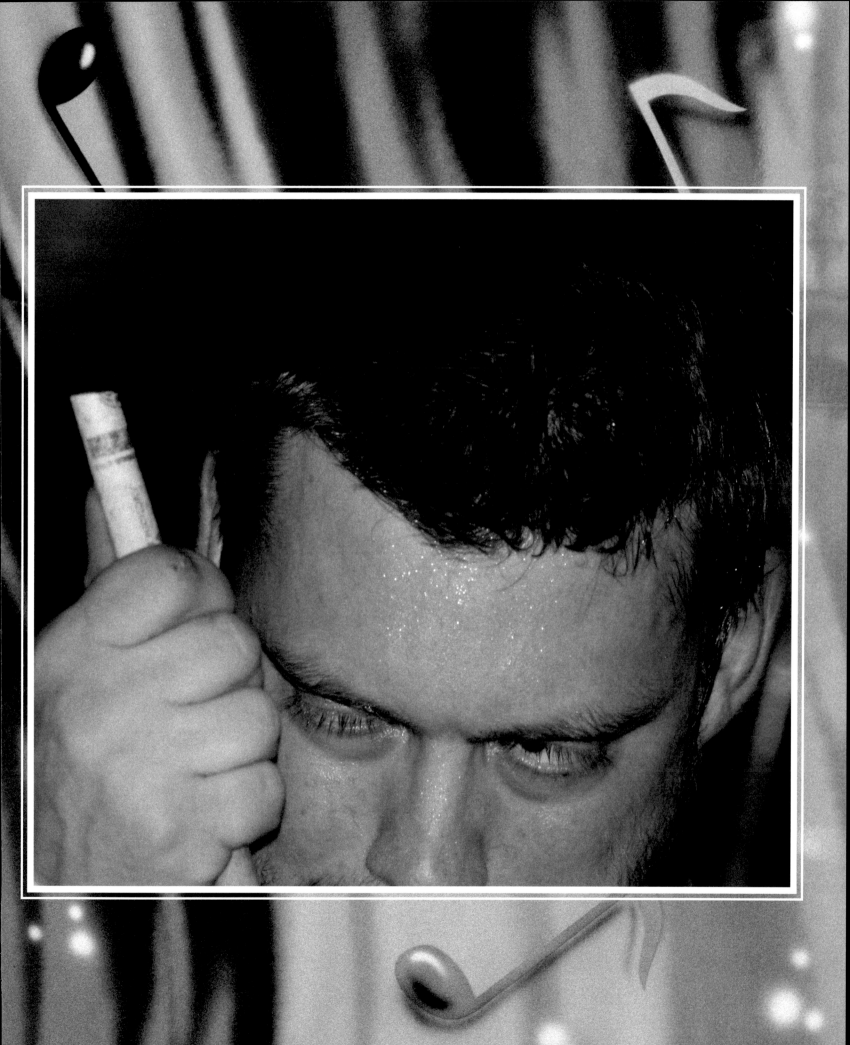

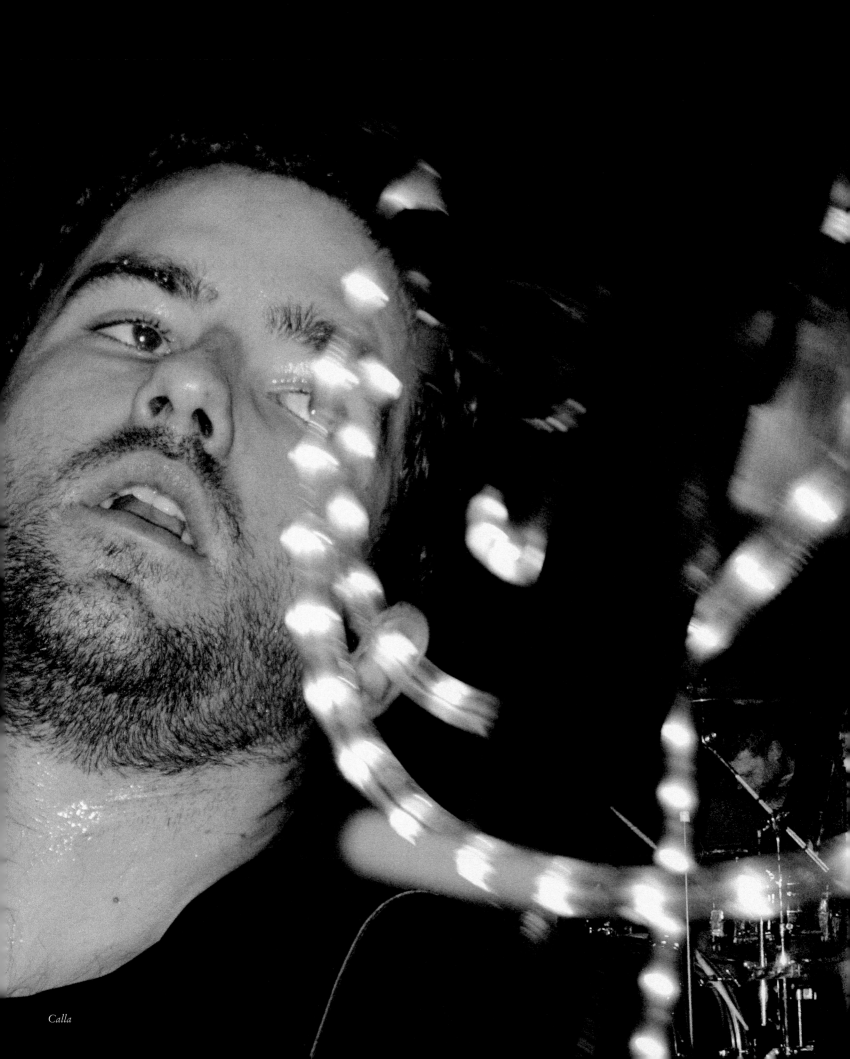

Calla

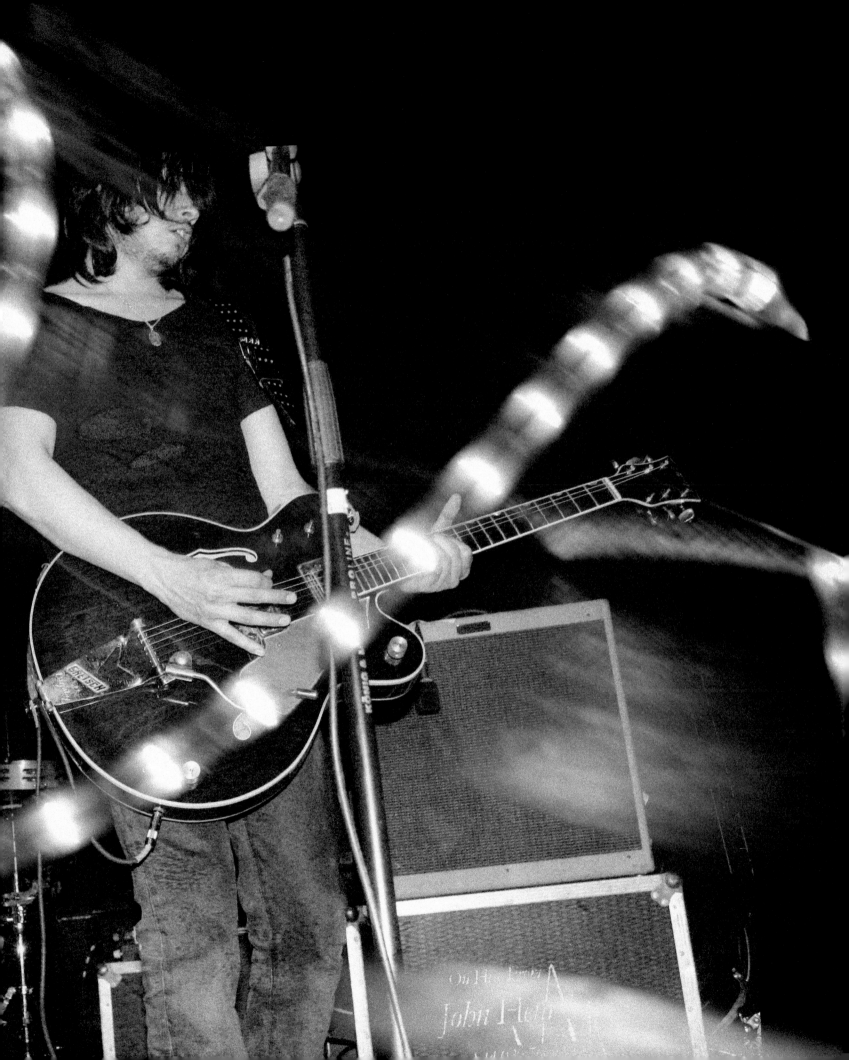

KOLLAPS

In Via Zagabria

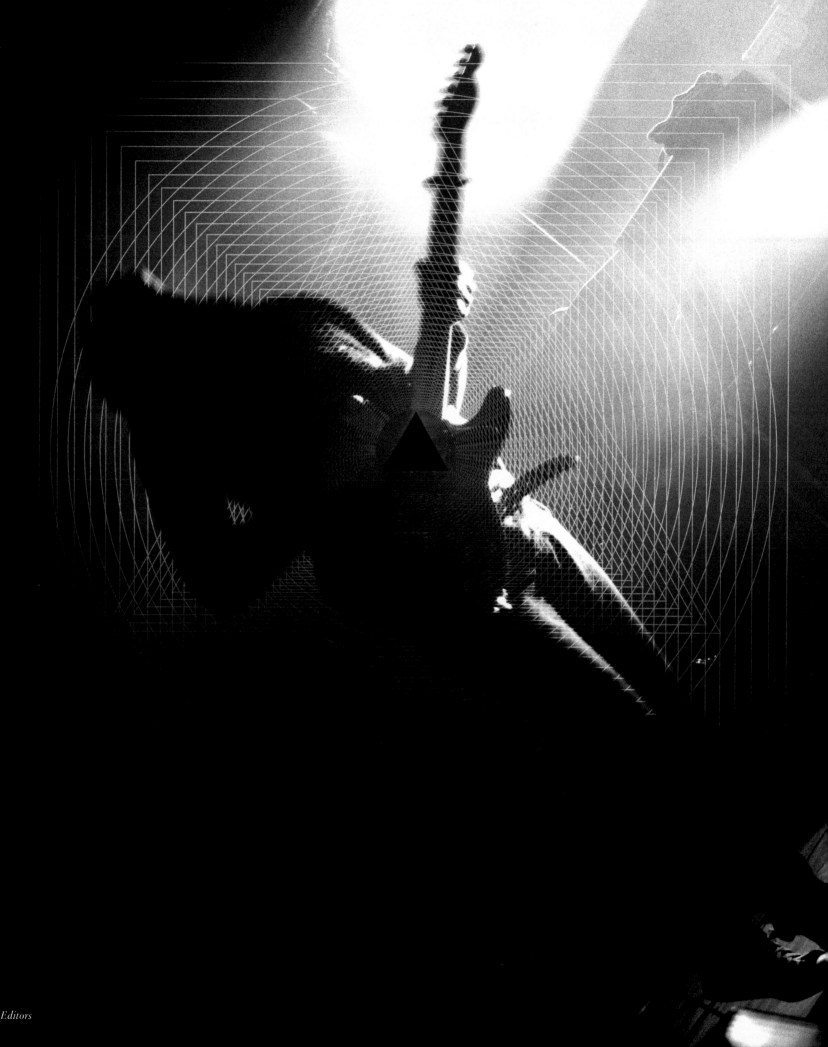

Editors

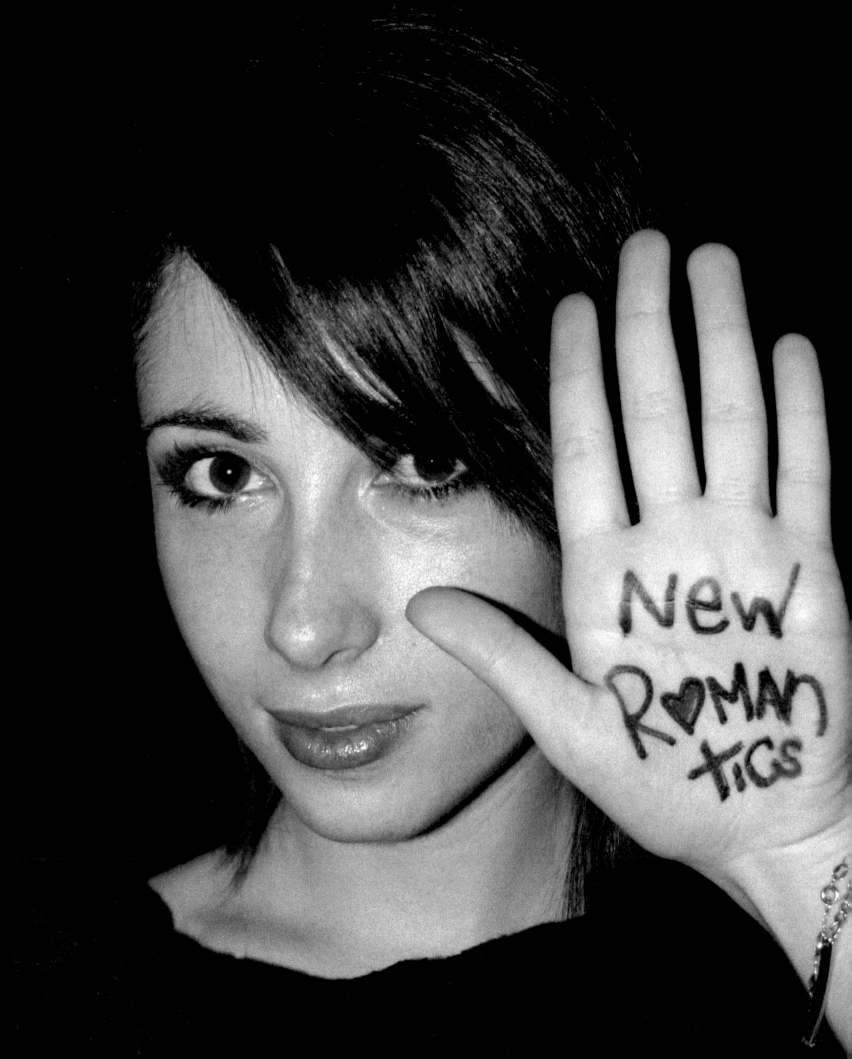

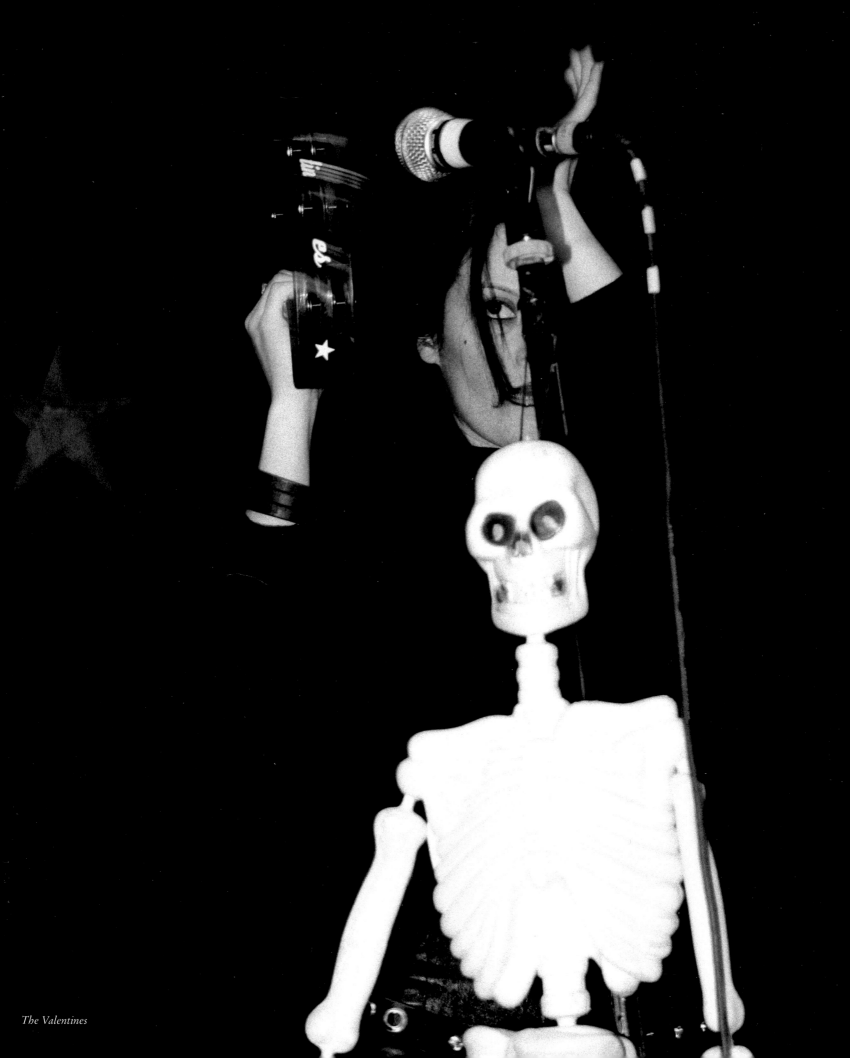

The Valentines

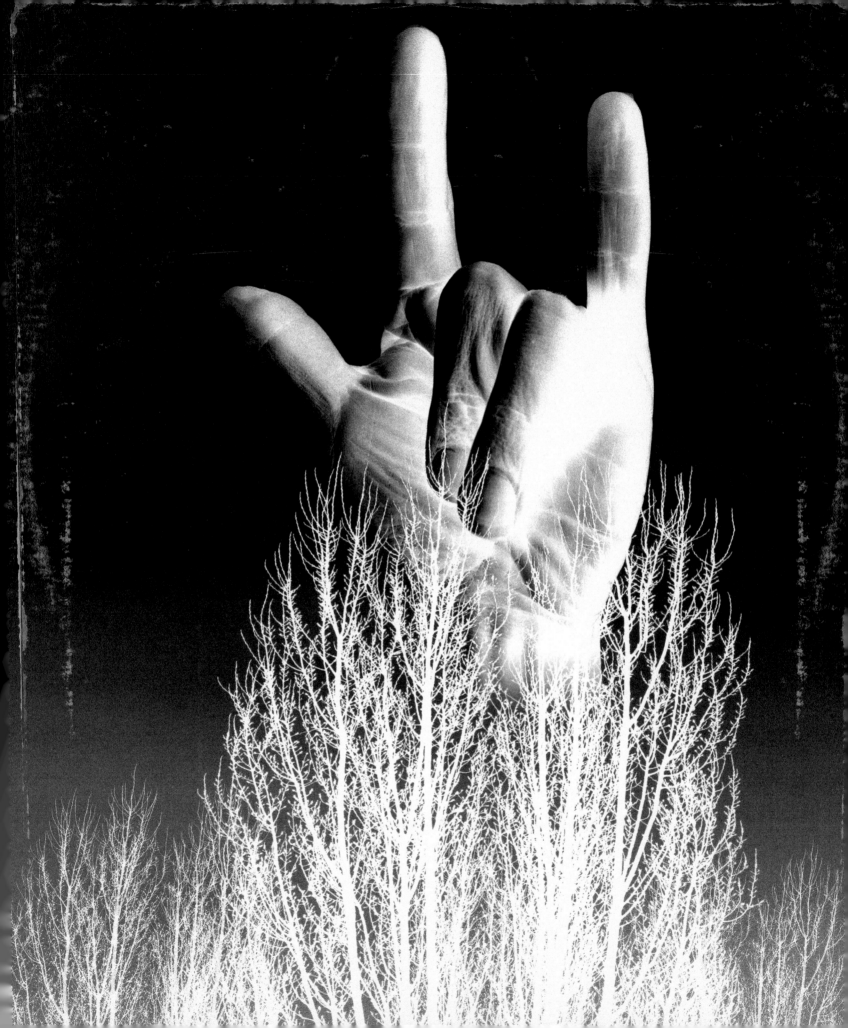

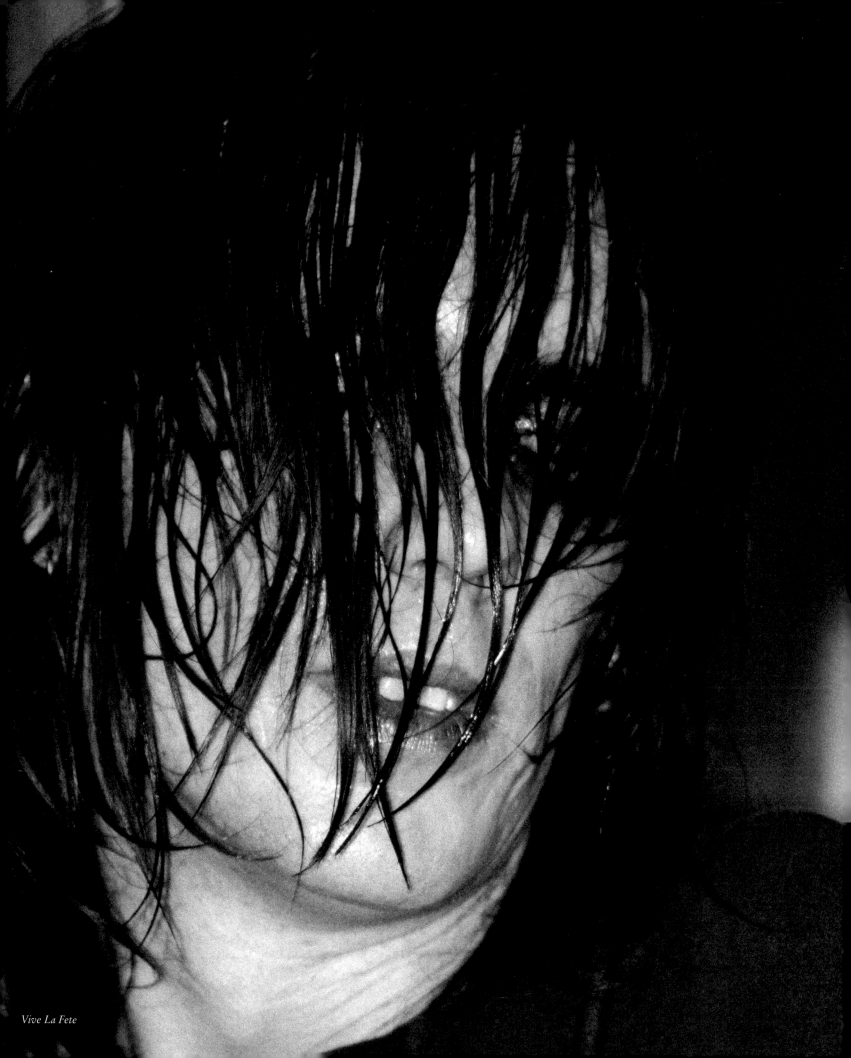

Vive La Fete

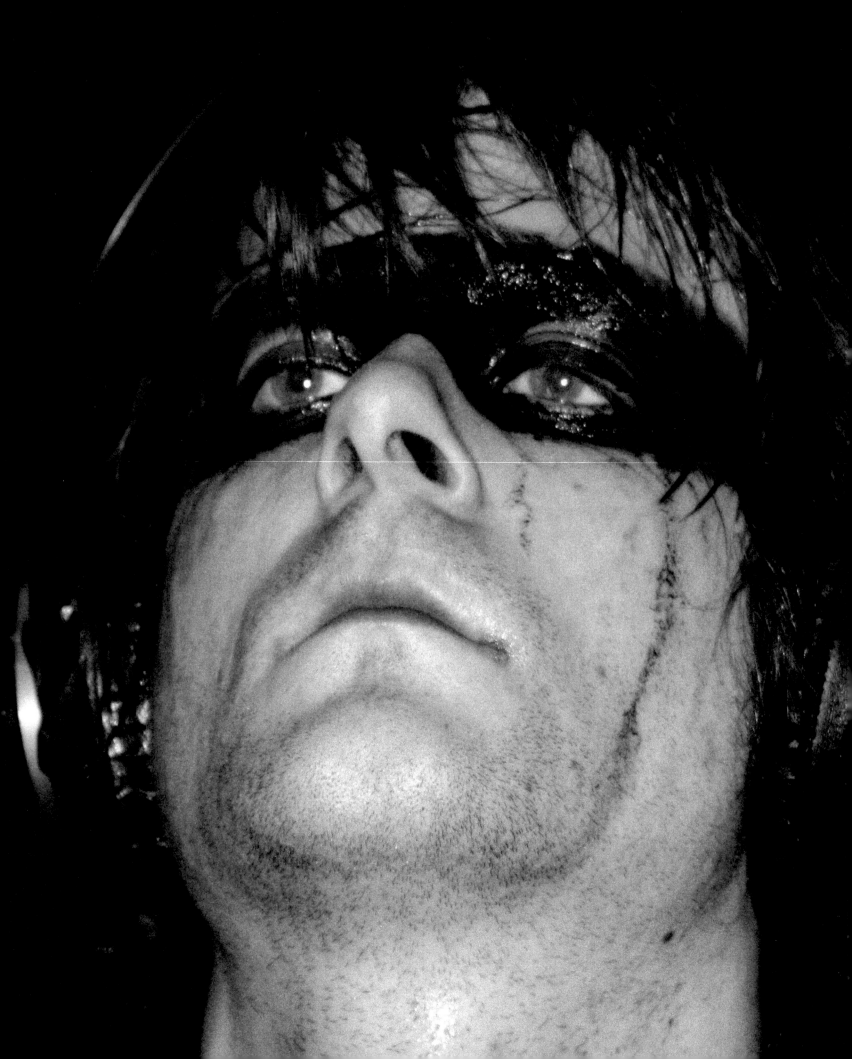

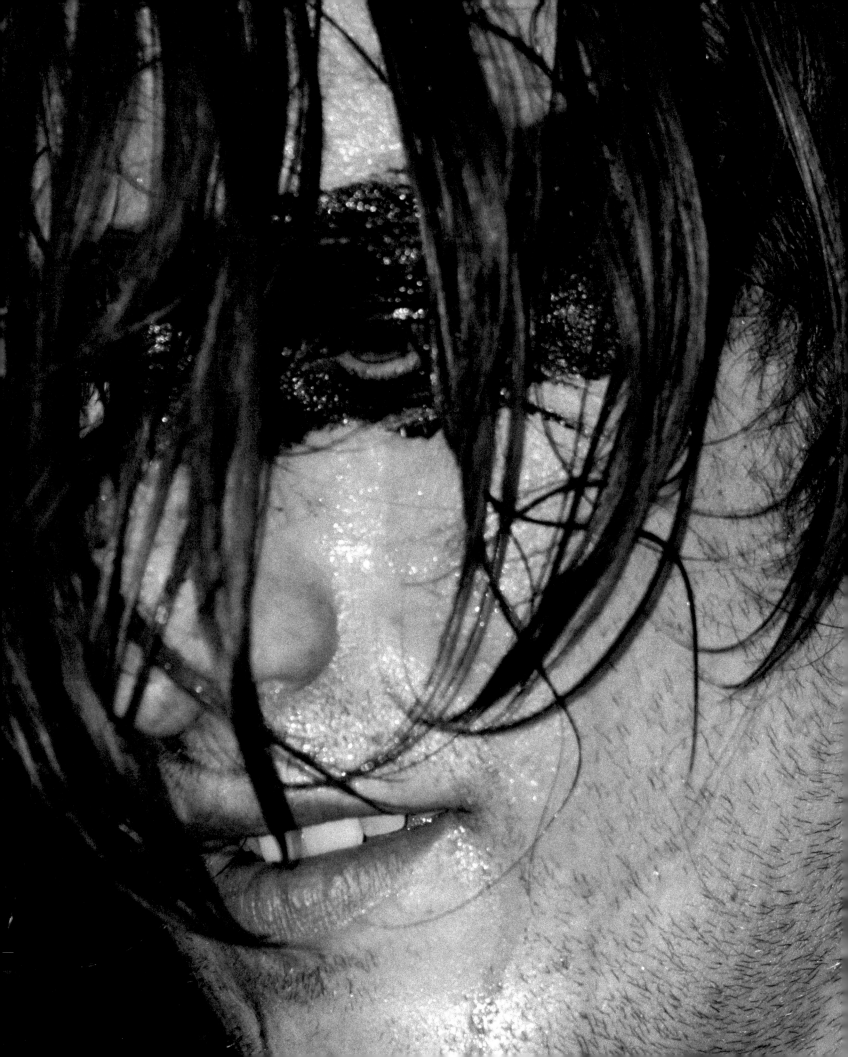

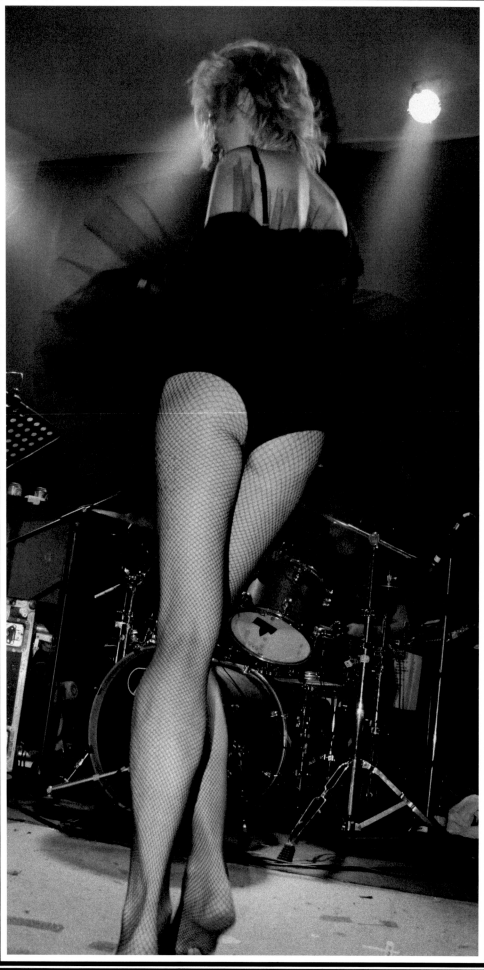

Vive La Fete

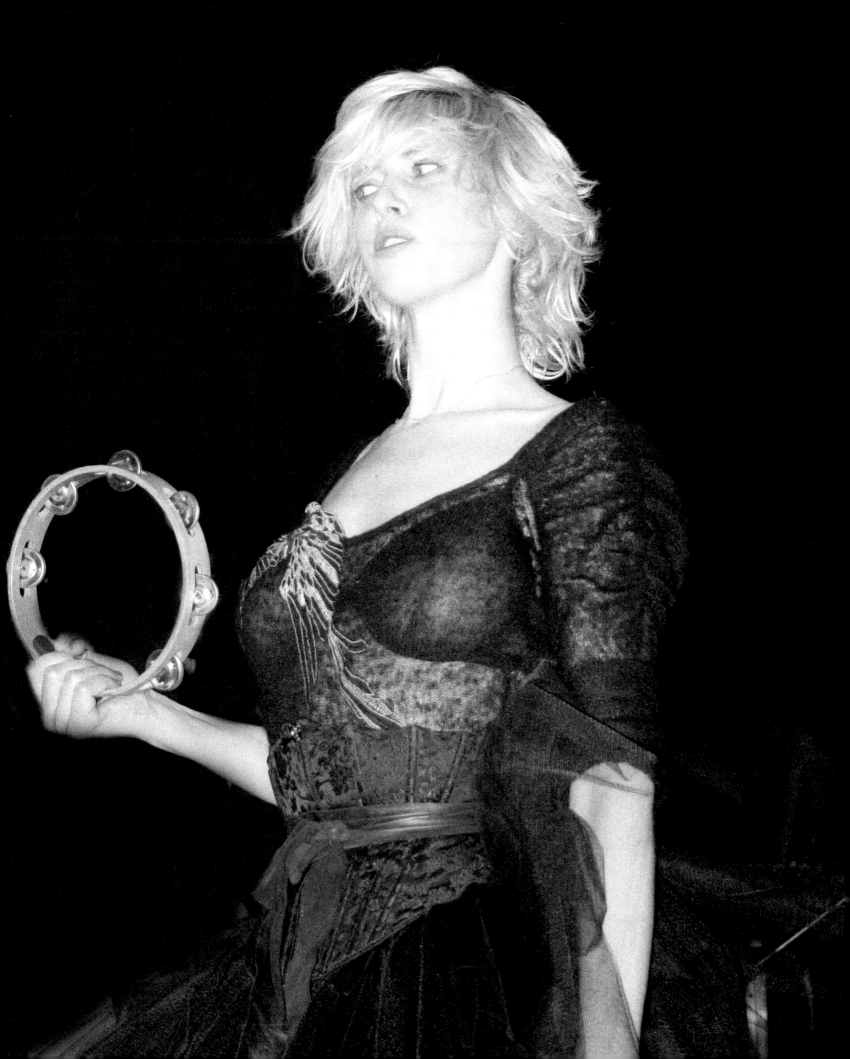

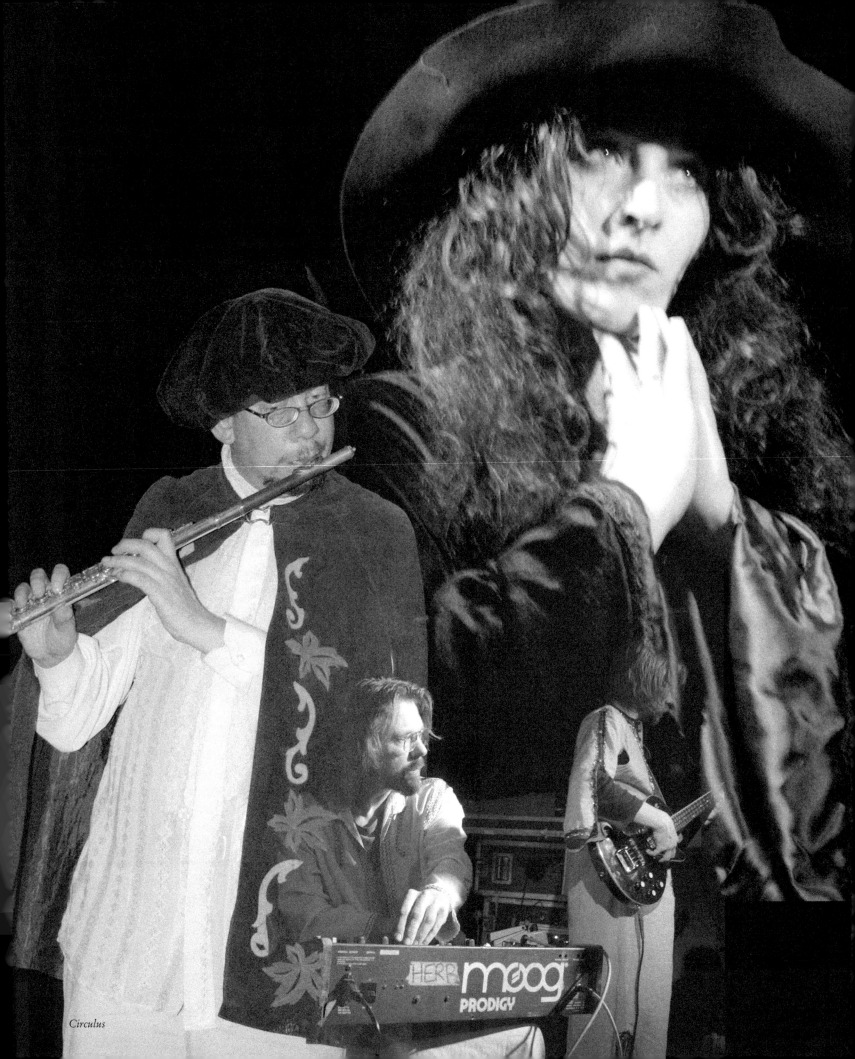

Circulus

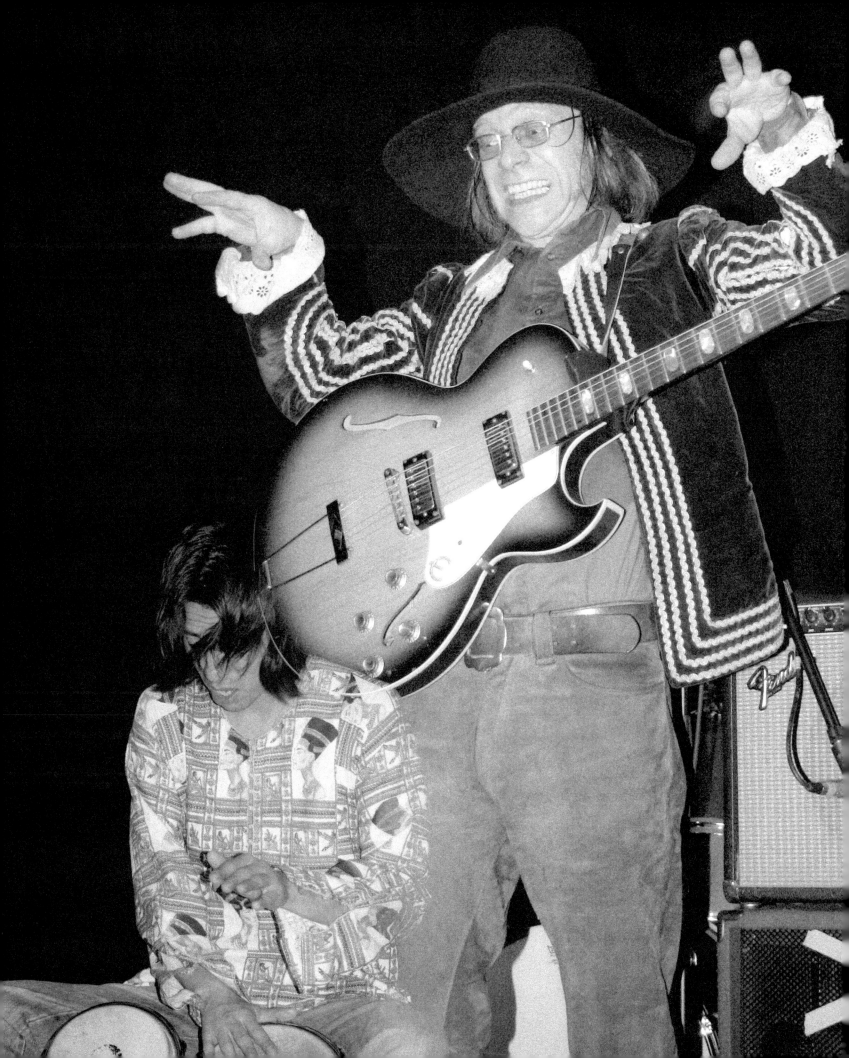

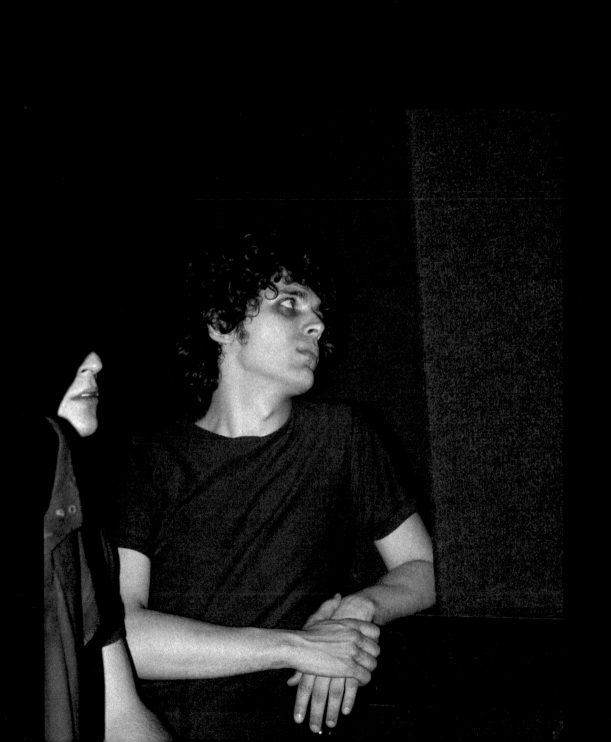

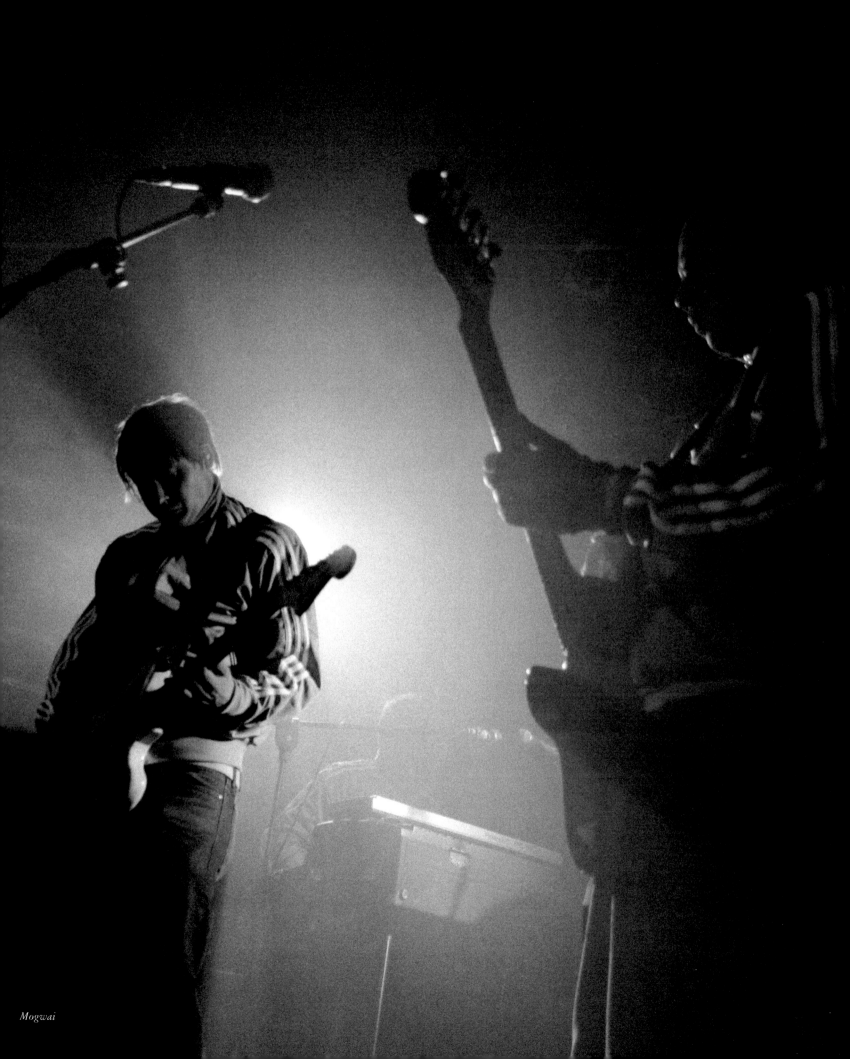

Mogwai

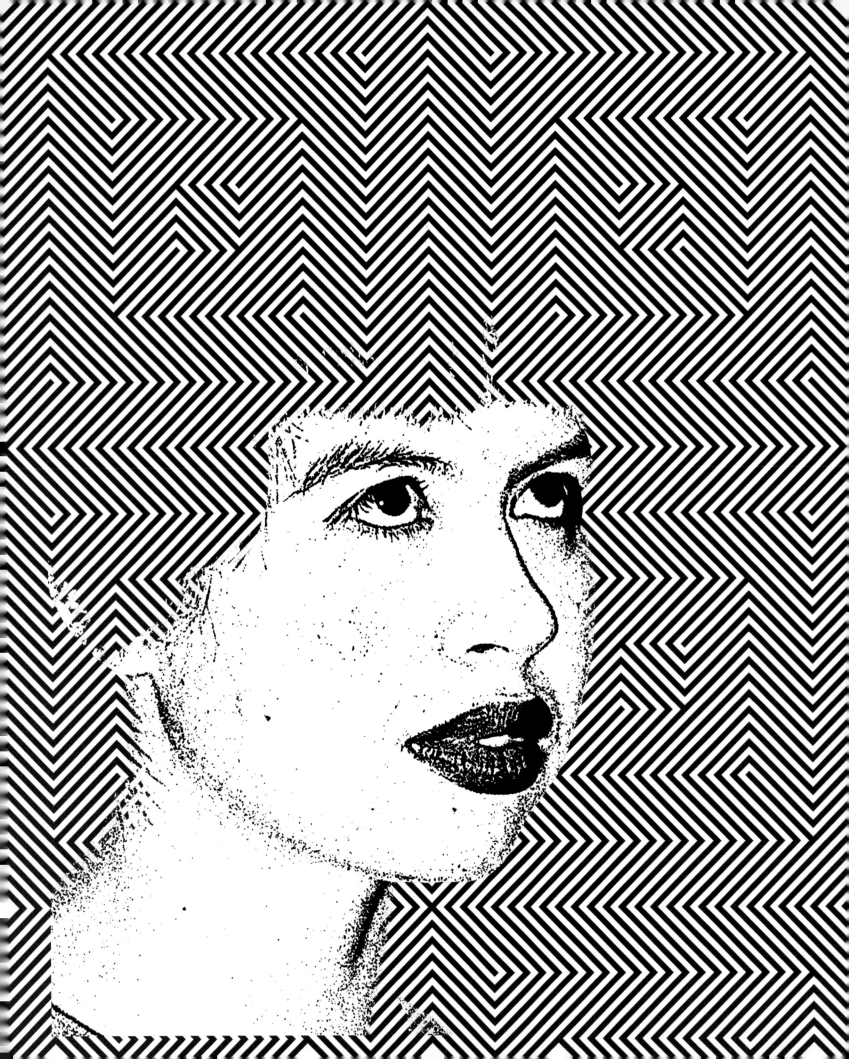

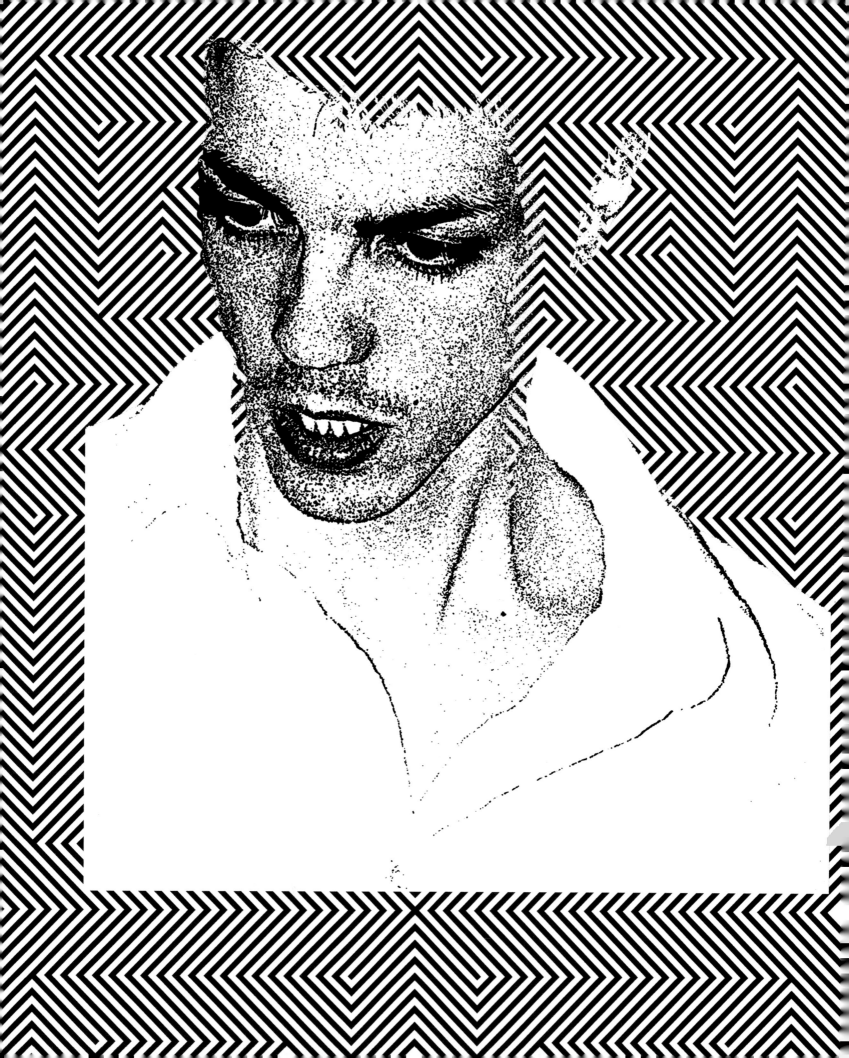

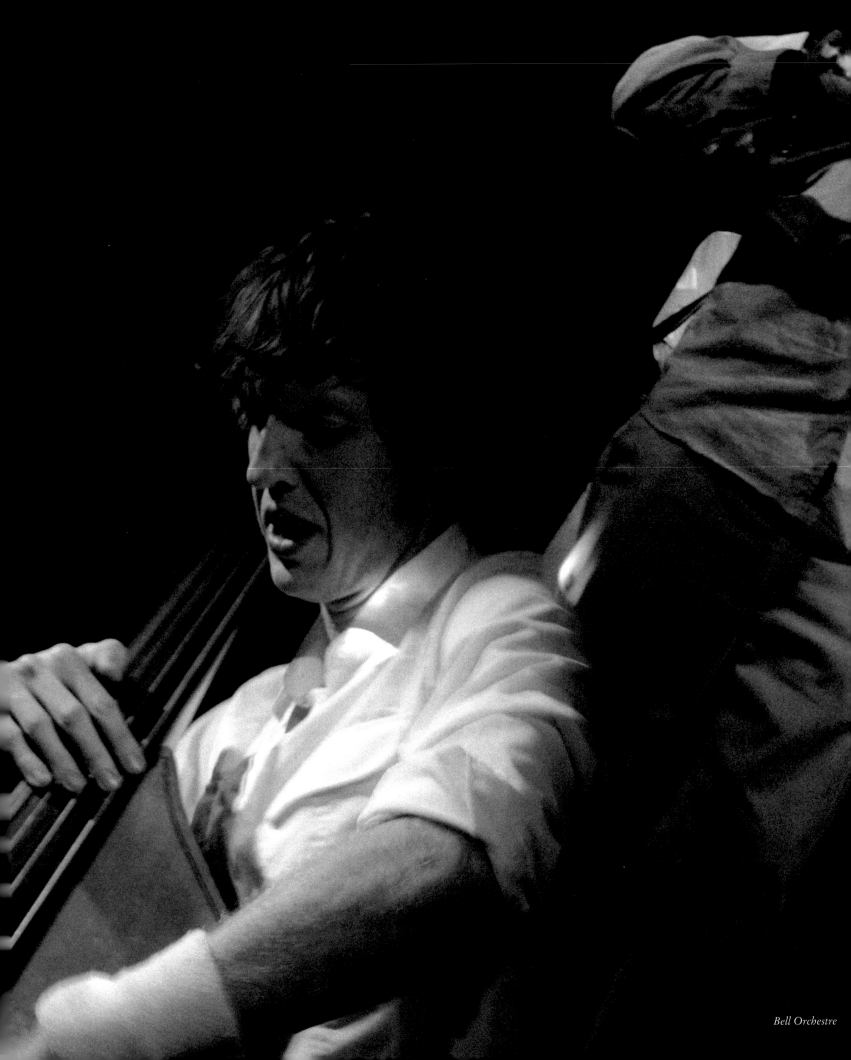

Bell Orchestre

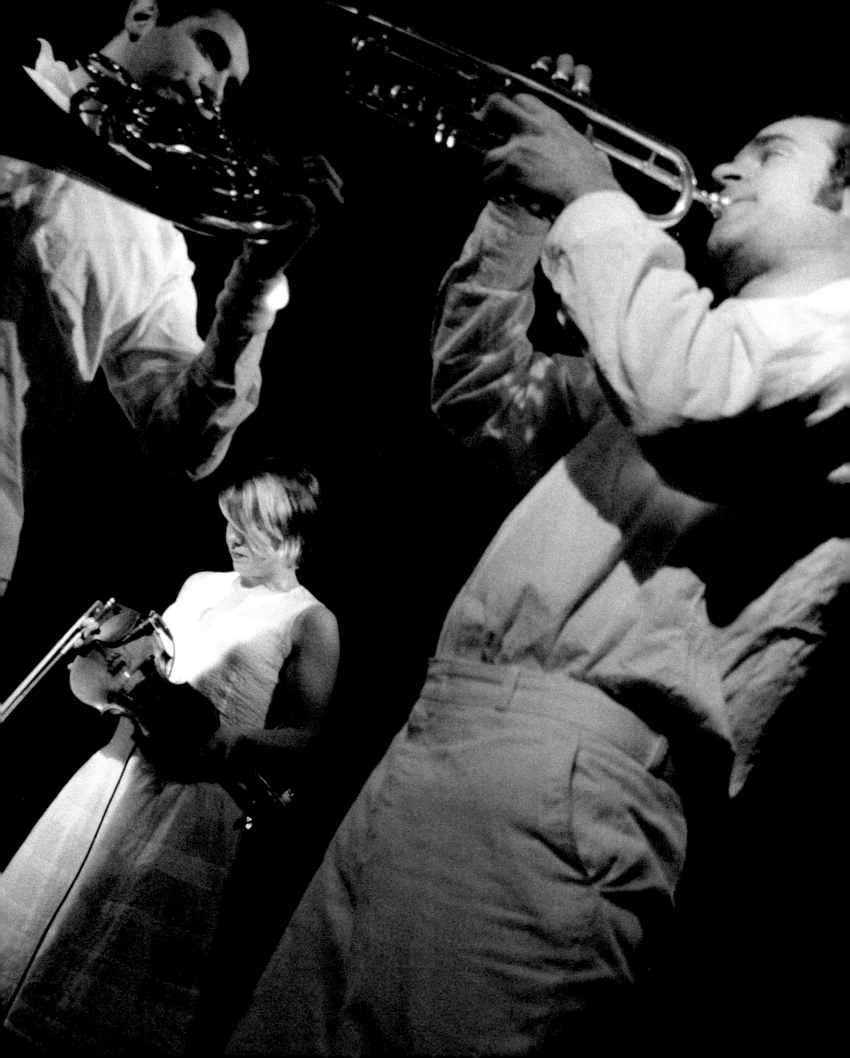

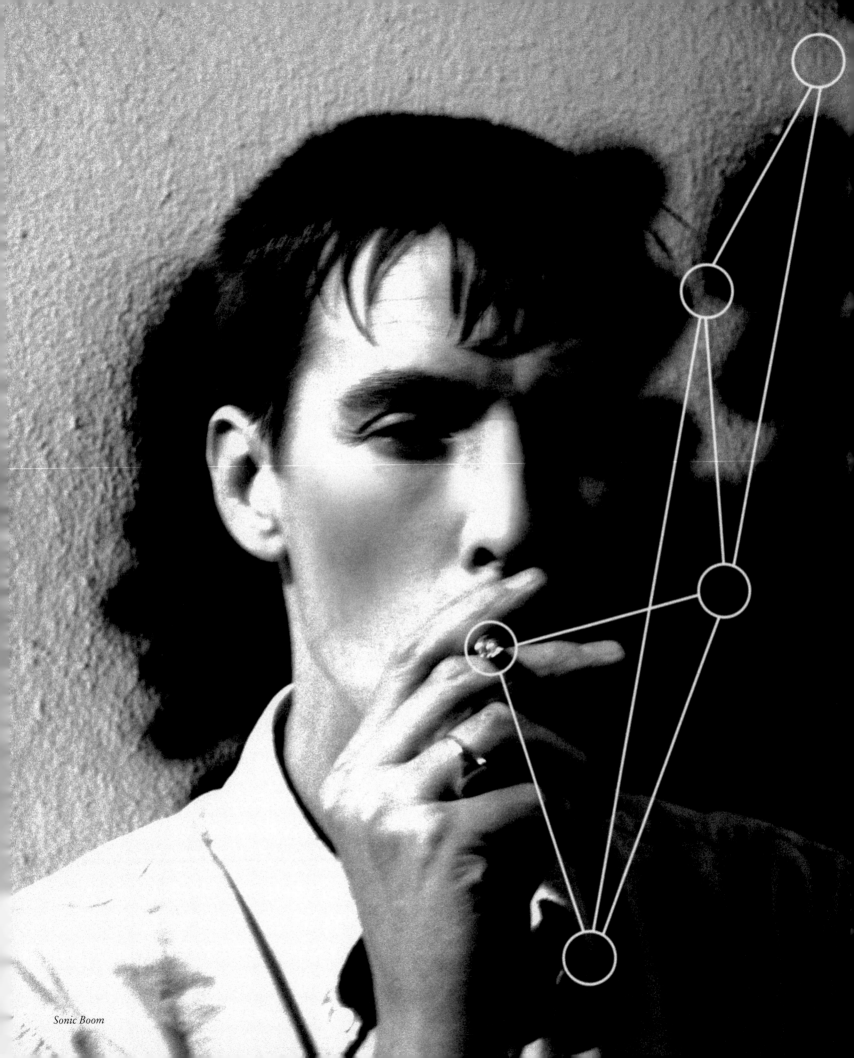

Sonic Boom

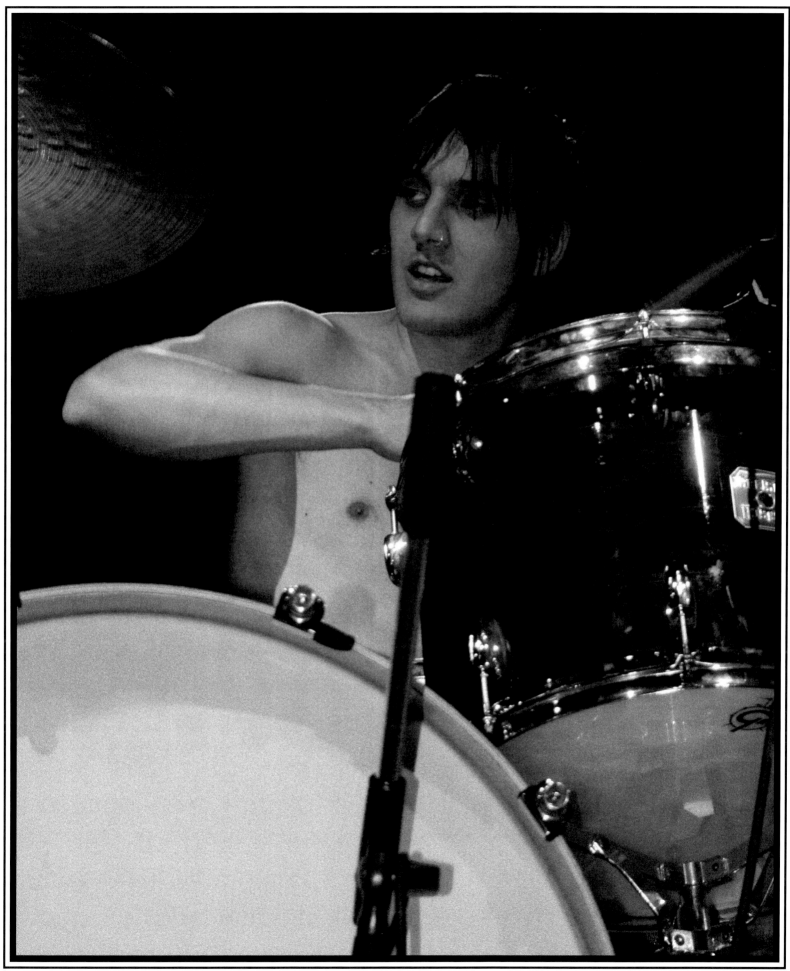

Zen Circus

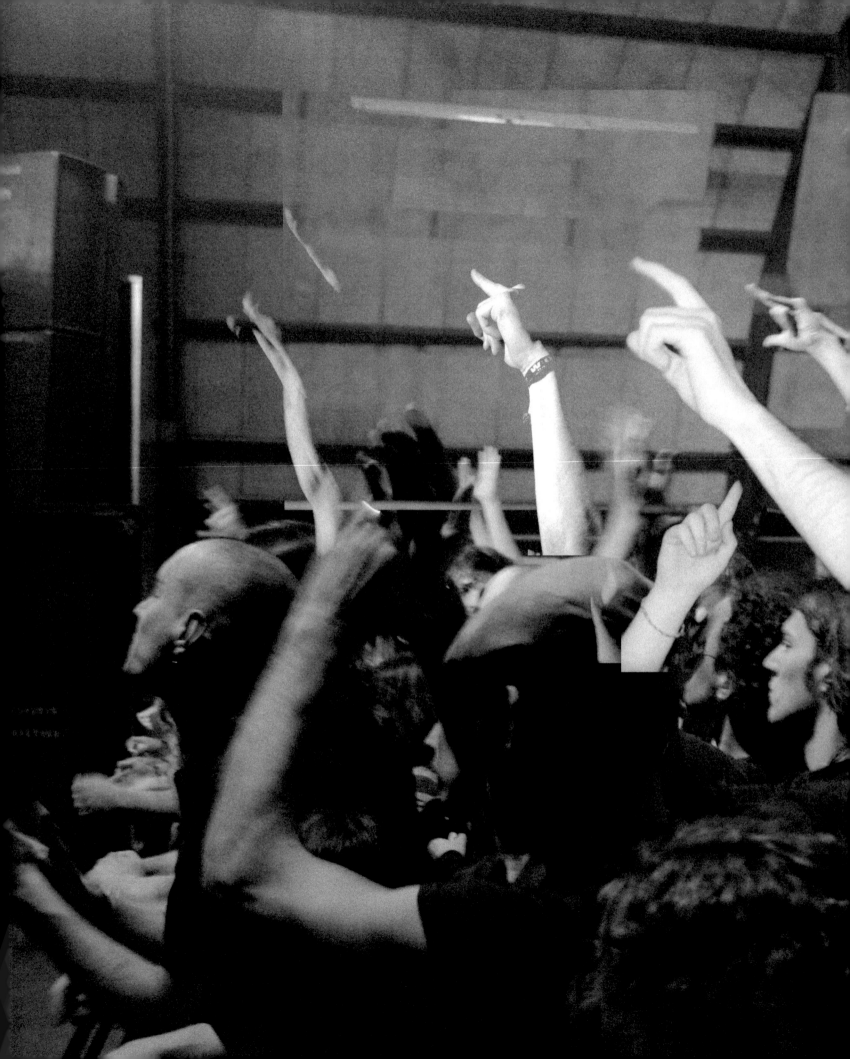

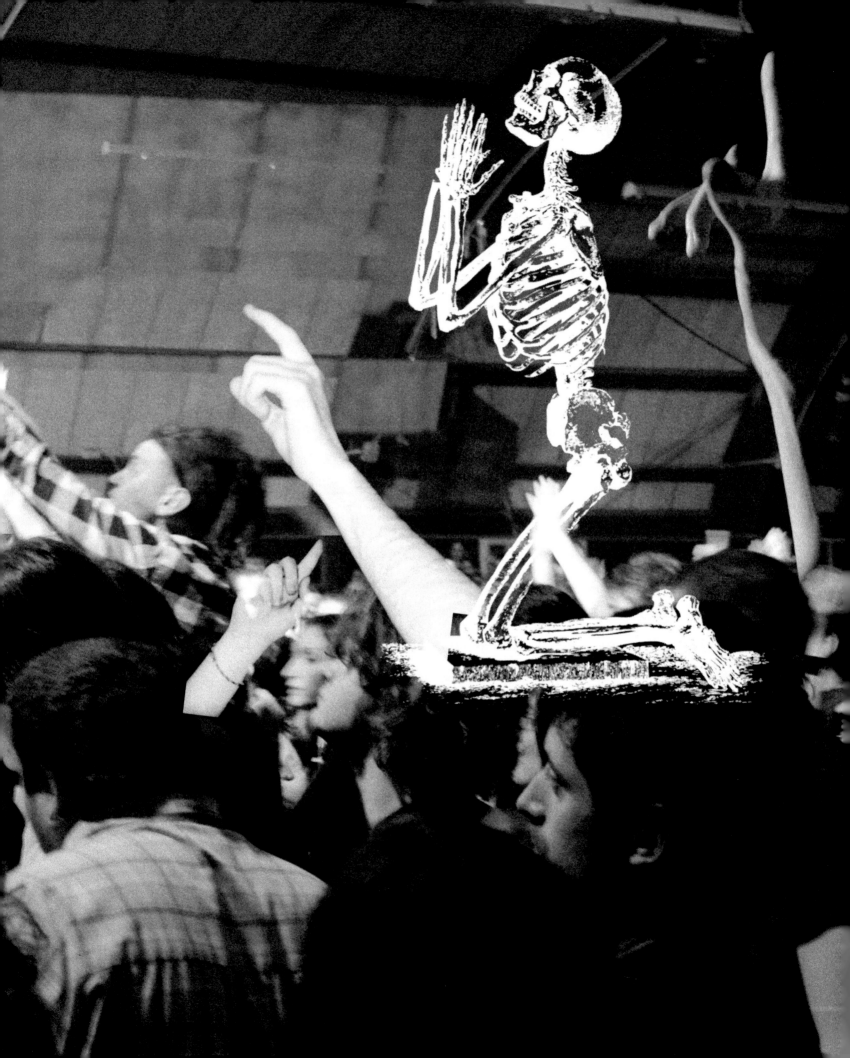

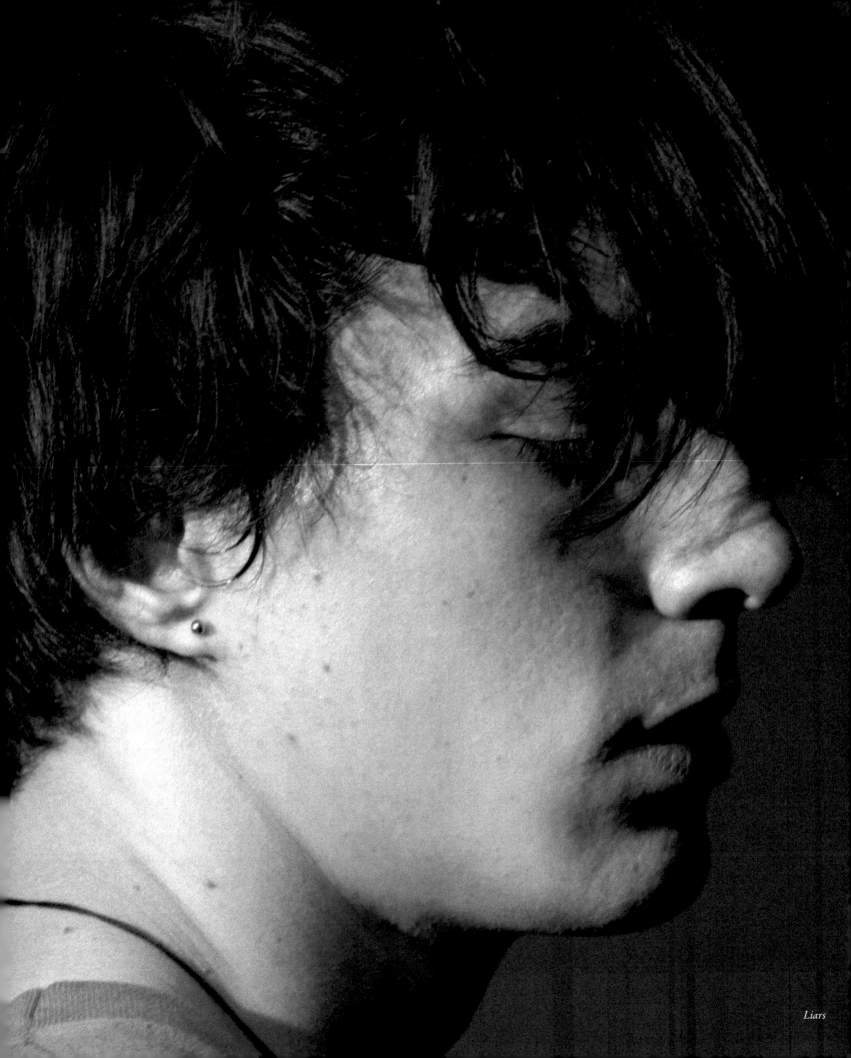

Liars

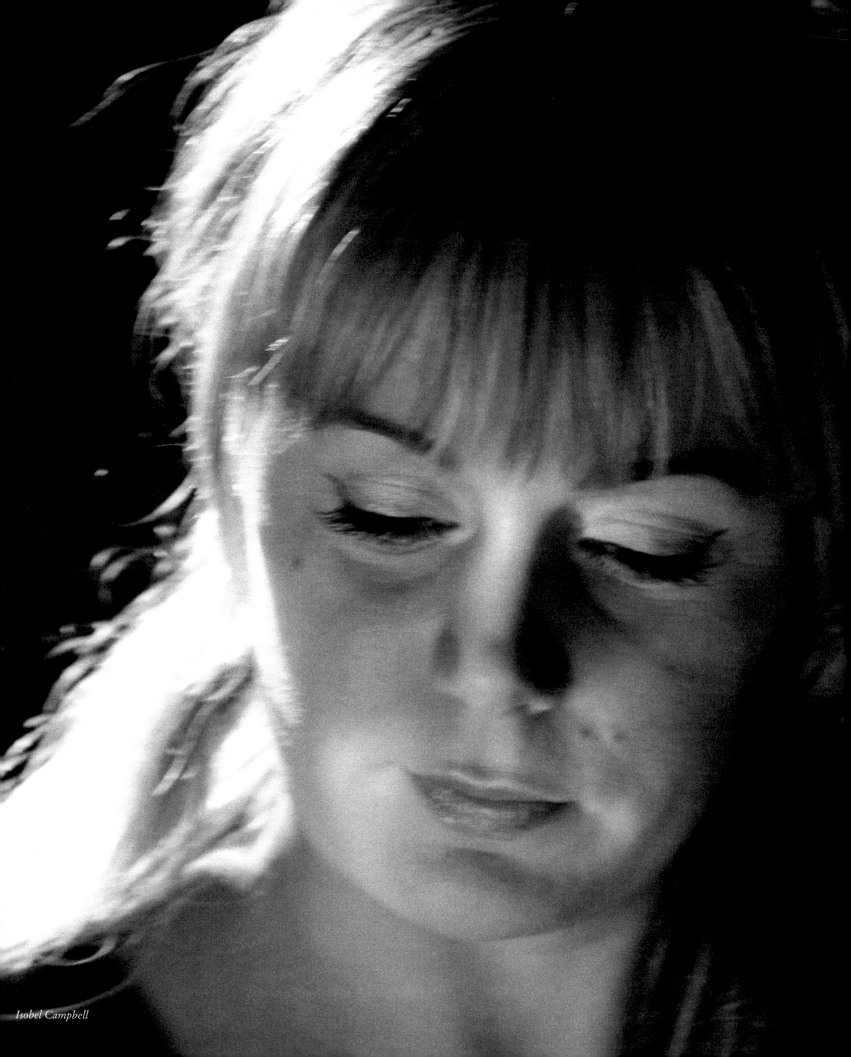

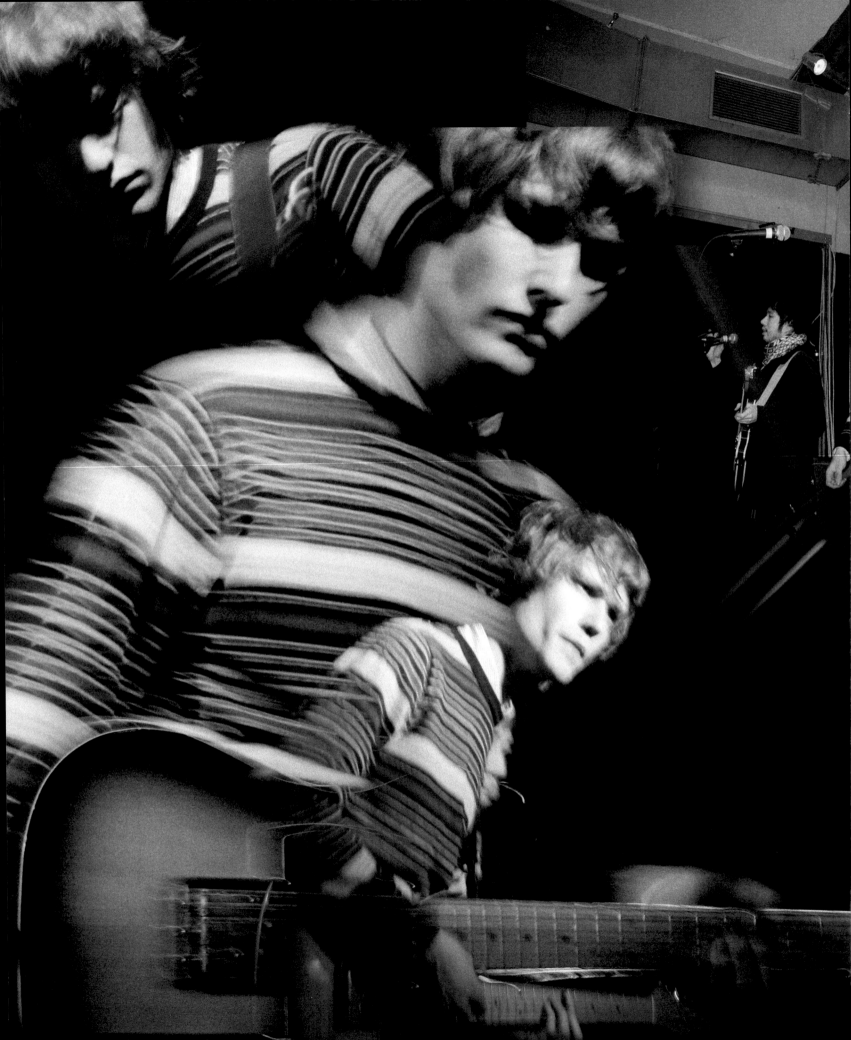

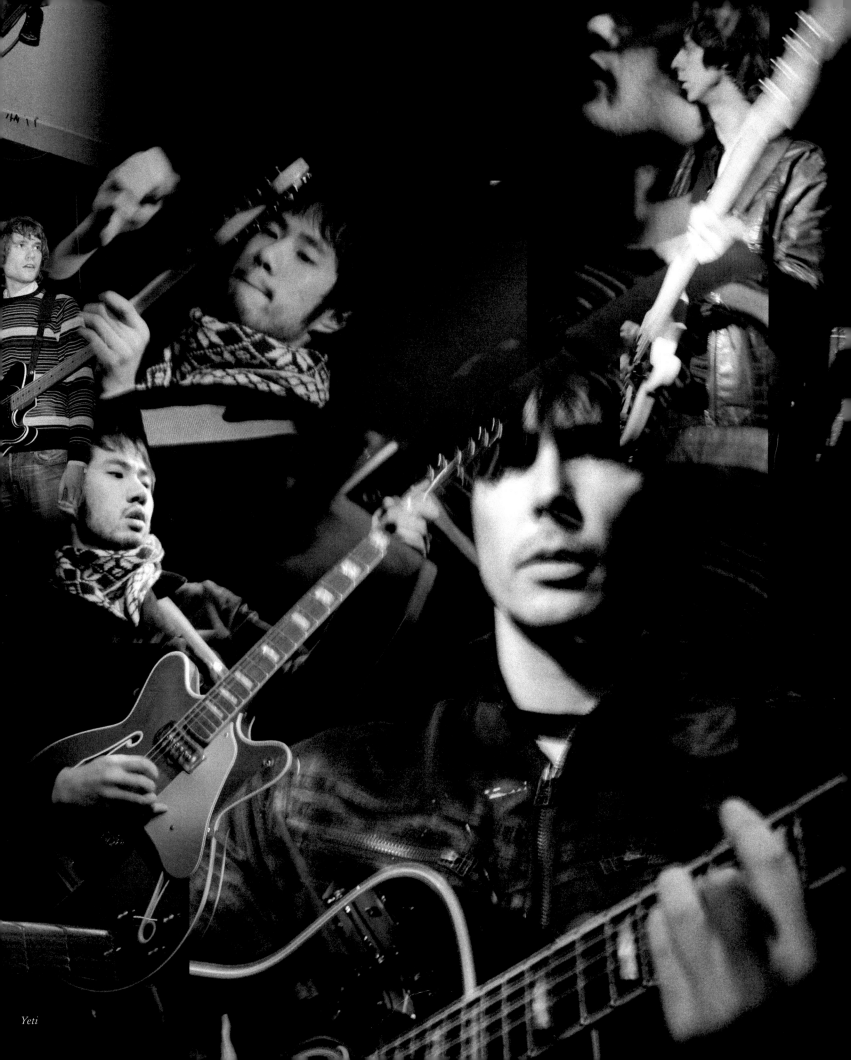

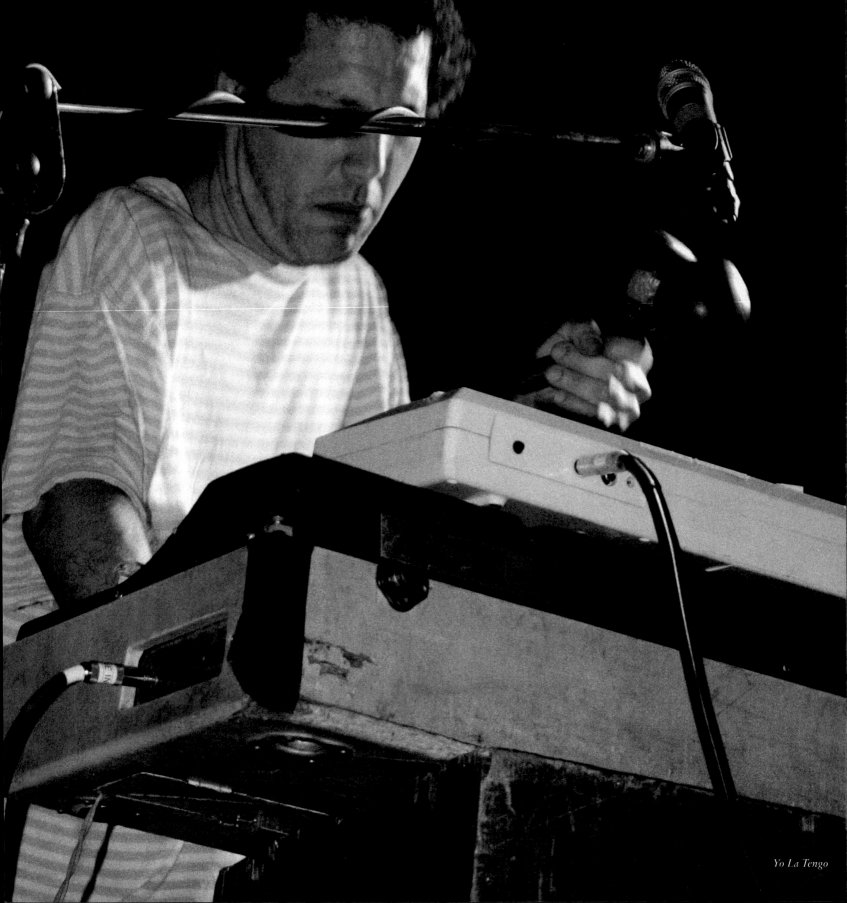

Yo La Tengo

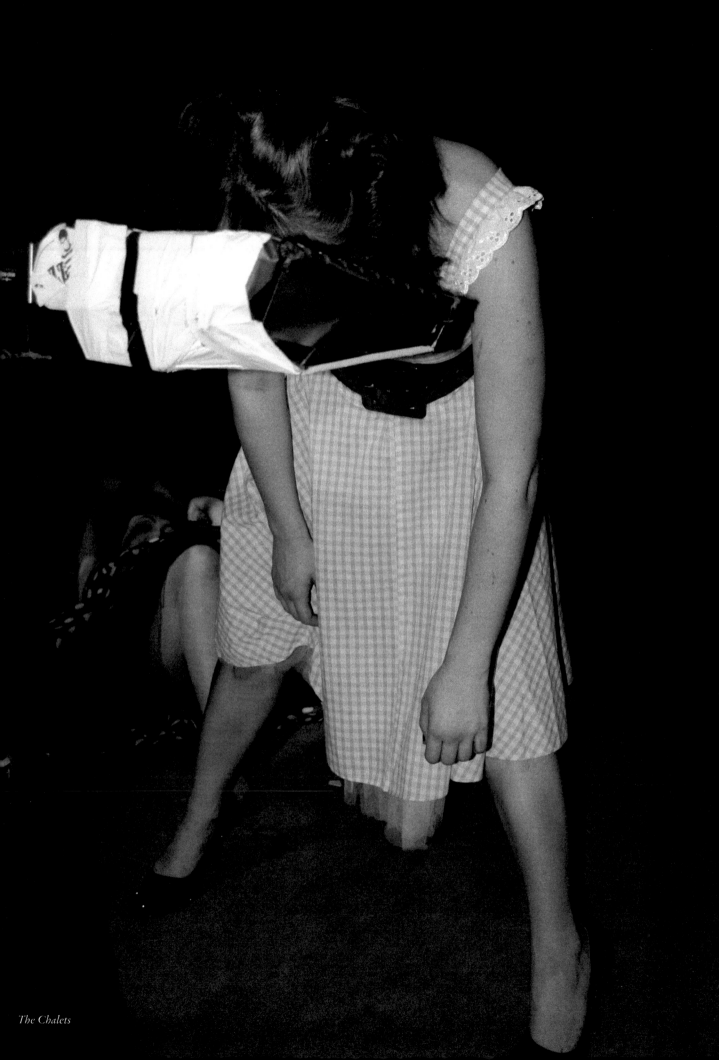

The Chalets

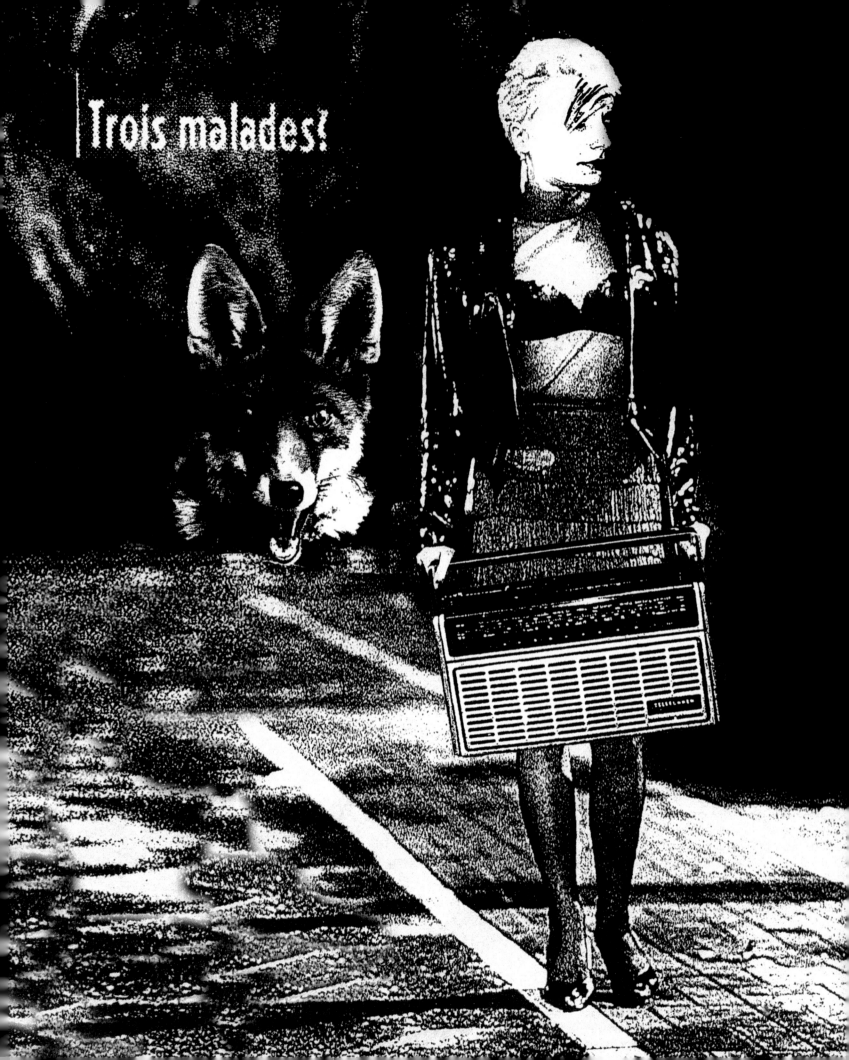

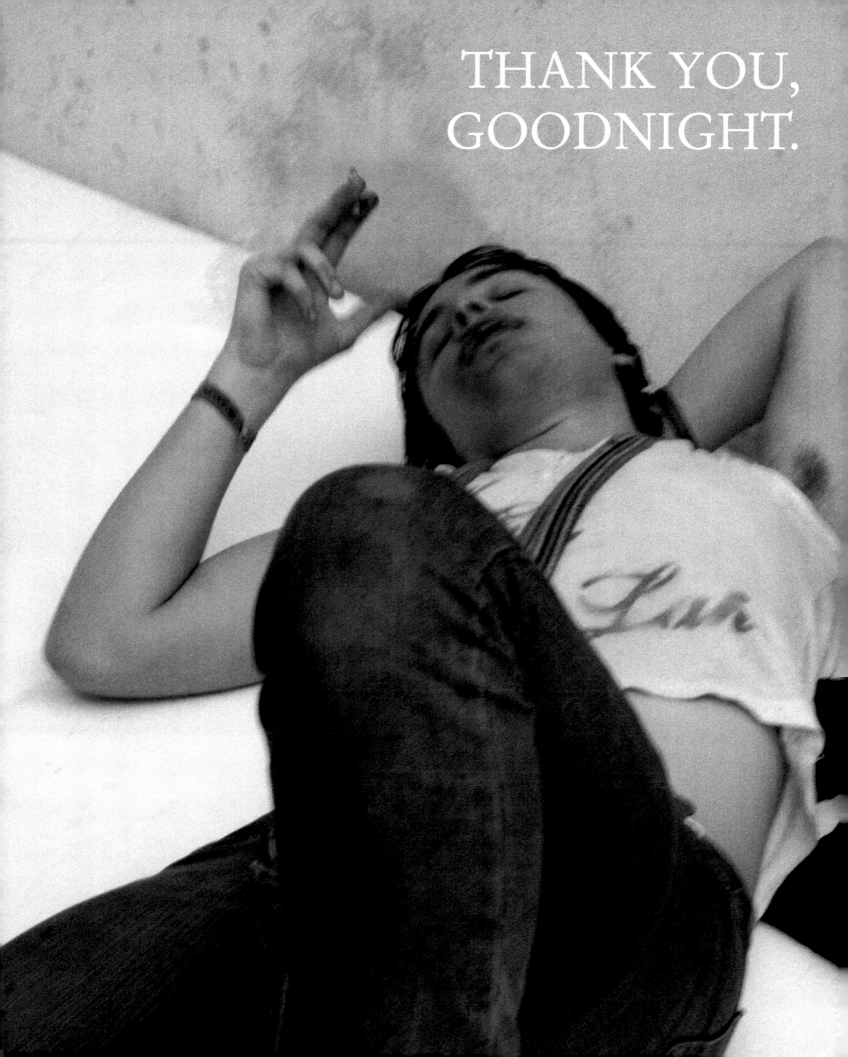

THANK YOU,
GOODNIGHT.

ANGELO SINDACO would like to thank all the bands involved in this book and:

Fidel Sindaco I, Max & Daniele @ COVO, Dr. Kiko

Eva & Emiliano @ Grinding Halt, Romina and all @ DNA

Dado @ Radio Fujiko, Massimo Torrigiani, Selva Barni, David Gross

A special thank to my publisher Paulo "CHE" von Vacano, who believed in this project.

PUBLISHED BY DRAGO ARTS & COMMUNICATIONS S.R.L.
VIA ADDA, 87 - 00198 ROMA
TEL: +39 06 45439018
TEL: +39 06 45439132
MOBILE: +39 393 9710199
FAX: +39 06 45439159
WWW.DRAGOLAB.IT

©2006 DRAGO ARTS AND COMMUNICATION (ROME - ITALY)

ISBN# 88-88493-29-8

PRINTED IN ITALY

DISTRIBUTED IN UNITED STATES OF AMERICA BY
D.A.P./DISTRIBUTED ART PUBLISHERS, INC.
155 SIXTH AVENUE
NEW YORK, NEW YORK 10013
WWW.DAPINC.COM - INFO@DAPINC.COM
PHONE: 001 212 627 1999
FAX: 001 212 627 9484
INFO@DAPINC.COM

UK AND NON-EXCLUSIVE EUROPE
ART BOOKS INTERNATIONAL
UNIT 200A, THE FOUNDRY
156 BLACKFRIARS ROAD
LONDON SE1 8EN – UNITED KINGDOM
PHONE: 0044 23 9220 0080
FAX: 0044 23 9220 0090
FOR SALES, PLEASE CONTACT: TOBY@ART-BKS.COM

FRANCE
CRITIQUES LIVRES DISTRIBUTION S.A.S.
B. P. 93 24, RUE MALMAISON,
93172 BAGNOLET CEDEX FRANCE
PHONE: 0033 1 4360 3910
FAX: 0033 1 4897 3706
FOR SALES AND PRESS, PLEASE CONTACT: CRITIQUES.LIVRES@WANADOO.FR

ITALY
LIBRIMPORT SAS
VIA BIONDELLI, 9
20141 MILANO
TEL: +39 02 89501422
FAX: +39 02 89502811
FOR SALES, PLEASE CONTACT:
LIBRIMPORT@LIBERO.IT

SPAIN-PORTUGAL-GREECE
BOOKPORT ASSOCIATES
VIA LUIGI SALMA, 7
20094 CORSICO (MI), ITALY
TEL: + 39 02 4510 3601
FAX: +39 024510 6426
FOR SALES, PLEASE CONTACT:
BOOKPORT.ASSOCIATES@LIBERO.IT

GERMANY AND AUSTRIA
VISUAL BOOKS SALES AGENCY
LAUBACHER STR. 16, 14197 BERLIN
TEL.: 0049 0 30 69 819 007
FAX: 0049 0 30 69 819 005
SERVICE@VISUALBOOKS-SALES.COM

AUSTRALIA AND NEW ZEALAND
BOOKWISE INTERNATIONAL
174 CORMACK ROAD
WINGFIELD, SA 5013
PHONE: 00 61 419 340056
WWW.BOOKWISE.COM.AU
INFO@BOOKWISE.COM.AU

FAR EAST AND CHINA
ART BOOKS INTERNATIONAL
UNIT 200A, THE FOUNDRY
156 BLACKFRIARS ROAD
LONDON SE1 8EN – UNITED KINGDOM
PHONE: 0044 23 9220 0080
FAX: 0044 23 9220 0090
FOR SALES, PLEASE CONTACT: TOBY@ART-BKS.C